Put any picture you want on any state book cover. Makes a great gift. Go to www.america24-7.com/customcover

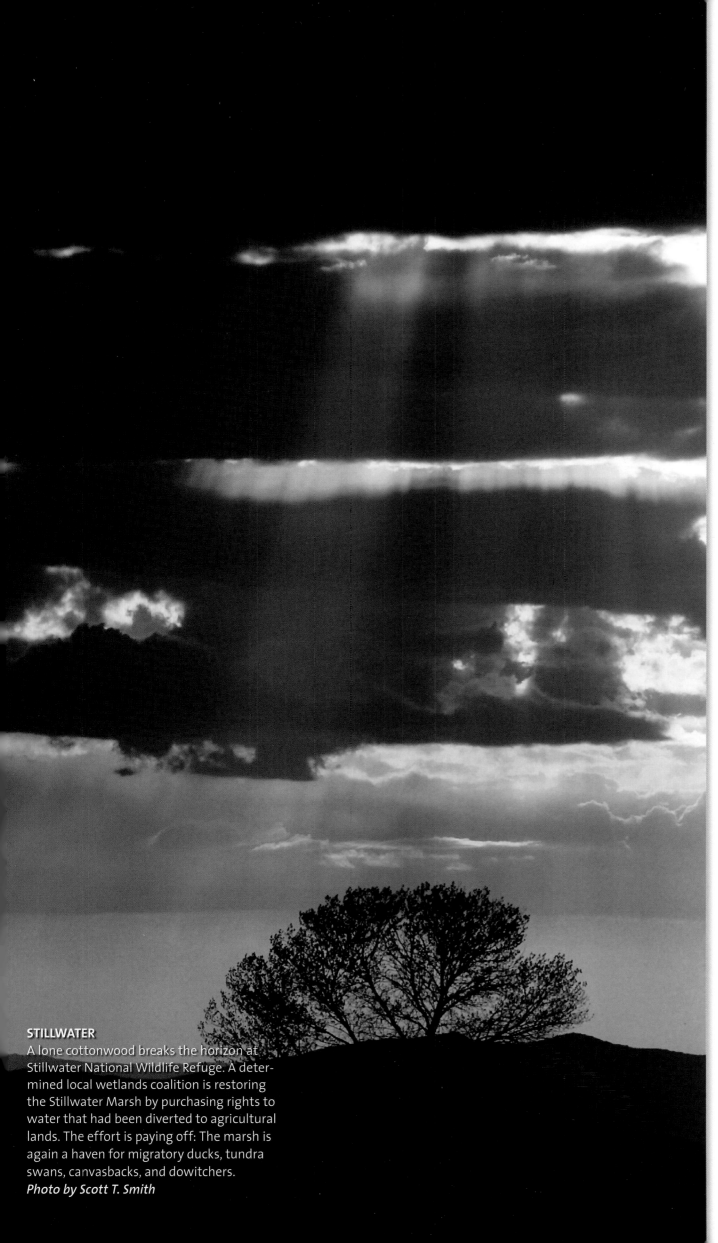

STILLWATER
A lone cottonwood breaks the horizon at Stillwater National Wildlife Refuge. A determined local wetlands coalition is restoring the Stillwater Marsh by purchasing rights to water that had been diverted to agricultural lands. The effort is paying off: The marsh is again a haven for migratory ducks, tundra swans, canvasbacks, and dowitchers.
Photo by Scott T. Smith

Nevada 24/7 is the sequel to *The New York Times* bestseller *America 24/7* shot by tens of thousands of digital photographers across America over the course of a single week. We would like to thank the following sponsors, the wonderful people of Nevada, and the talented photojournalists who made this book possible.

Adobe

OLYMPUS

LEXAR
Media

snapfish

jetBlue
AIRWAYS

WEBWARE

Google

DIGITAL
POND

ebaY

LONDON, NEW YORK, MUNICH, MELBOURNE, and DELHI

Created by Rick Smolan and David Elliot Cohen

24/7 Media, LLC
PO Box 1189
Sausalito, CA 94966-1189
www.america24-7.com

First Edition, 2004
04 05 06 07 08 10 9 8 7 6 5 4 3 2 1

Published in the United States by
DK Publishing, Inc.
375 Hudson Street
New York, NY 10014

DK Publishing, Inc. offers special discounts for bulk purchases for sales promo-
tions or premiums. Specific, large-quantity needs can be met with special edi-
tions, personalized covers, excerpts of existing guides, and corporate imprints.
For more information, contact:

Special Markets Department
DK Publishing, Inc.
375 Hudson Street
New York, NY 10014
Fax: 212-689-5254

Cataloging-in-Publication data is available
from the Library of Congress
ISBN 0-7566-0068-5

Printed in the UK by Butler & Tanner Limited

First printing, October 2004

CLARK COUNTY
Dawn spills across the Desert National Wildlife
Range and makes a prickly silhouette out of a
cholla cactus. The 1.5-million-acre refuge,
the largest in the Lower 48, is tucked into the
Mojave Desert, north of Las Vegas.
Photo by Jim Laurie, Stephens Press

NEVADA 24/7

24 Hours. 7 Days.
Extraordinary Images of
One Week in Nevada.

Created by Rick Smolan and David Elliot Cohen

DK Publishing

About the America 24/7 Project

A hundred years hence, historians may pose questions such as: What was America like at the beginning of the third millennium? How did life change after 9/11 and the ensuing war on terrorism? How was America affected by its corporate scandals and the high-tech boom and bust? Could Americans still express themselves freely?

To address these questions, we created *America 24/7*, the largest collaborative photography event in history. We invited Americans to tell their stories with digital pictures. We asked them to shoot a visual memoir of their lives, families, and communities.

During one week in May 2003, more than 25,000 professionals and amateurs shot more than a million pictures. These images, sent to us via the Internet, compose a panoramic yet highly intimate view of Americans in celebration and sadness; in action and contemplation; at work, home, and school. The best of these photographs, more than 6,000, are collected in 51 volumes that make up the *America 24/7* series: the landmark national volume *America 24/7*, published to critical acclaim in 2003, and the 50 state books published in 2004.

Our decision to make *America 24/7* an all-digital project was prompted by the fact that in 2003 digital camera sales overtook film camera sales. This techno-logical evolution allowed us to extend the project to a huge pool of photographers. We were thrilled by the response to our challenge and moved by the insight offered into American life. Sometimes, the amateurs outshot the pros—even the Pulitzer Prize winners.

The exuberant democracy of images visible throughout these books is a revela-tion. The message that emerges is that now, more than ever, America is a supersized idea. A dreamspace, where individuals and families from around the world are free to govern themselves, worship, read, and speak as they wish. Within its wide margins, the polyglot American nation manages to encompass an inexplicably complex yet workable whole. The pictures in this book are dedicated to that idea.

—*Rick Smolan and David Elliot Cohen*

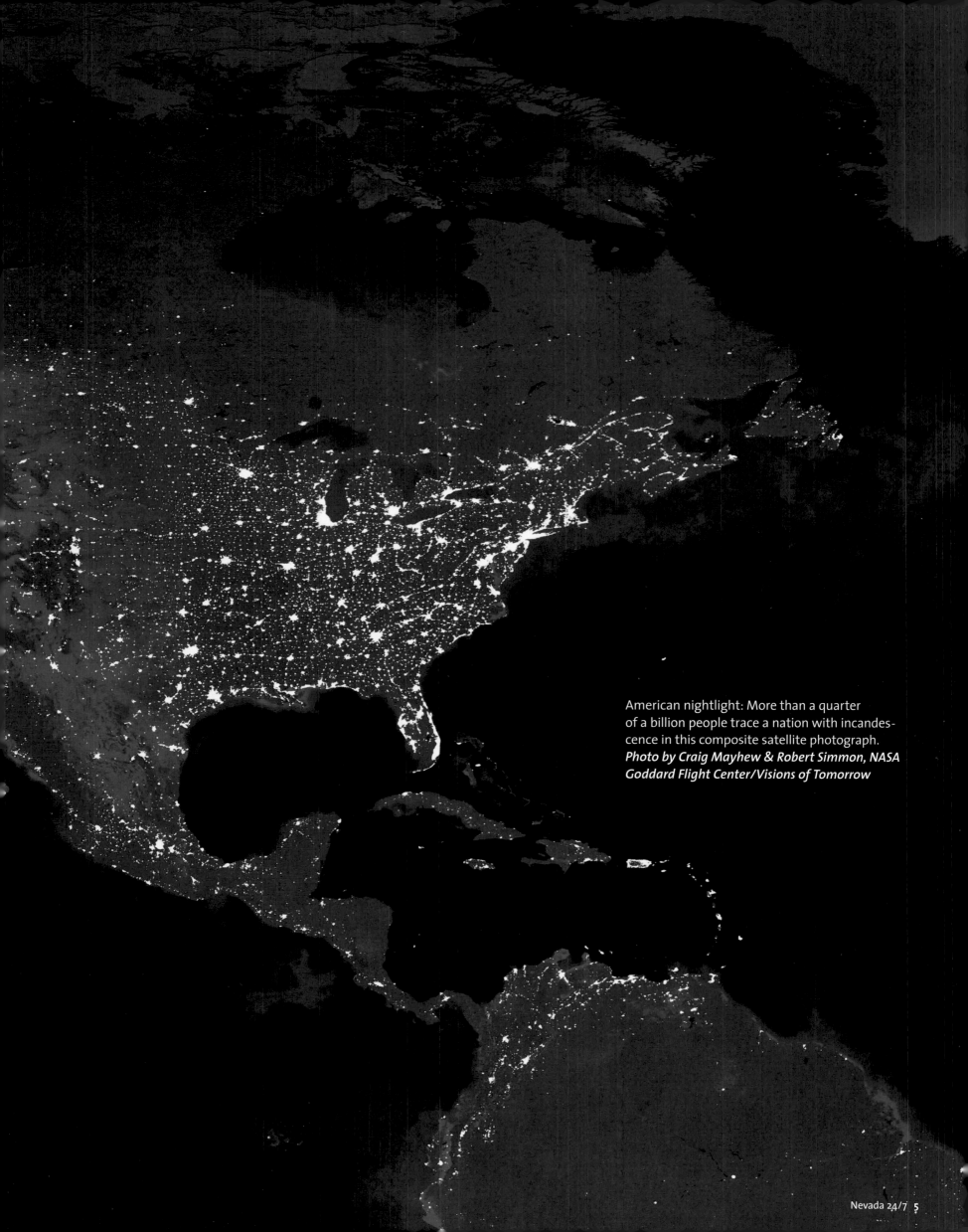

American nightlight: More than a quarter of a billion people trace a nation with incandescence in this composite satellite photograph.
Photo by Craig Mayhew & Robert Simmon, NASA Goddard Flight Center/Visions of Tomorrow

The Nevada Road

By John L. Smith

Bust out of the neon-juiced hyperbole of Las Vegas, and Nevada stretches beyond the blazing horizon into a scarlet sunset. Snakes and coyotes flash in the mind's eye as the car heads north with only the headlights to tell the road ahead.

Suddenly, the senses get that tequila tingle. As the roaring desert silence and sage-scented air wash over, the question rises: Which is the real Nevada? The audacious excess of Las Vegas, or the equally surreal big empty of the open road?

The answer is both. Of Nevada's 2.2 million people, 1.7 million of them crowd into the Las Vegas Valley, and most of the rest cluster in Reno. That leaves much of the Great Basin desolate—most of it burdened with sad, tiny tales of boom and bust. Ghost towns pepper the wide, wide valleys and mountain washes, sporting names like Aurora and Manhattan. Bone-dry piles of tumbled planks and faint lines of old roads through the sagebrush tell of a prosperity that played out with the claims. In towns like Eureka, Ely, and Elko, the economic pulse still rises and falls with the price of gold.

The bigger story of the Silver State is its lawful libertinism. We only won our statehood (1864) because of the Union's need for Comstock silver. Then, when we let gambling in in 1931, newspapers across the nation demanded that our statehood be revoked. We were scorned for our quickie divorces and then for our legalized brothels. We bore the nation's moralizing—right up until

MINERAL COUNTY
Along the Wassuk Range in southeastern Nevada, powerlines cross expanses of land caressed by a late afternoon rainstorm. The precipitation is welcome; Nevada is the driest state in the nation.
Photo by Larry Angier

Las Vegas became the all-American *Carnaval.* Incidentally, 48 states have embraced some form of legalized gambling.

Meanwhile, we haven't lost our defiant streak. With 86 percent of the state under federal supervision, there are deep veins of antigovernment sentiment, especially in the northern cow counties, where ranchers and miners battle to keep open their arid range and their wilderness roads. The feds plan to bury the nation's nuclear waste at Yucca Mountain. Opposition to becoming the nation's ultimate dump has been a unifying force in this politically divided state.

The state's low-tax landscape and libertarian political ethic have created an inviting stage for dreamers and grifters, entrepreneurs and immigrants. This is the place where America's gambling bosses once sought sanctuary from the government, only to have corporate titans move in and make them look like rubes. Imagine that a place that nourished the Paiute mystic Wovoka and gave meaning to Wayne Newton, and you begin to get the full, stereoscopic picture.

The long, strange Nevada road trip cruises from the gaudiest street in the world all the way to Highway 50, the Loneliest Road in America. Out the window are more than 200 mountain ranges, heaving up like waves in a desert sea. Off on a distant mountain top, the Earth's oldest trees have seen it all. On a ridge up ahead, herds of wild horses.

A fourth-generation Nevadan, John L. Smith *writes a column for the* Las Vegas Review-Journal.

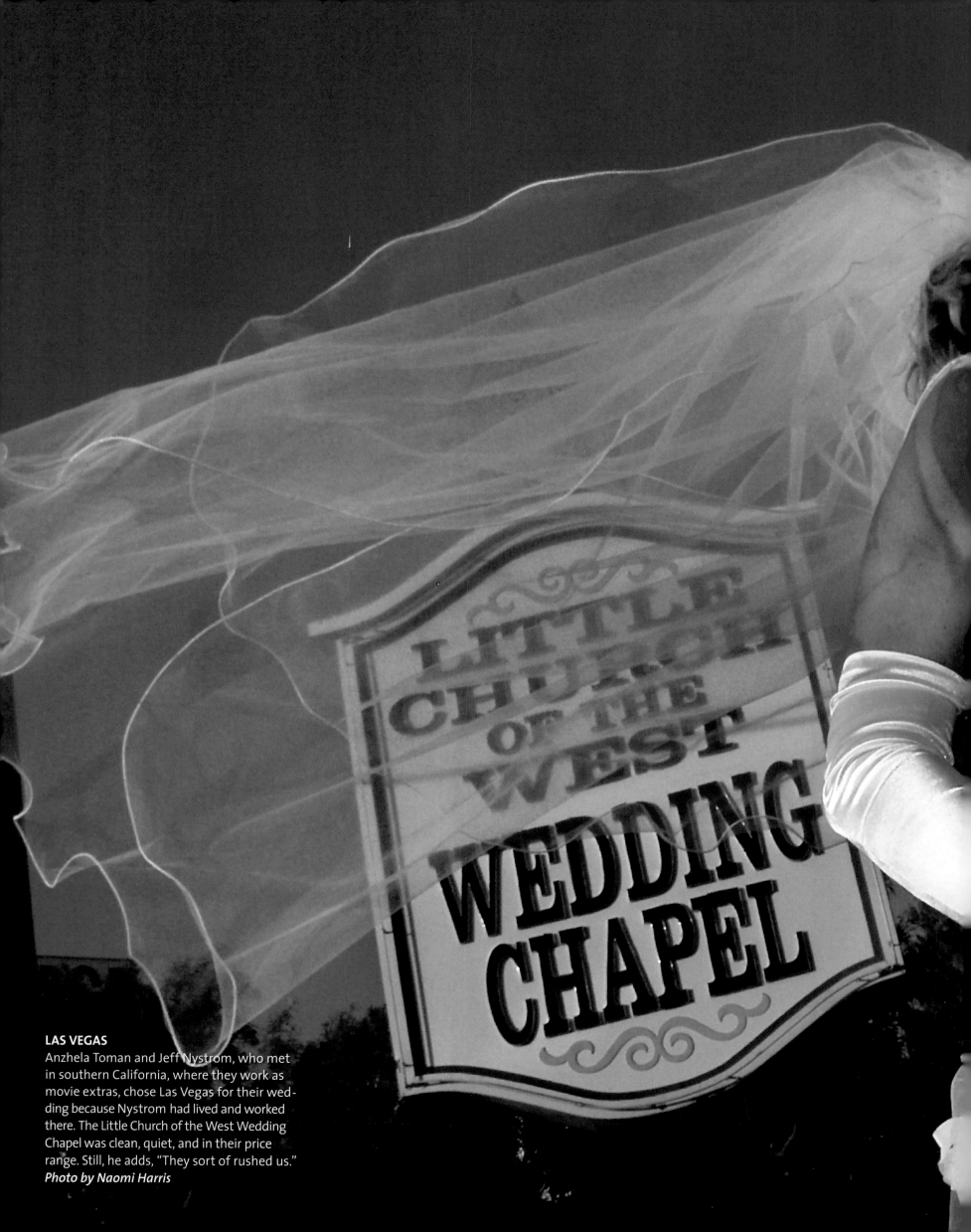

LAS VEGAS

Anzhela Toman and Jeff Nystrom, who met in southern California, where they work as movie extras, chose Las Vegas for their wedding because Nystrom had lived and worked there. The Little Church of the West Wedding Chapel was clean, quiet, and in their price range. Still, he adds, "They sort of rushed us."

Photo by Naomi Harris

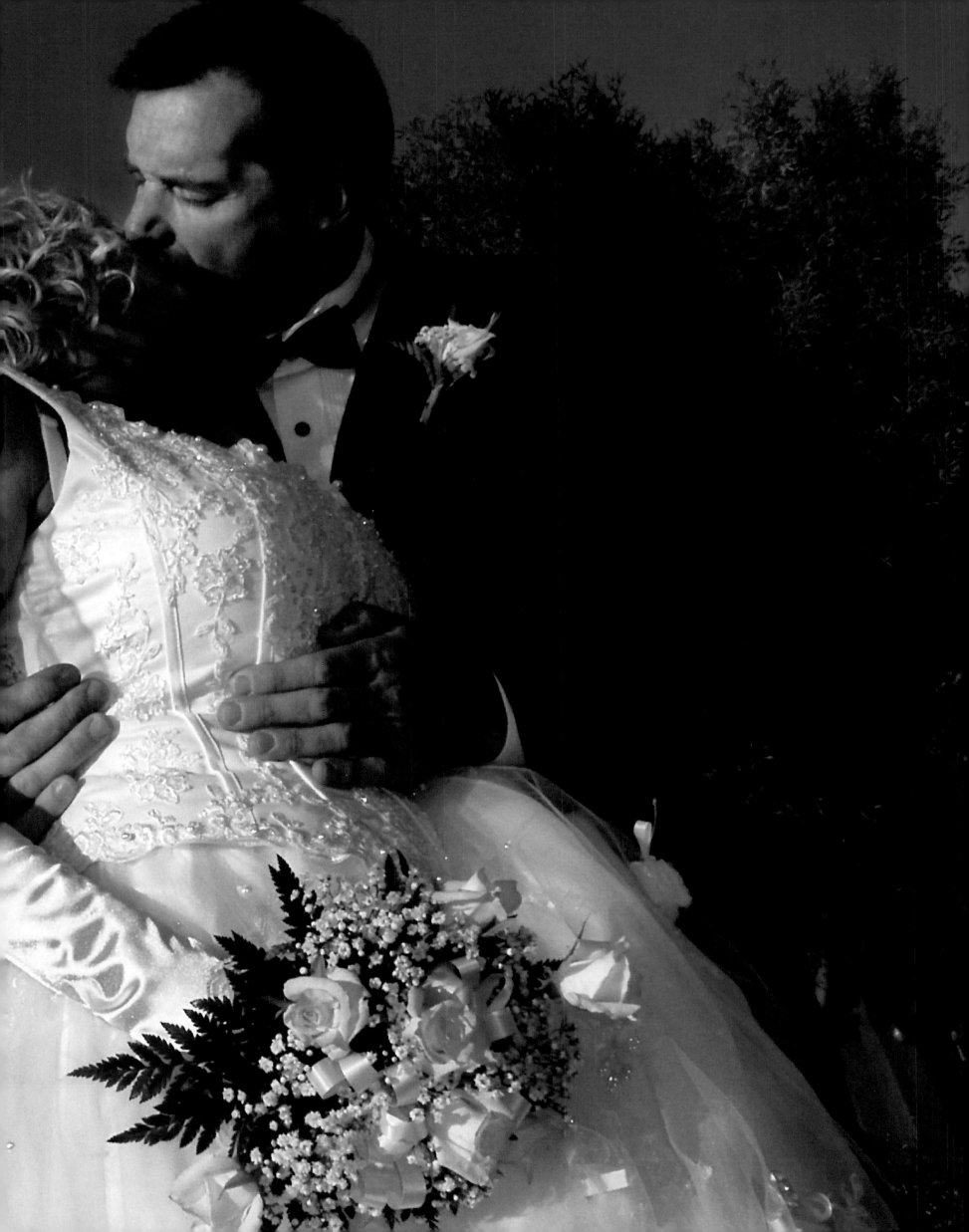

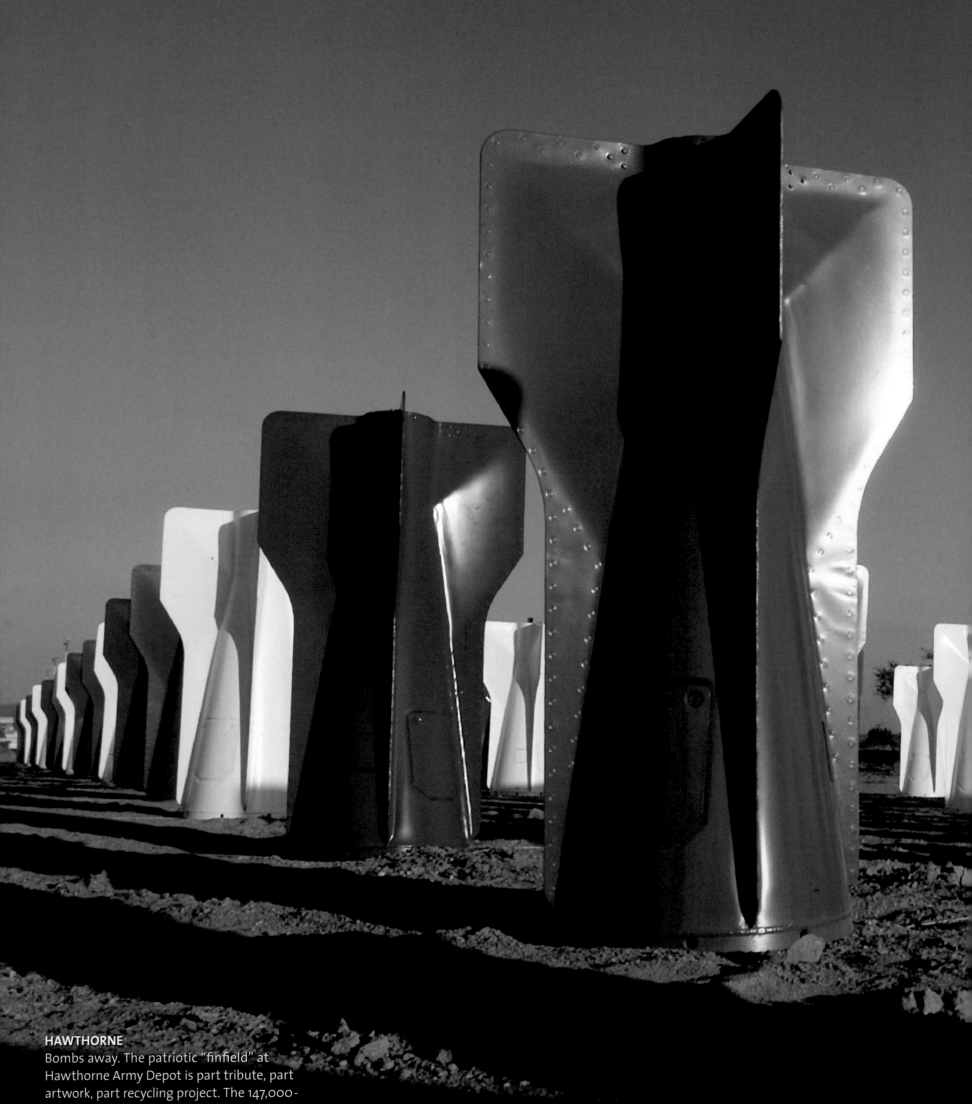

HAWTHORNE
Bombs away. The patriotic "finfield" at Hawthorne Army Depot is part tribute, part artwork, part recycling project. The 147,000-acre storage site can hold more munitions than any other U.S. facility but is at half capacity now. Blame satellites for using fewer and smarter bombs.
Photo by Larry Angier

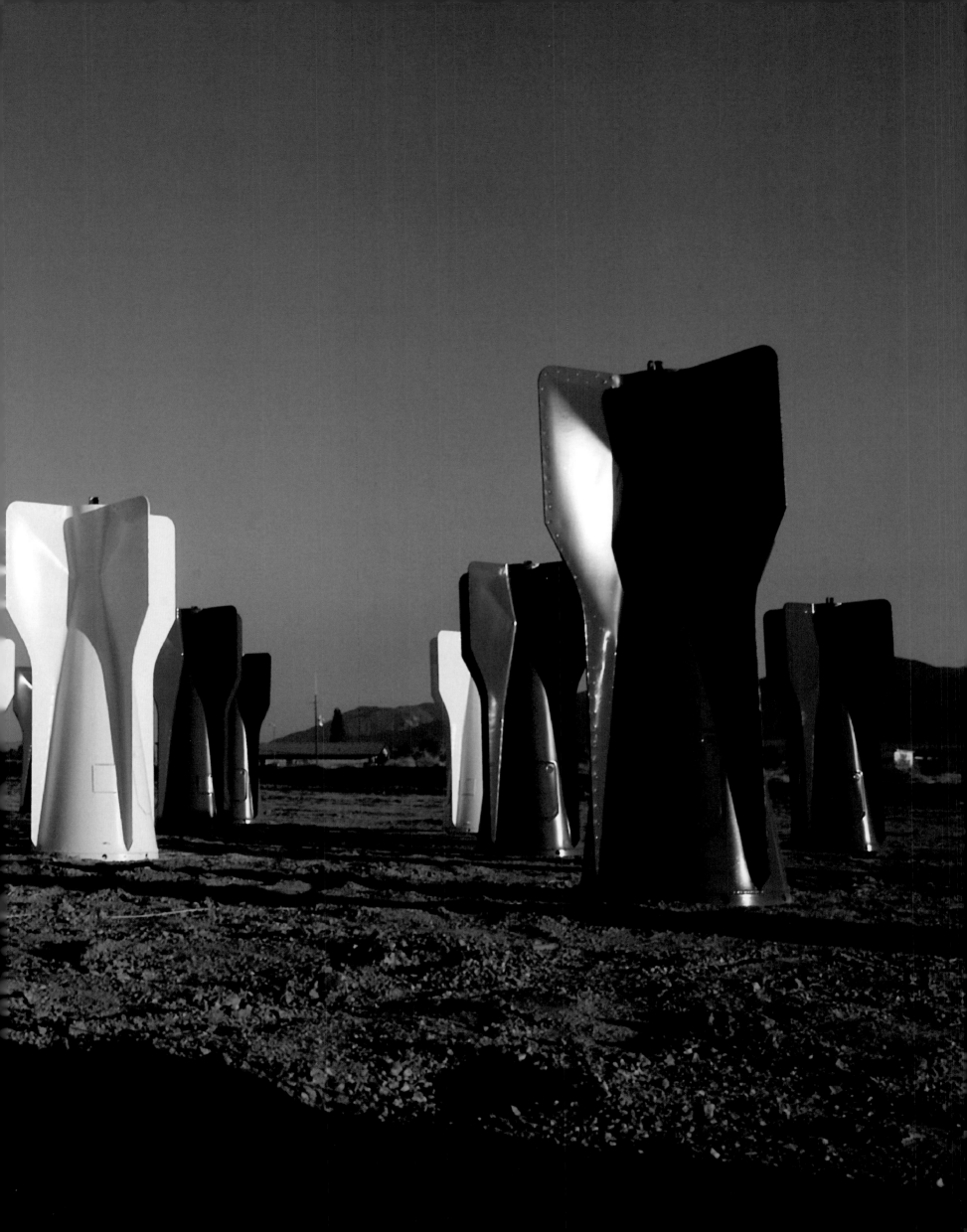

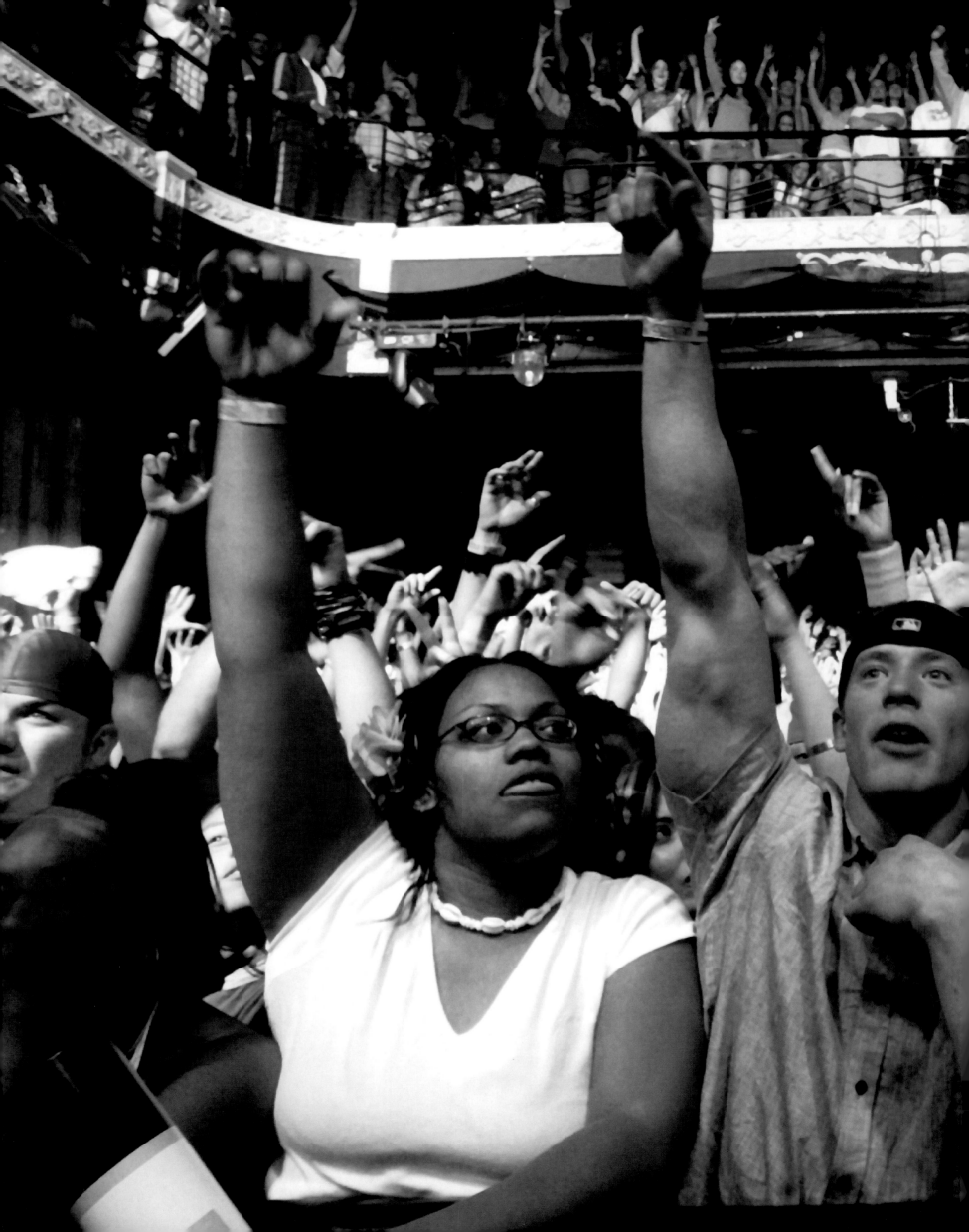

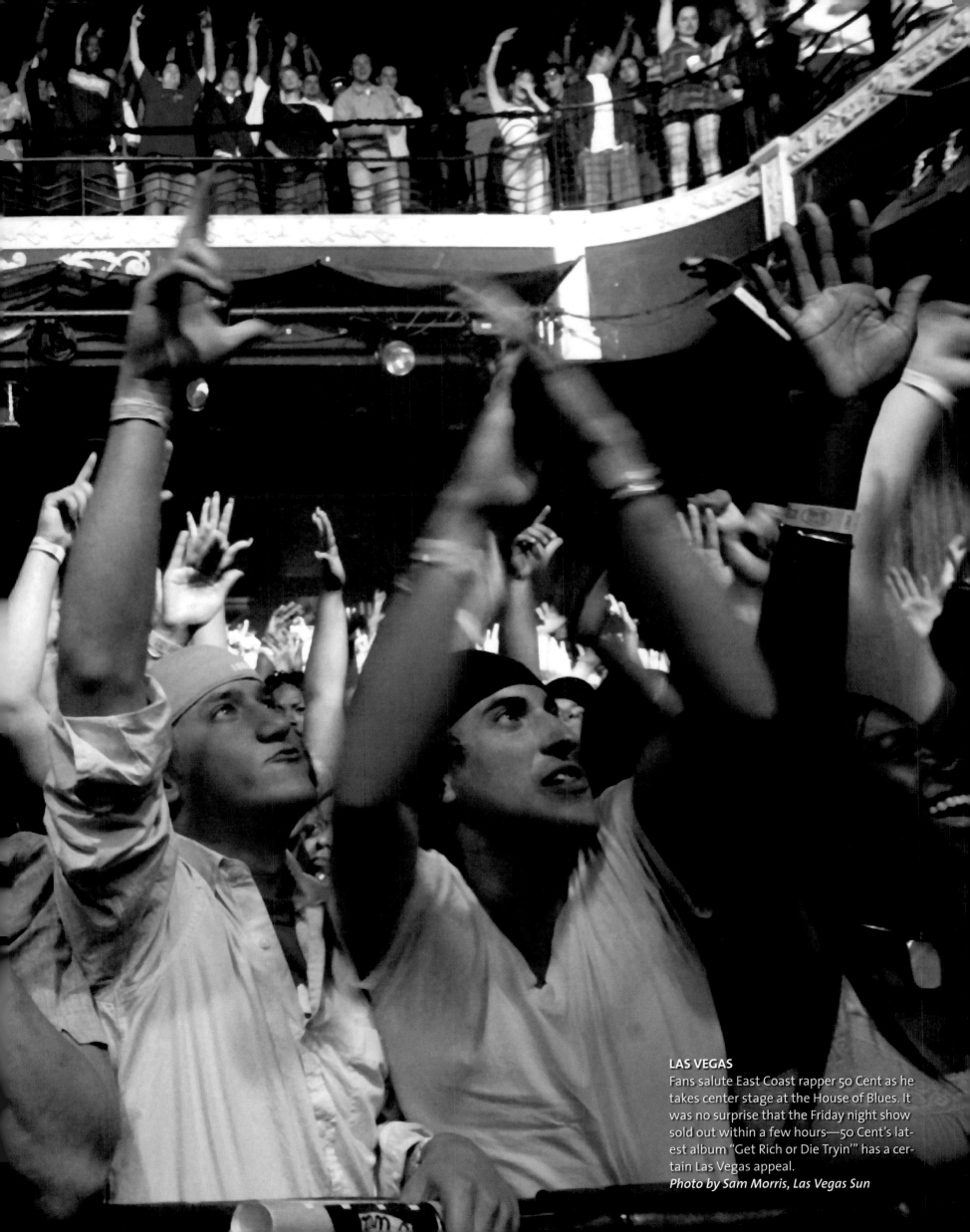

LAS VEGAS
Fans salute East Coast rapper 50 Cent as he takes center stage at the House of Blues. It was no surprise that the Friday night show sold out within a few hours—50 Cent's latest album "Get Rich or Die Tryin'" has a certain Las Vegas appeal.
Photo by Sam Morris, Las Vegas Sun

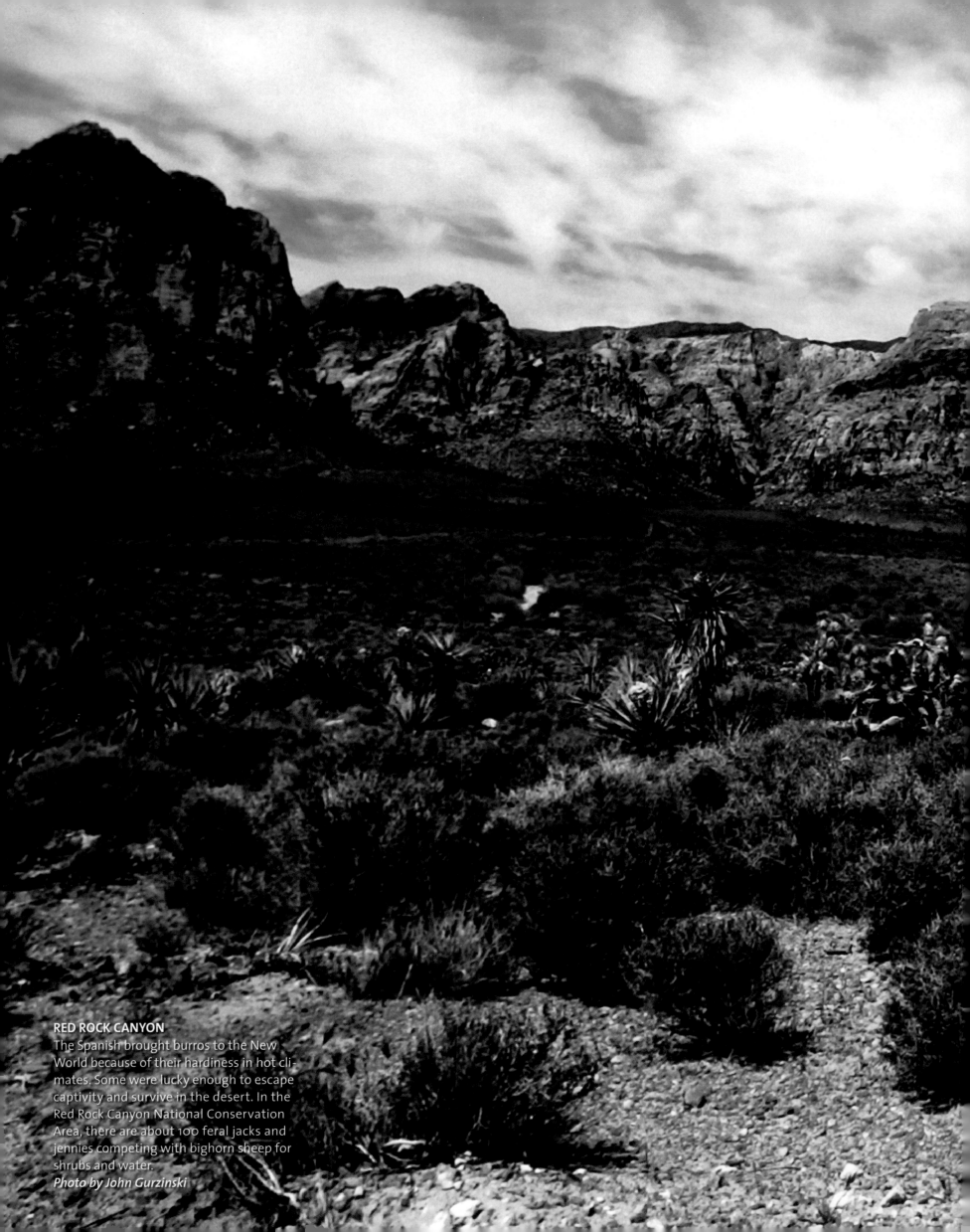

RED ROCK CANYON

The Spanish brought burros to the New World because of their hardiness in hot climates. Some were lucky enough to escape captivity and survive in the desert. In the Red Rock Canyon National Conservation Area, there are about 100 feral jacks and jennies competing with bighorn sheep for shrubs and water.

Photo by John Gurzinski

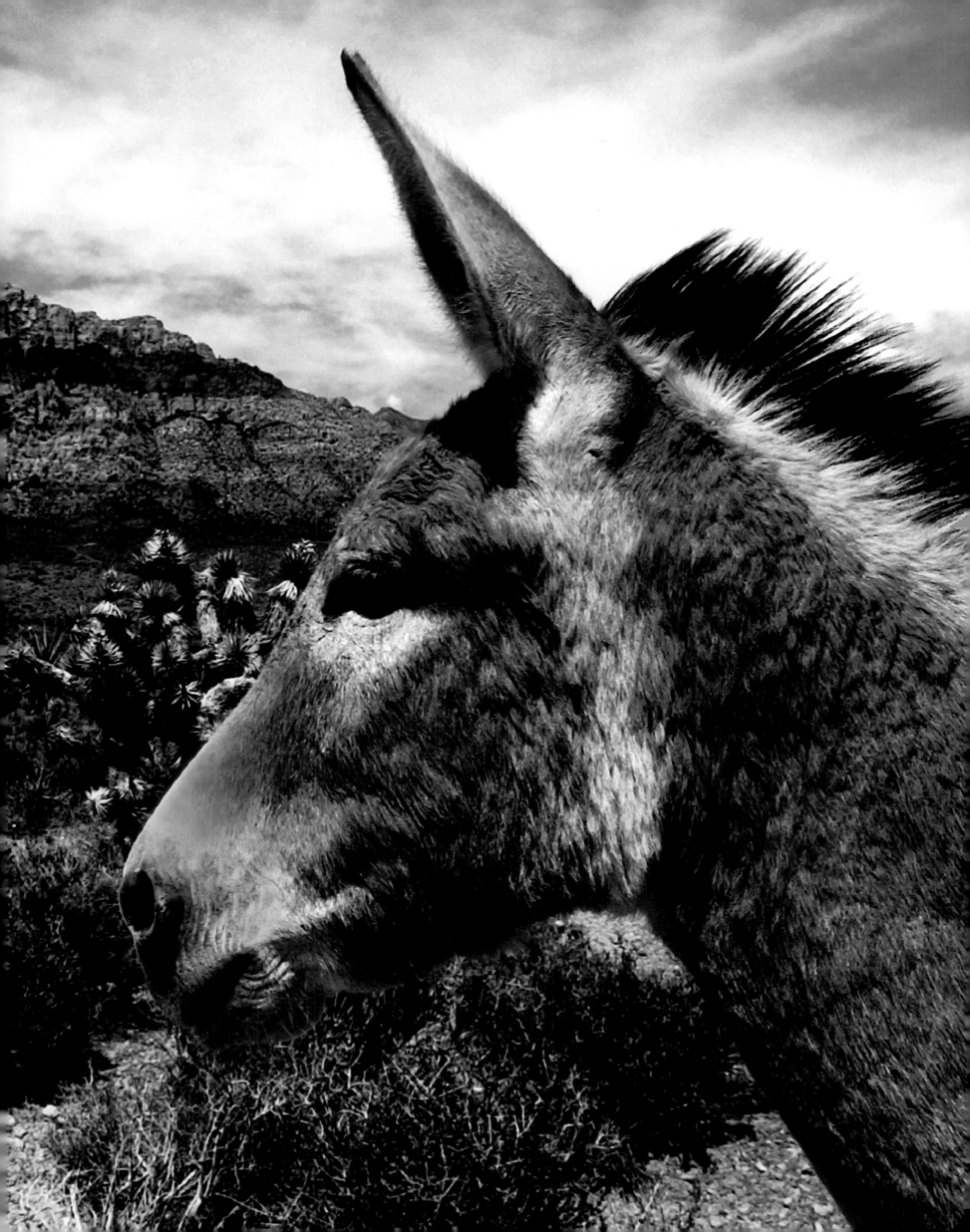

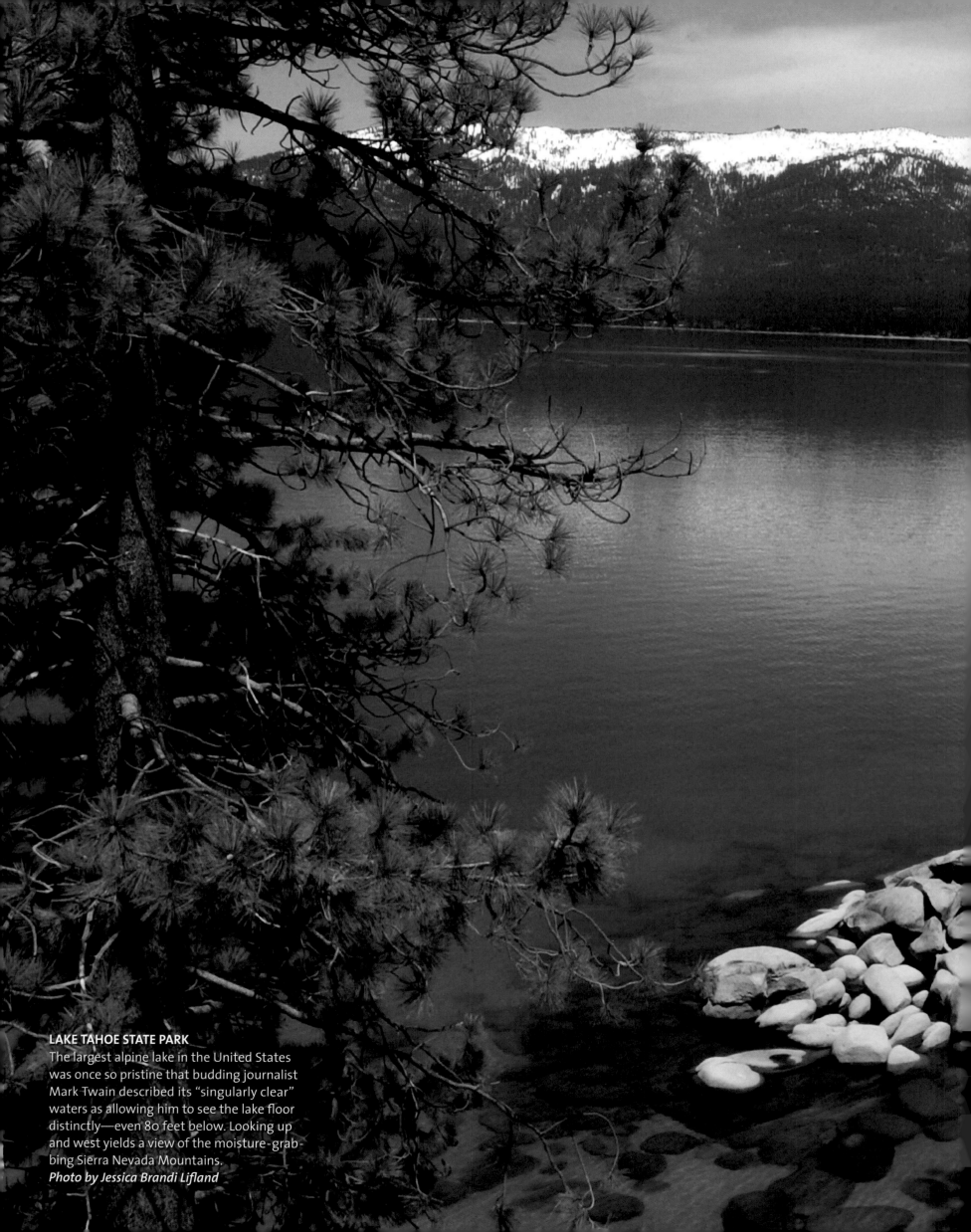

LAKE TAHOE STATE PARK
The largest alpine lake in the United States was once so pristine that budding journalist Mark Twain described its "singularly clear" waters as allowing him to see the lake floor distinctly—even 80 feet below. Looking up and west yields a view of the moisture-grabbing Sierra Nevada Mountains.
Photo by Jessica Brandi Lifland

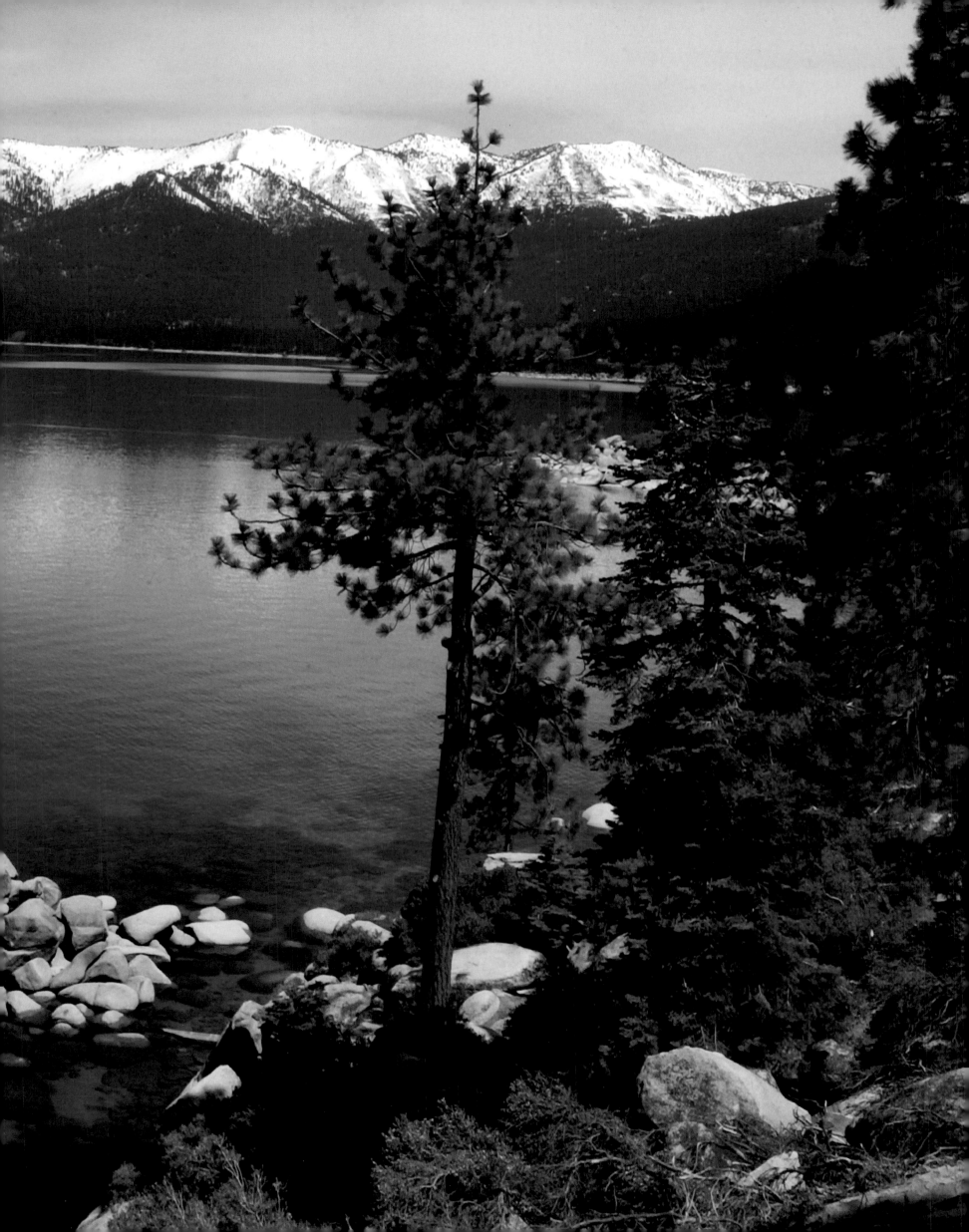

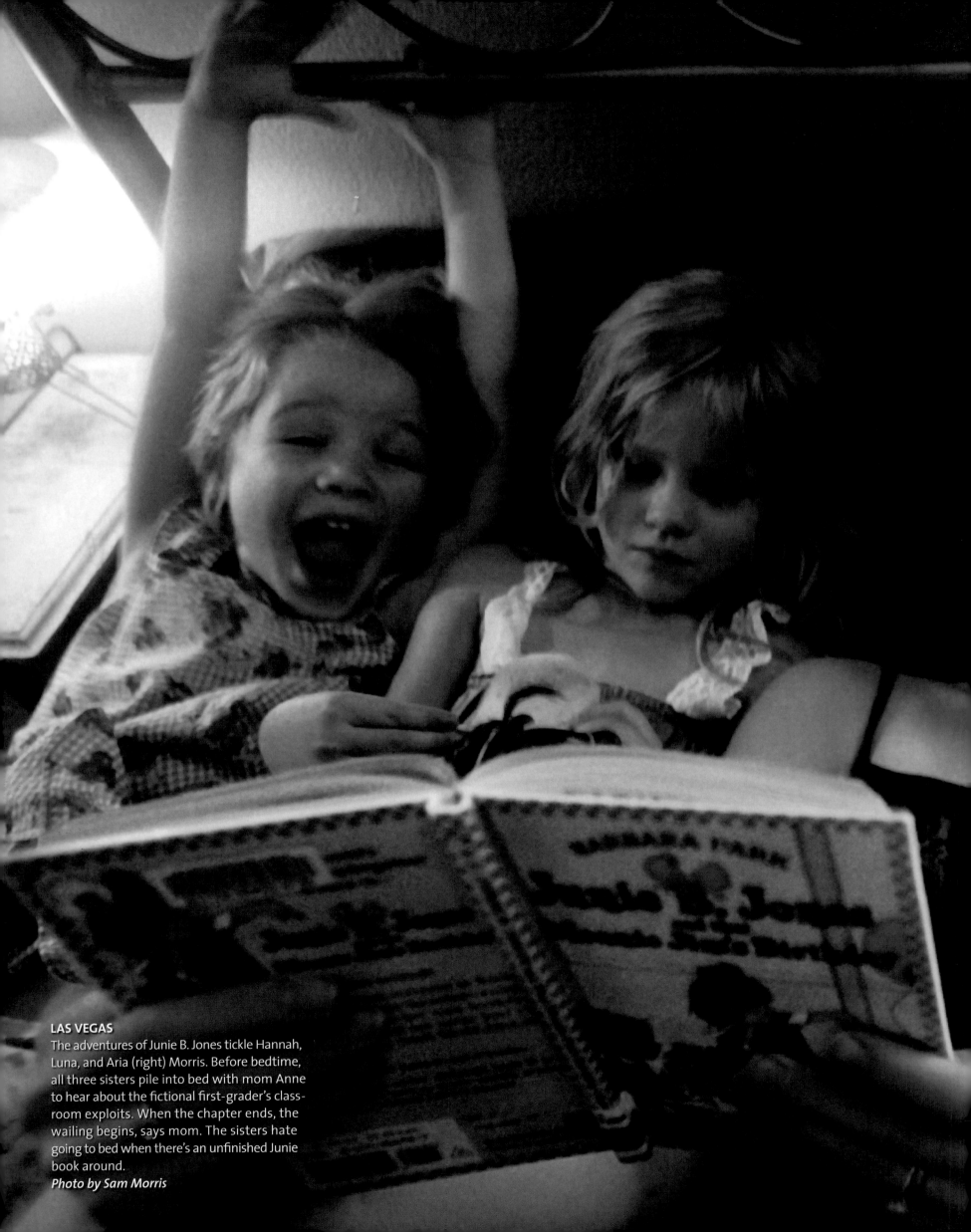

LAS VEGAS
The adventures of Junie B. Jones tickle Hannah, Luna, and Aria (right) Morris. Before bedtime, all three sisters pile into bed with mom Anne to hear about the fictional first-grader's classroom exploits. When the chapter ends, the wailing begins, says mom. The sisters hate going to bed when there's an unfinished Junie book around.
Photo by Sam Morris

Hearth & Home

LAS VEGAS

When Air Force Reservist Marc Jaggi returned home briefly after six months of active duty at Beale Air Force Base in California, his daughters stuck to him like glue. "Being away gave family-time a lot more quality and value," says Jaggi. A full-time firefighter and trained EMT in civilian life, Jaggi was sent to the California base to teach firefighting and emergency techniques.

Photos by Karen Jaggi, JaggiDesign.com

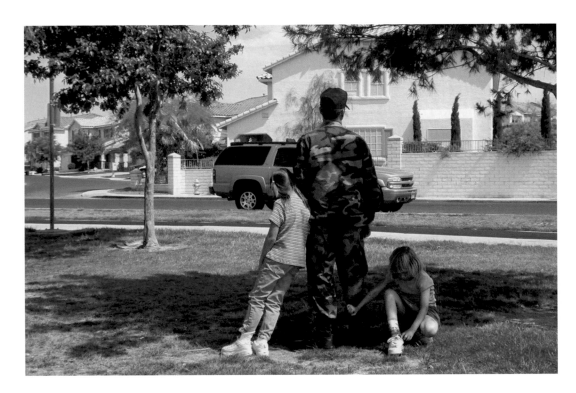

LAS VEGAS
Accustomed to carrying up to 60 pounds of fire-fighting equipment, Marc Jaggi finds this burden easier to bear. Elizabeth, 6, devised her own version of a snuggly pack to stay in touch.

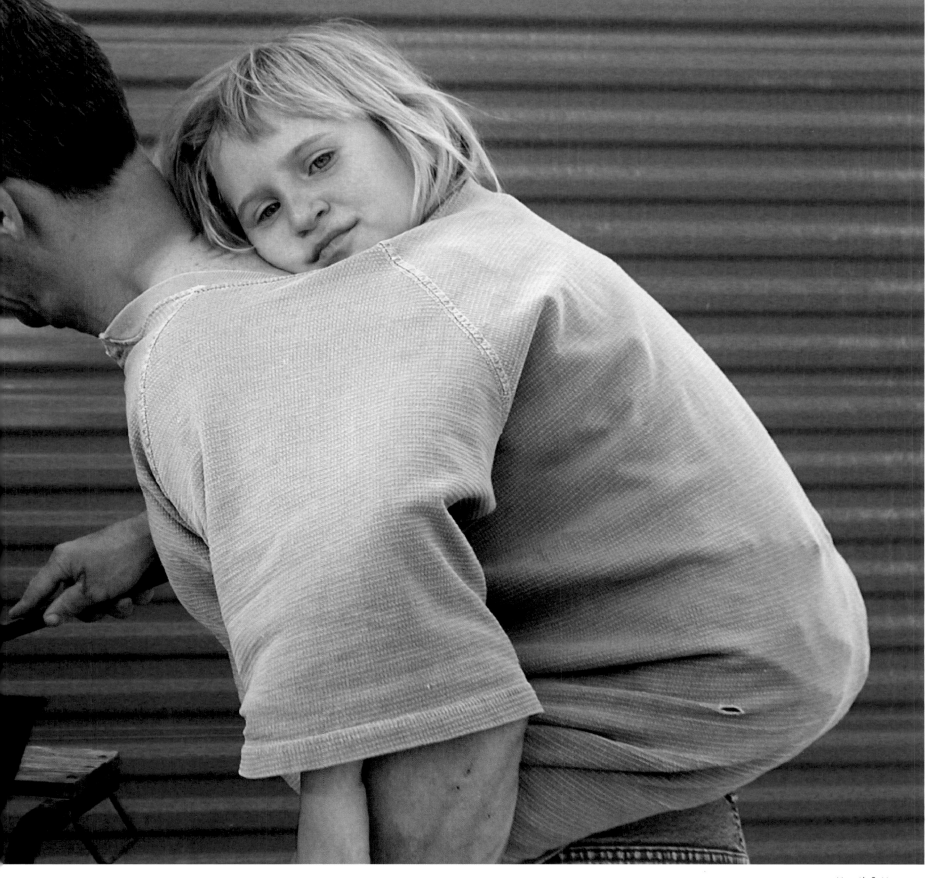

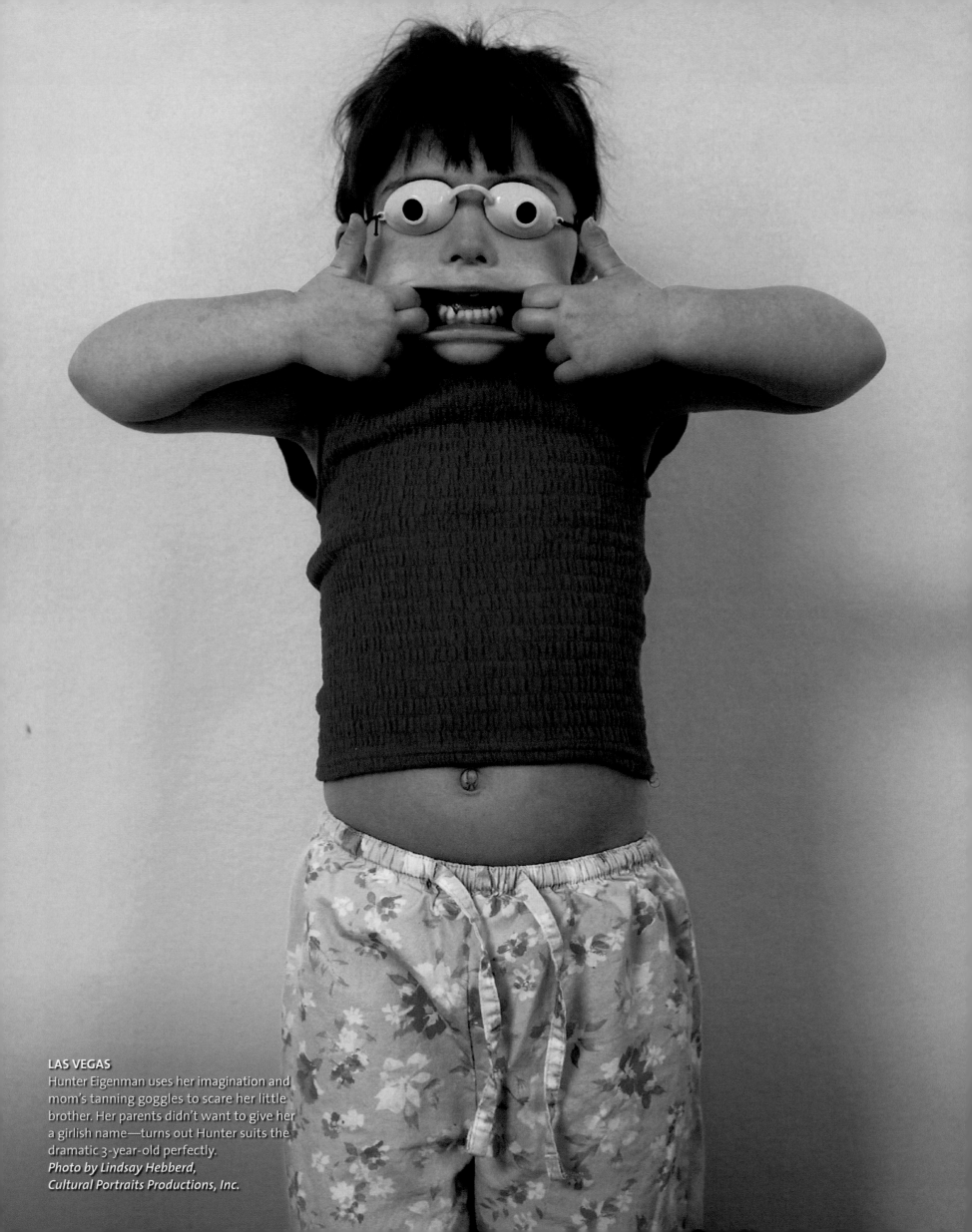

LAS VEGAS
Hunter Eigenman uses her imagination and mom's tanning goggles to scare her little brother. Her parents didn't want to give her a girlish name—turns out Hunter suits the dramatic 3-year-old perfectly.
Photo by Lindsay Hebberd,
Cultural Portraits Productions, Inc.

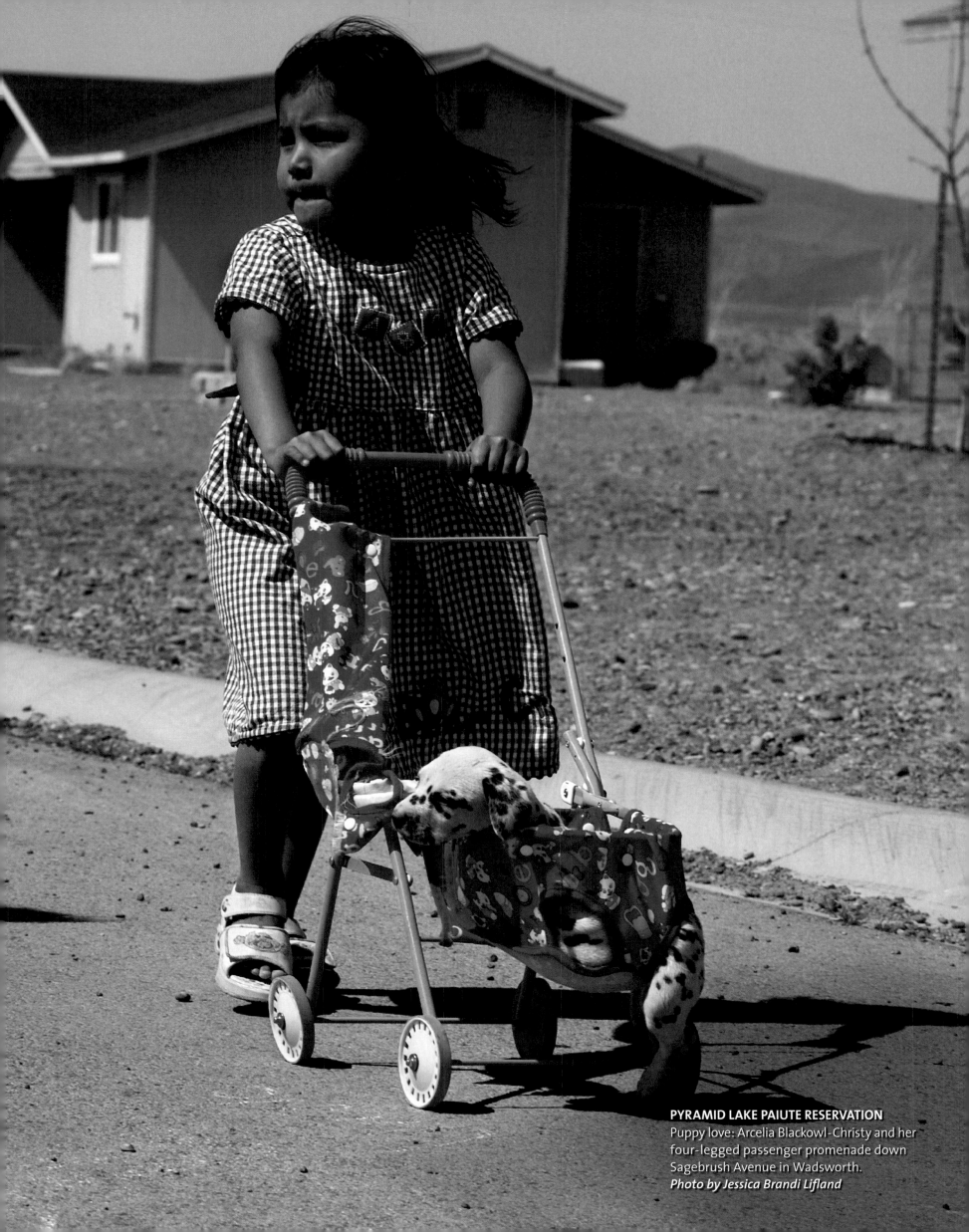

PYRAMID LAKE PAIUTE RESERVATION
Puppy love: Arcelia Blackowl-Christy and her four-legged passenger promenade down Sagebrush Avenue in Wadsworth.
Photo by Jessica Brandi Lifland

Pesa awamooa'a! That's "good morning" in Paiute. Twenty-year-old Keri Romo—tending to her awakening 5-day-old son Tucker Hall—has been studying the language of her people. She works in a tribal office developing a curriculum to help reservation schools teach Paiute.
Photo by Jessica Brandi Lifland

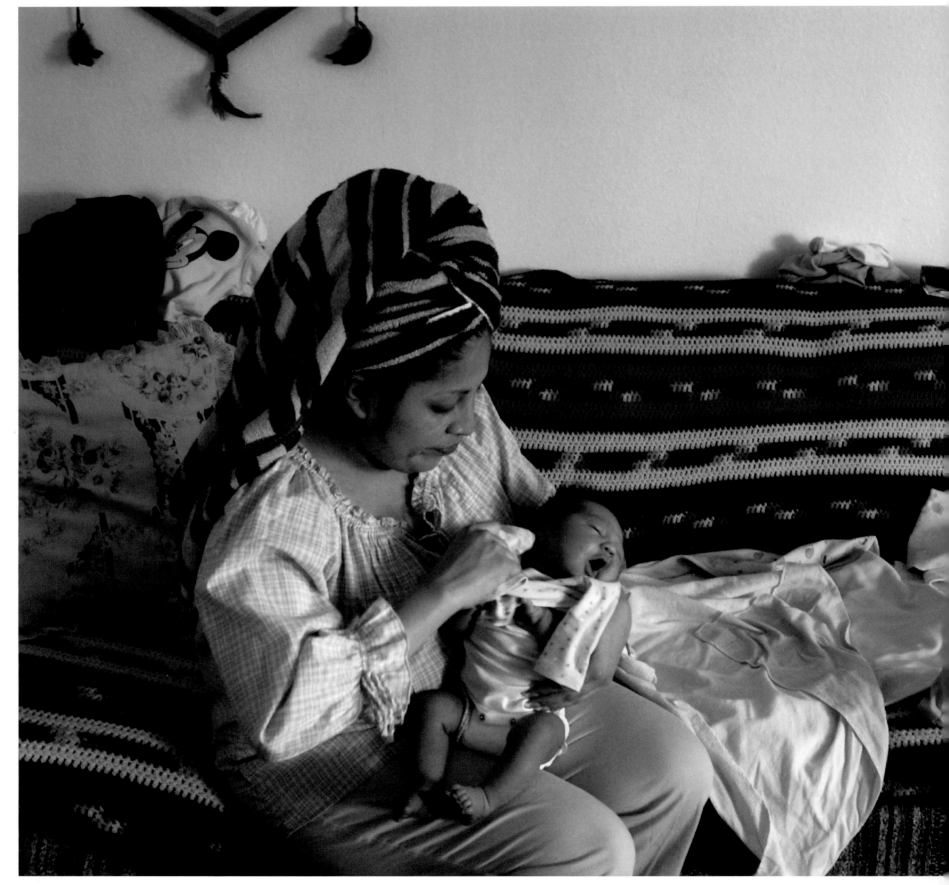

LAS VEGAS
Catherine Jaggi earns TV privileges by doing her homework. Having finished her math, she's taking full advantage of the best chair in front of the tube.
Photo by Karen Jaggi, JaggiDesign.com

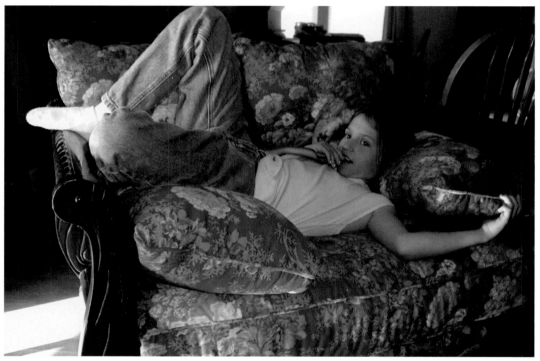

WHITE PINE COUNTY

Luis Rivas Reyes takes a break in his one-room trailer at S&H Ranch after a long shift overseeing several hundred sheep and newborn lambs. The Chilean came to Nevada on a temporary work visa but found the time away from his family difficult. He returned to Chile shortly after this photo was taken.
Photo by Lin Alder, alderphoto.com

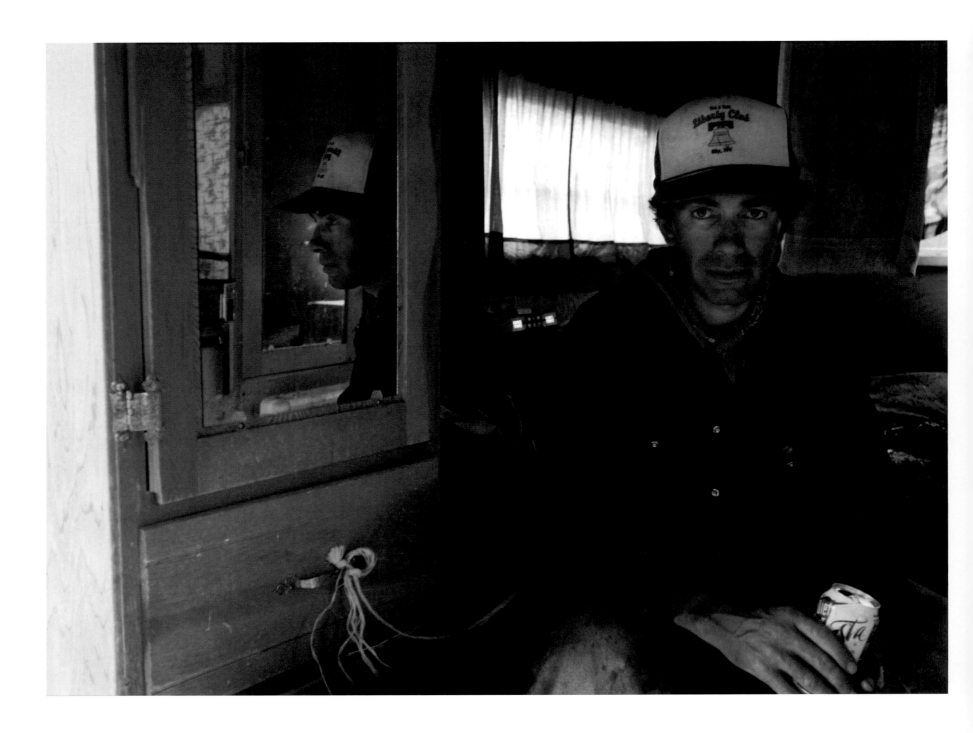

MARIETTA

Prospector Roy Ladd, 89, built his "Ford Chevy" from parts collected in the old mining town of Marietta, high in the Excelsior Mountains. A tail-gunner during World War II, Ladd's plane ditched into the English Channel. When he came to the town after the war, his plan was to stake a claim yielding enough gold to marry. He's still a bachelor.

Photo by Larry Angier

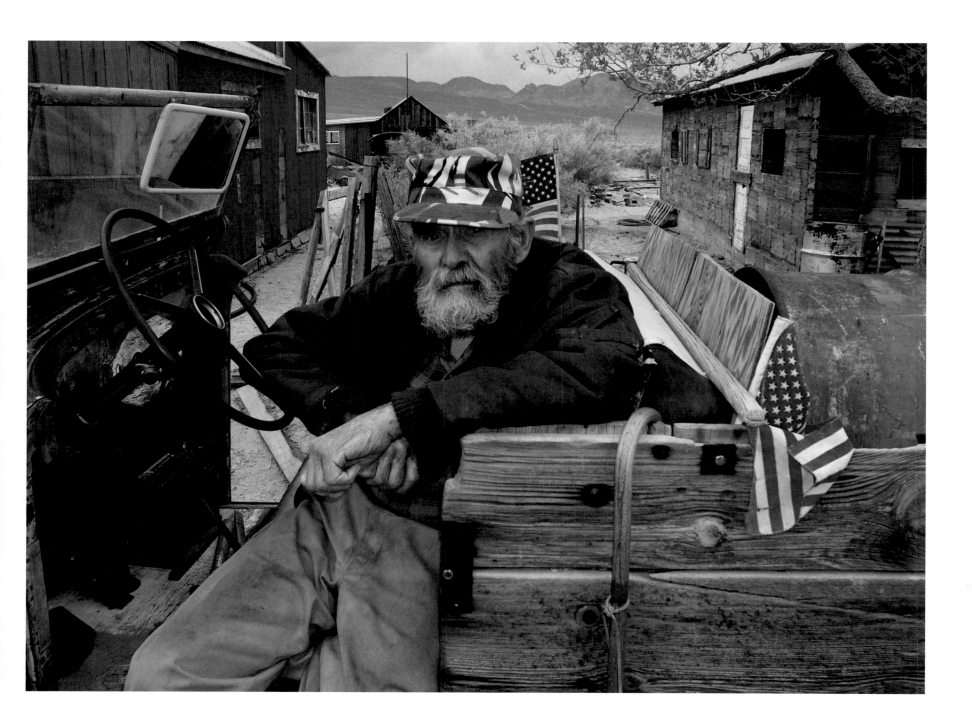

PYRAMID LAKE PAIUTE RESERVATION

James Shaw and Judy Davis of the Pyramid Lake Paiute Nation plant trees along a street in a new housing development. Other tribe members installed the irrigation system. Money for the community project came from a federally funded grant administered by the Nevada Division of Forestry.

Photos by Jessica Brandi Lifland

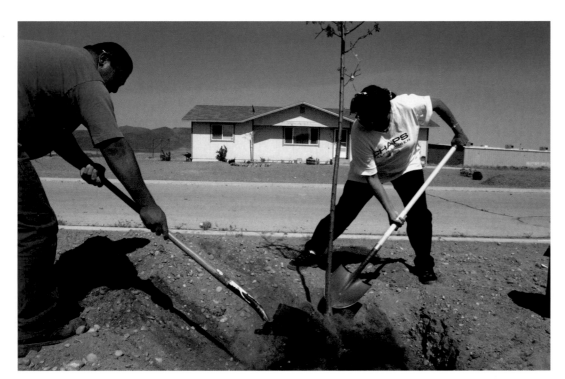

PYRAMID LAKE PAIUTE RESERVATION
The Paiute community received a federal grant to populate the reservation with trees. They chose red oaks, gingkos, box elders, locusts, and maples for their shade-making qualities and ability to survive in arid conditions.

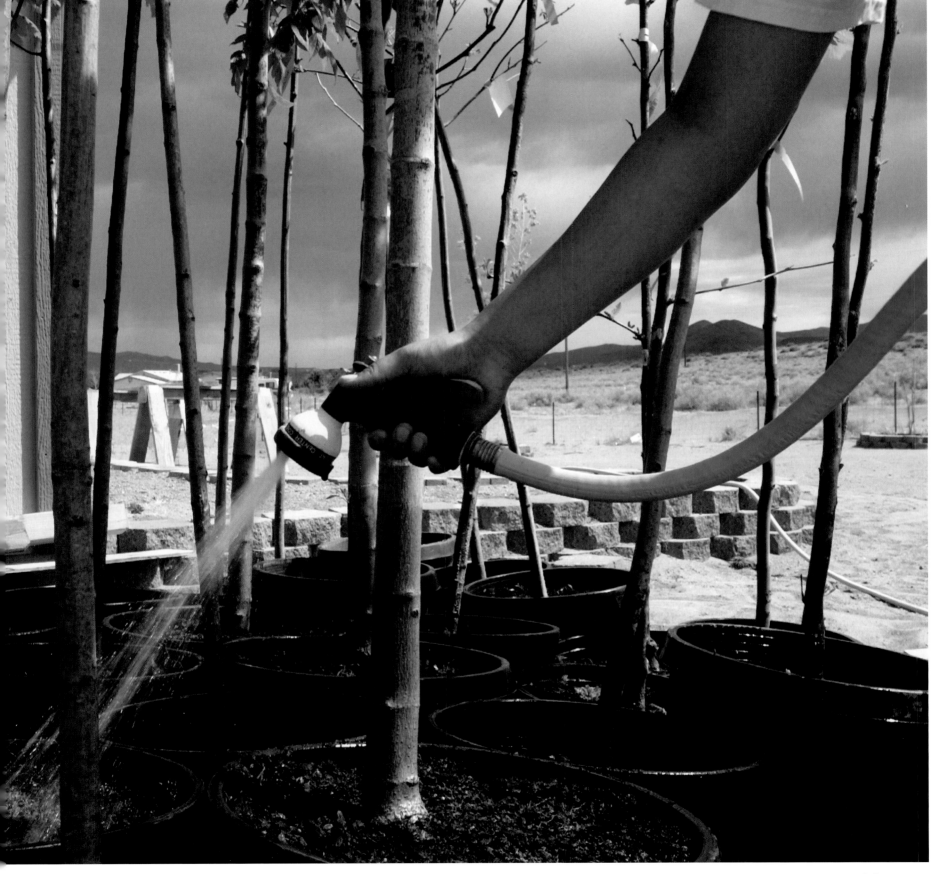

Love them tender: While Maryland newlyweds Ioana and Bobby Viman kiss, his Elvis-dressed father, Alexander, records the moment—as he did with the wedding, streaming it over the Internet for the couple's families in Romania. Proclaims the groom: "Las Vegas is the nicest place in the world to get married." The state is famous for its "no wait, no blood test" marriages.
Photo by Naomi Harris

Bodhi Hays and Tiffany Miller, of Mt. Vernon, Washington, drove 21 hours straight to get married at A Little White Wedding Chapel on South Las Vegas Boulevard. Driving lengthy distances is in the couple's blood—they plan to go into long-haul trucking together.
Photo by John Gurzinski

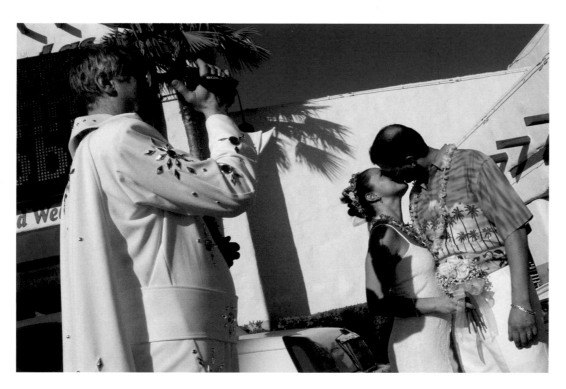

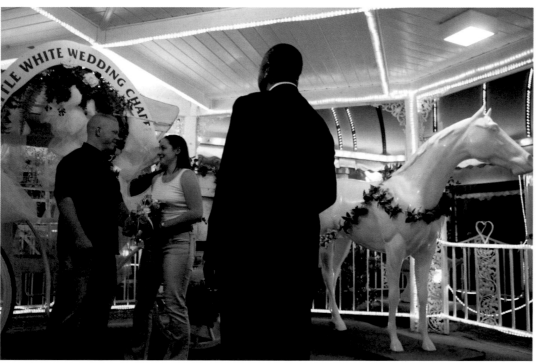

STATELINE

Newlyweds Matt and Shannon Simpson of Novato, California, held their ceremony at the Edgewood Tahoe Golf Course on the shores of Lake Tahoe. The couple waited an extra eight months because the venue was booked solid. "It was so worth it," says Matt. "It's an incredibly beautiful place."

Photo by Eric Jarvis

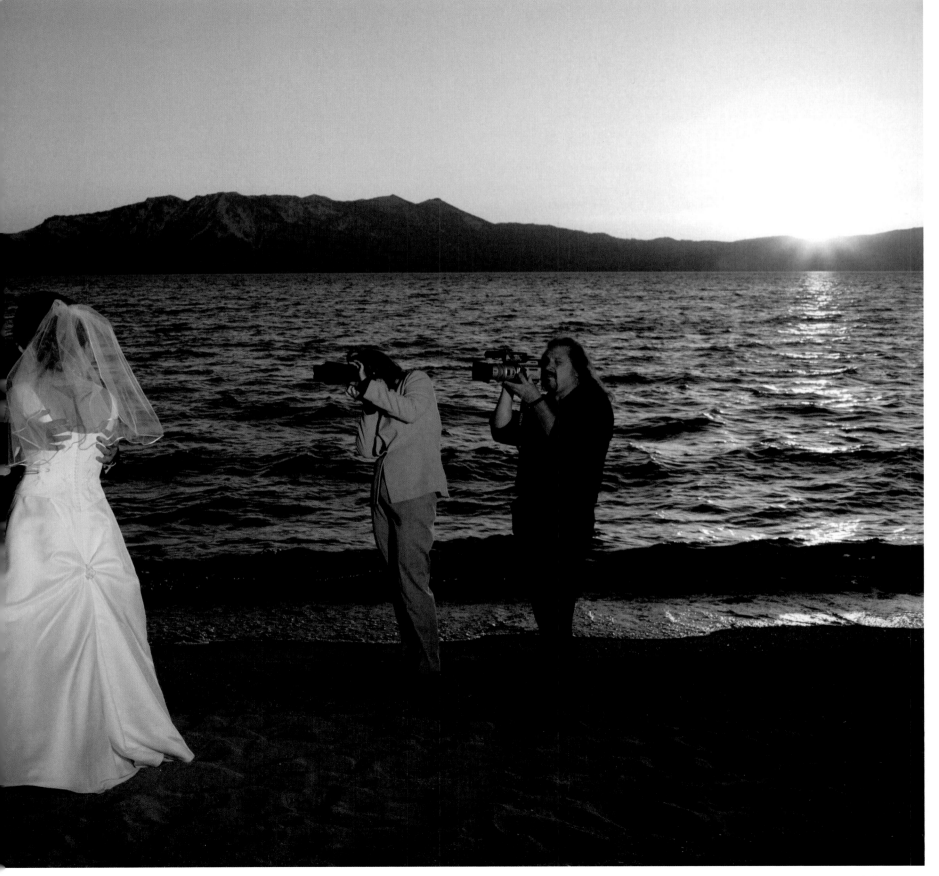

LUNING

The mining town of Luning once supported 1,500 residents. Now it's down to 30, including Dick Hegg, proprietor of the Long Branch Saloon. Hegg, a New Yorker, served as a World War II medic who did time at Guadalcanal, became a lab technician, took over a Nevada dispensary, then bought the saloon. "If I was to gross $6 a day," he says, "I'd be happy."
Photo by Larry Angier

The year 2003 marked a turning point in the history of photography: It was the first year that digital cameras outsold film cameras. To celebrate this unprecedented sea change, the *America 24/7* project invited amateur photographers—along with students and professionals—to shoot and, via the Internet, submit digital images. Think of it as audience participation. Their visions of community are interspersed with the professional frames throughout this book. On the following four pages, however, we present a gallery produced exclusively by amateur photographers.

RENO At the Virginia Lake Park playground, Muriel Branson, who's spending the afternoon with a friend's grandson, gets reacquainted with her inner jungle-gymnast. *Photo by Lynn Mahannah*

LAS VEGAS Indulging in hydrotherapy, Las Vegas weekenders cool their heels after hours of gambling. *Photo by Adriene Hughes*

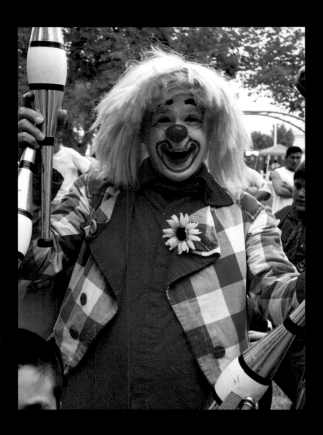

LAS VEGAS Ray Wold dropped out of school to run away to the circus—Clown College, that is. He keeps 10 clowns in red noses performing at parties with his business Amazing Clowns and performs in "O" for Cirque du Soleil at the Bellagio Hotel. *Photo by Lynn Hrnciar*

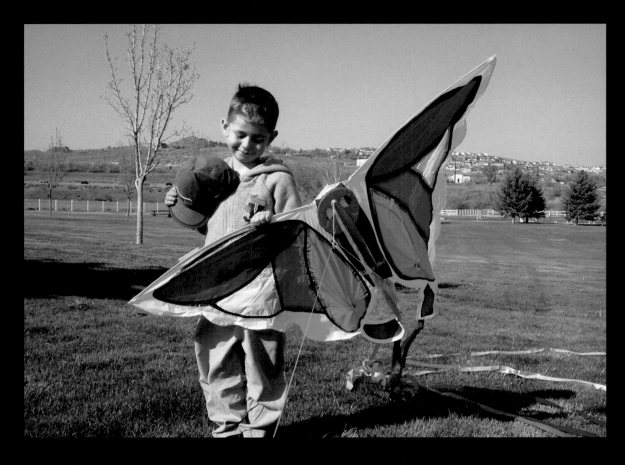

RENO Collin Bridgeman readies his very first kite at Rancho San Rafael Park, a perfect spot—it's home to the annual Great Reno Balloon Race for hot air balloons. *Photo by Joy Bridgeman*

CRYSTAL BAY Photographer and former Wall Street exec Ian Weiss moved from New York City to Incline Village after 9/11. Views like this one from Lake Tahoe's South Shore validate his decision. *Photo by Ian Weiss*

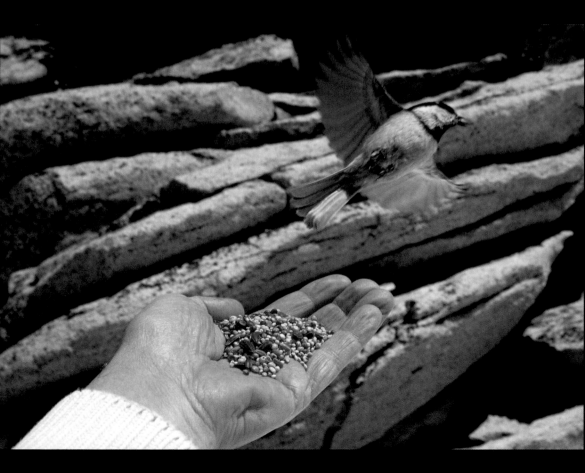

TAHOE MEADOWS There is a place near Lake Tahoe where wild mountain chickadees fly down from the trees to eat birdseed out of your hand. *Photo by William Kositzky*

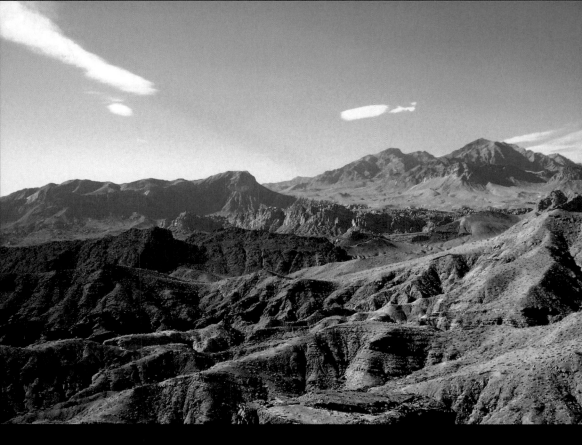

CLARK COUNTY Located just 100 miles from the Strip, this stretch of the Mojave has largely escaped Las Vegas's creep across the desert. Bighorn sheep and tortoises roam freely among these arid peaks and valleys, for now. *Photo by Diane Boisselle*

LAS VEGAS If a cowboy—in this case, the photographer—sees his own shadow on the Ides of May, does it mean six more weeks of drought? *Photo by Gregg Stokes*

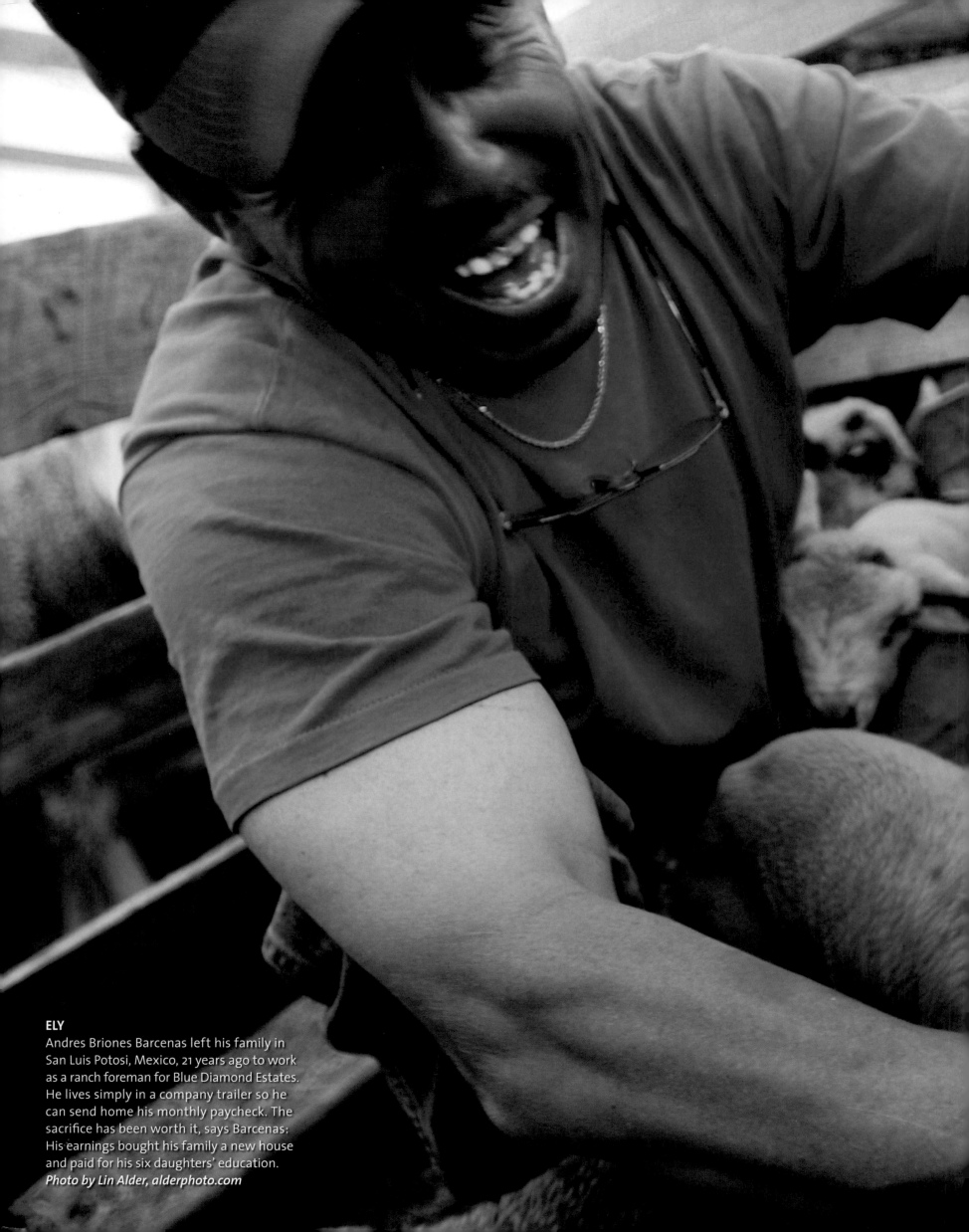

ELY

Andres Briones Barcenas left his family in San Luis Potosi, Mexico, 21 years ago to work as a ranch foreman for Blue Diamond Estates. He lives simply in a company trailer so he can send home his monthly paycheck. The sacrifice has been worth it, says Barcenas: His earnings bought his family a new house and paid for his six daughters' education.

Photo by Lin Alder, alderphoto.com

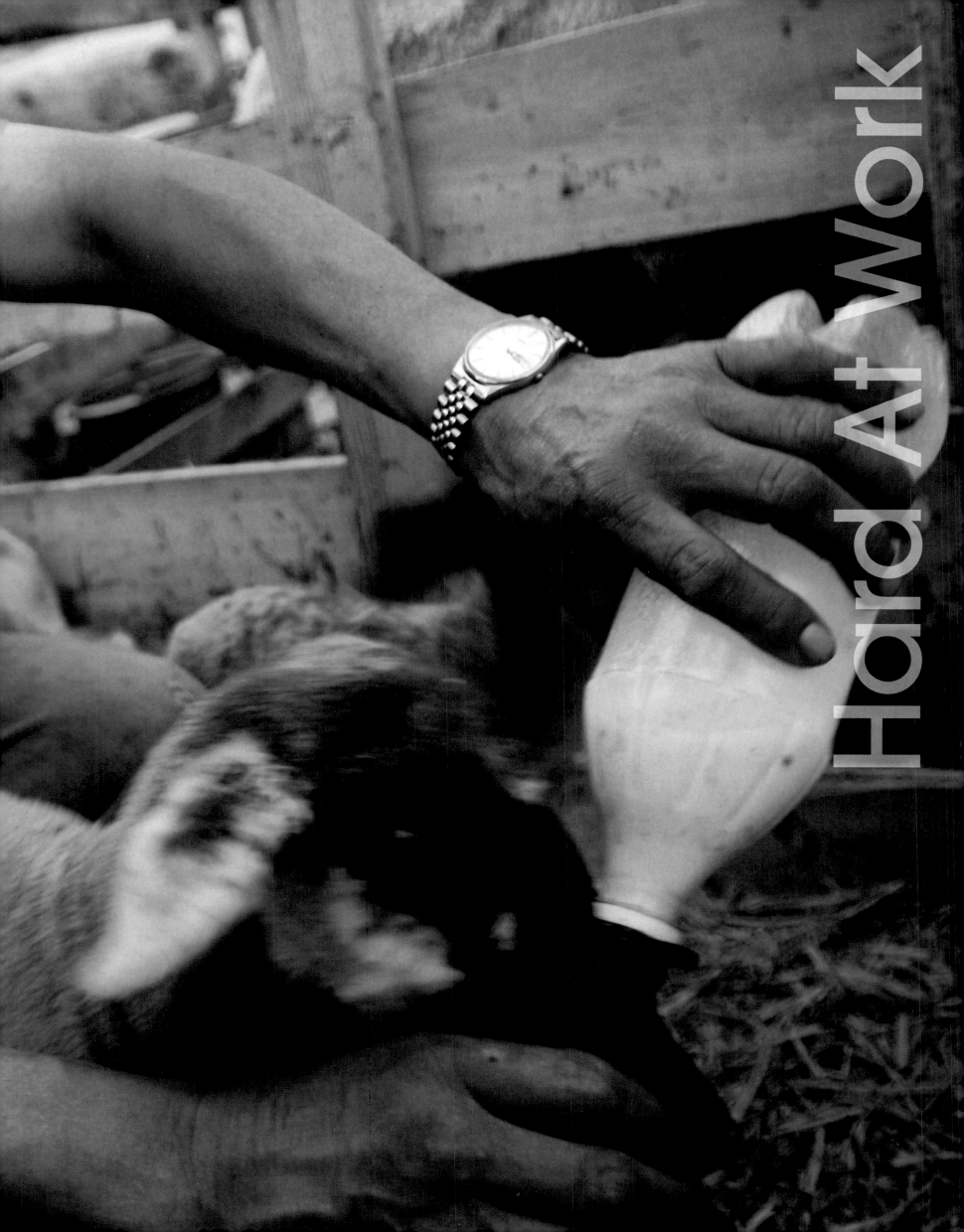

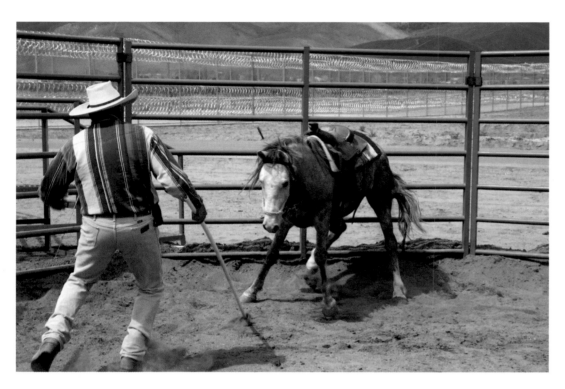

CARSON CITY
Hank Curry teaches inmates to break horses in a Warm Springs Correctional Center work program. "The men have to learn patience," says Curry. "It's a gentling process." The horses are removed from federal land to prevent overgrazing, then sold to private owners once they're broken.
Photo by Jean Dixon

FALLON

Sharon Harper has sorted cattle for 14 years. On sale days, when Gallagher Livestock sells 600–700 animals, Harper is one of four riders who herd them into the correct buyer's pen. "Some days, they just won't push, they'll come back and hunt you," she says of the times she's had to bail off her horse, over the fence.

Photo by Scott T. Smith

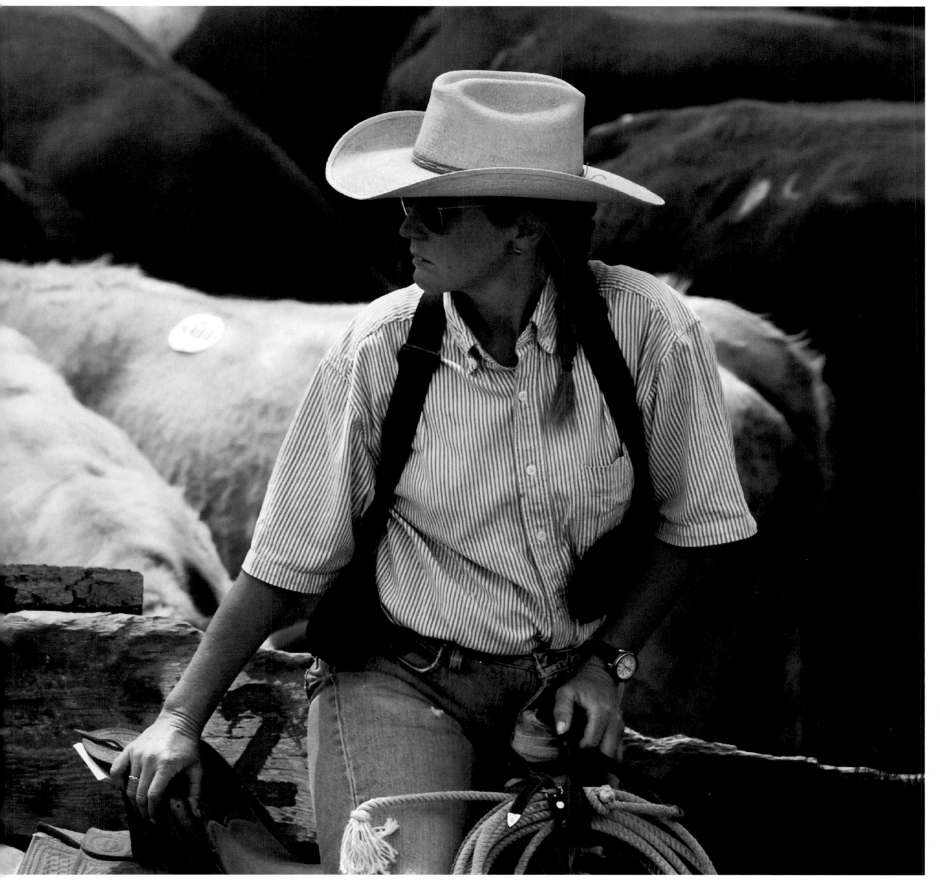

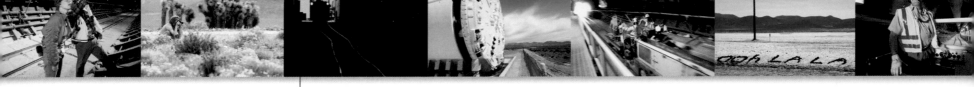

YUCCA MOUNTAIN

A shuttle carrying workers descends into the heart of Yucca Mountain, site of a federal high-level nuclear waste repository approved for development by Congress in 2002. Neighboring Shoshone and Paiute tribes as well as Nye County's small rural communities staunchly oppose the project. They worry the radioactive cache will contaminate ground water and become a terrorist target.
Photos by Amy Beth Bennett

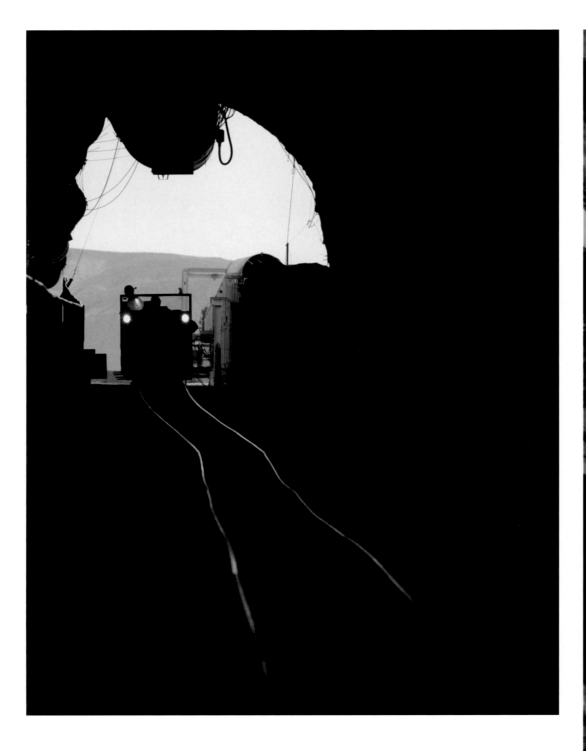

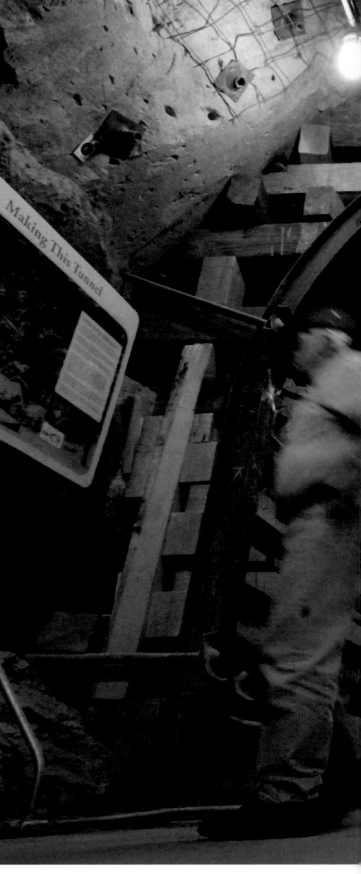

MERCURY

Alcove 2 inside Yucca Mountain's Exploratory Studies Facility includes an exhibit chronicling the construction of the nuclear waste repository. By 2010, radioactive byproducts from Navy nuclear-powered vessels, electricity generators, and research facilities will be consolidated in a metal storage container 1,000 feet below the mountain's surface.

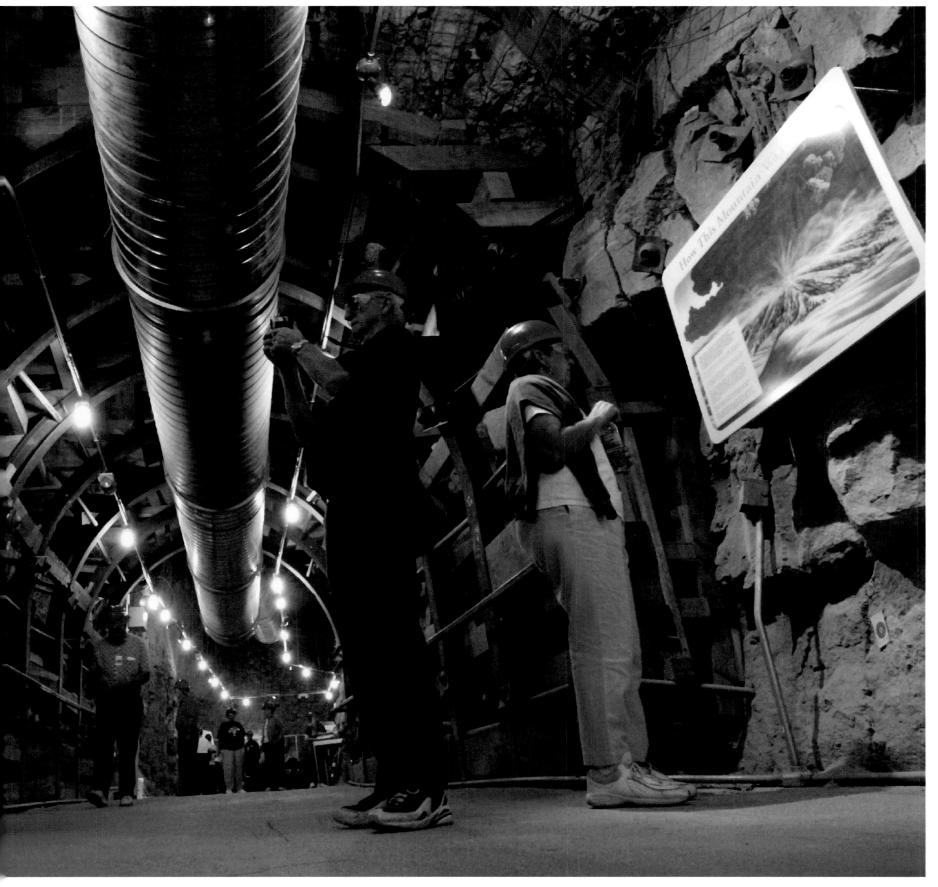

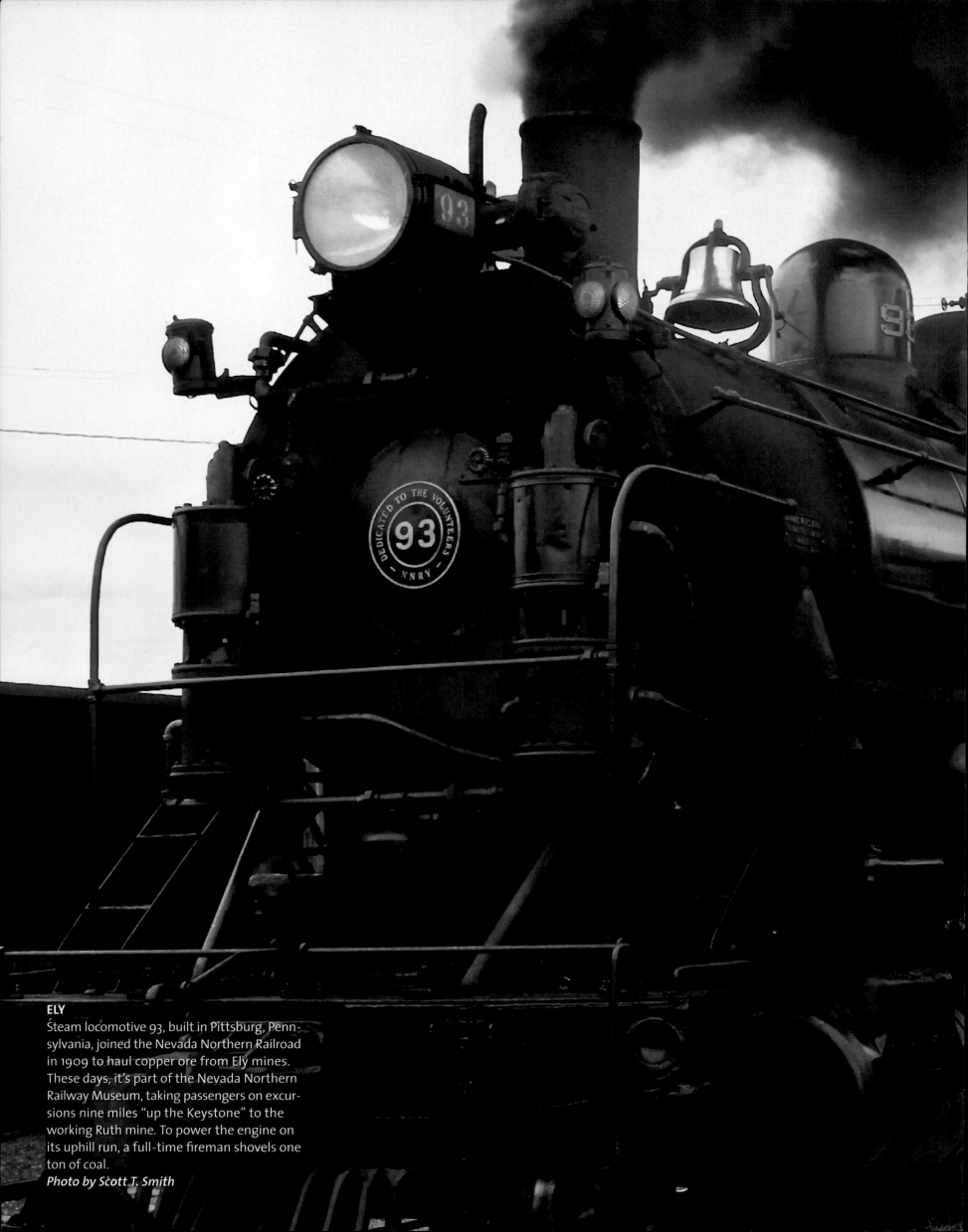

ELY
Steam locomotive 93, built in Pittsburg, Pennsylvania, joined the Nevada Northern Railroad in 1909 to haul copper ore from Ely mines. These days, it's part of the Nevada Northern Railway Museum, taking passengers on excursions nine miles "up the Keystone" to the working Ruth mine. To power the engine on its uphill run, a full-time fireman shovels one ton of coal.
Photo by Scott T. Smith

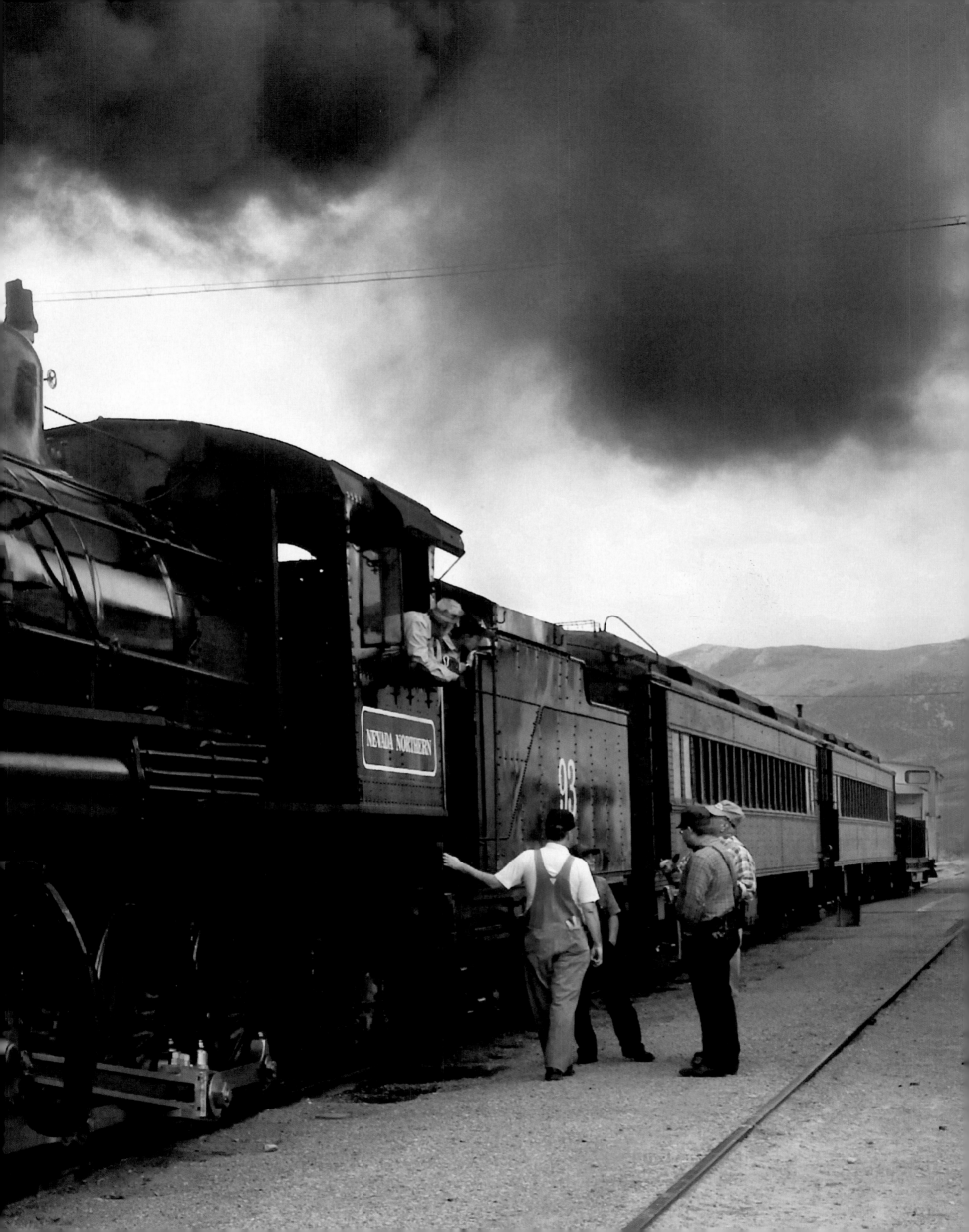

CARSON CITY

Using a rotating welding machine, Jim Ratledge fabricates the enclosure for a cogenerator at Hess Microgen. Cogenerators produce more than one form of energy from a single fuel source—for example, electrical and thermal power from natural gas—allowing for energy efficiency in industrial settings such as hospitals.

Photo by Day Williams

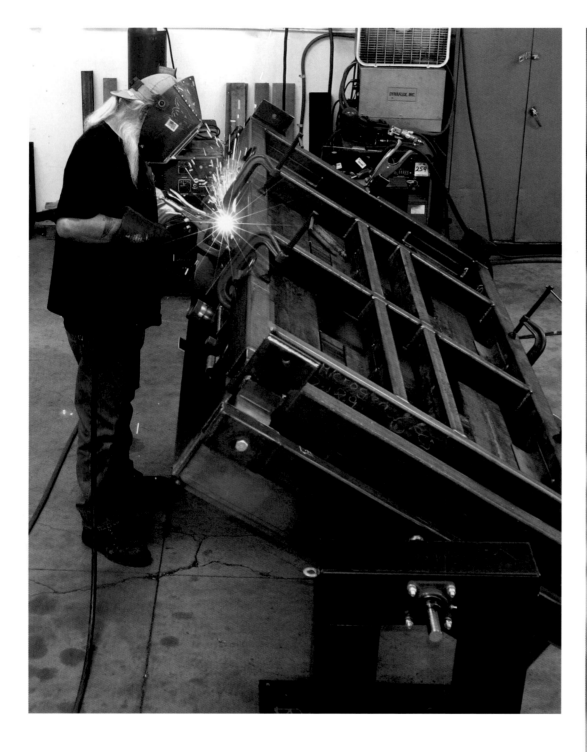

LAKE TAHOE

Kenneth Blake transforms for his role as Dolly Parton in Carnival Cabaret—a comedy and dance salute to celebrity women, played by men—at the Horizon Casino Resort. Fourteen years ago, Blake, an interior designer and makeup artist, saw *La Cage Aux Folles* and knew what he wanted to do. He specializes in impersonations of Dolly Parton and Madonna.
Photo by Marilyn Newton, Reno Gazette-Journal

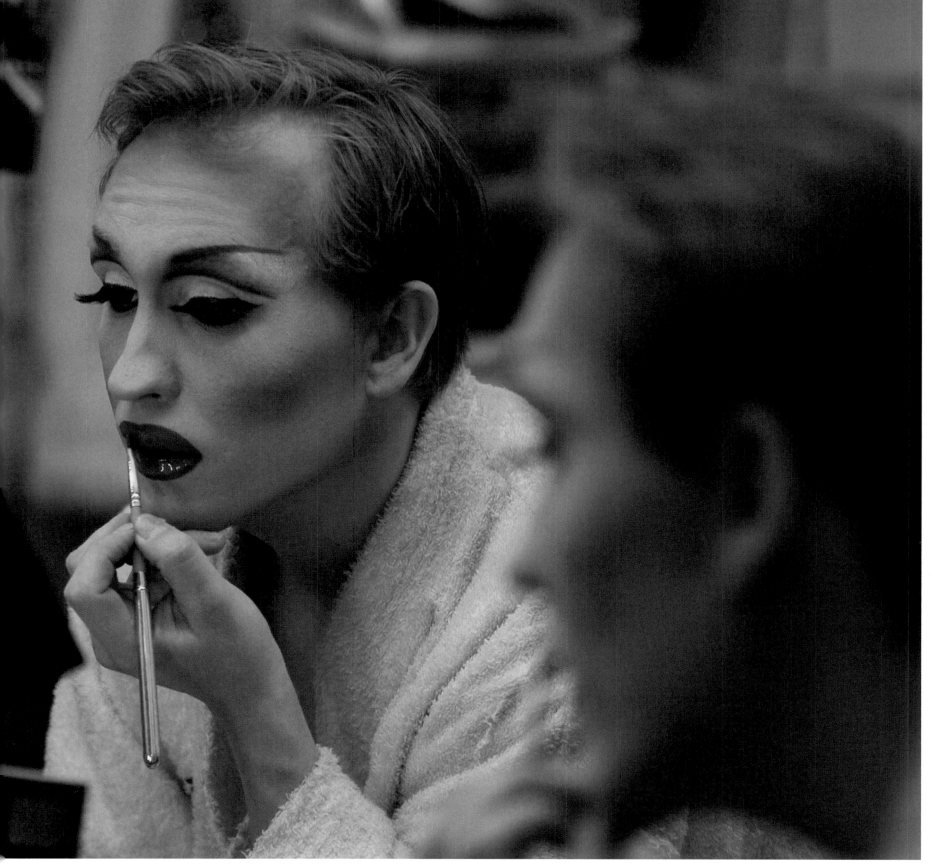

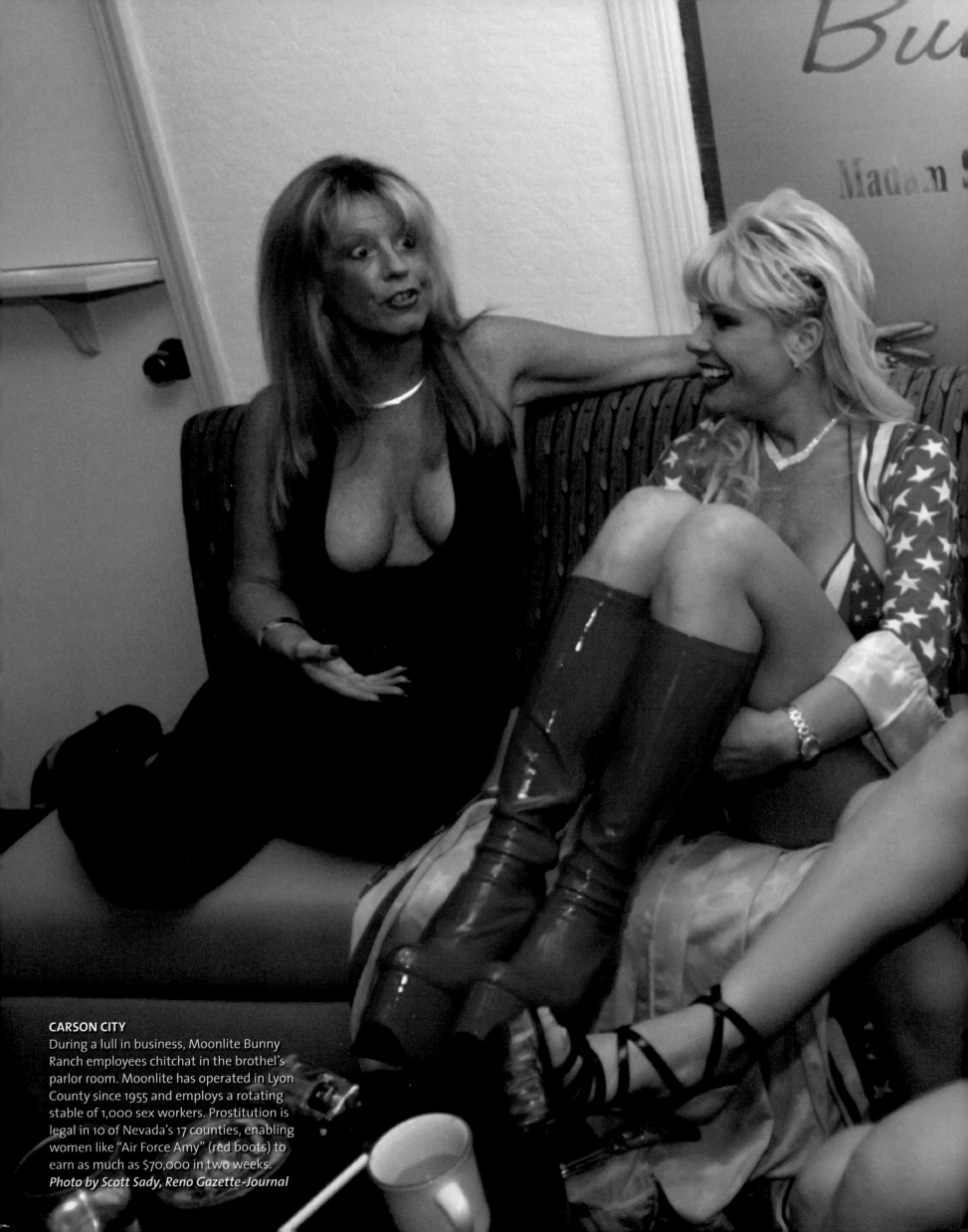

CARSON CITY
During a lull in business, Moonlite Bunny Ranch employees chitchat in the brothel's parlor room. Moonlite has operated in Lyon County since 1955 and employs a rotating stable of 1,000 sex workers. Prostitution is legal in 10 of Nevada's 17 counties, enabling women like "Air Force Amy" (red boots) to earn as much as $70,000 in two weeks.
Photo by Scott Sady, Reno Gazette-Journal

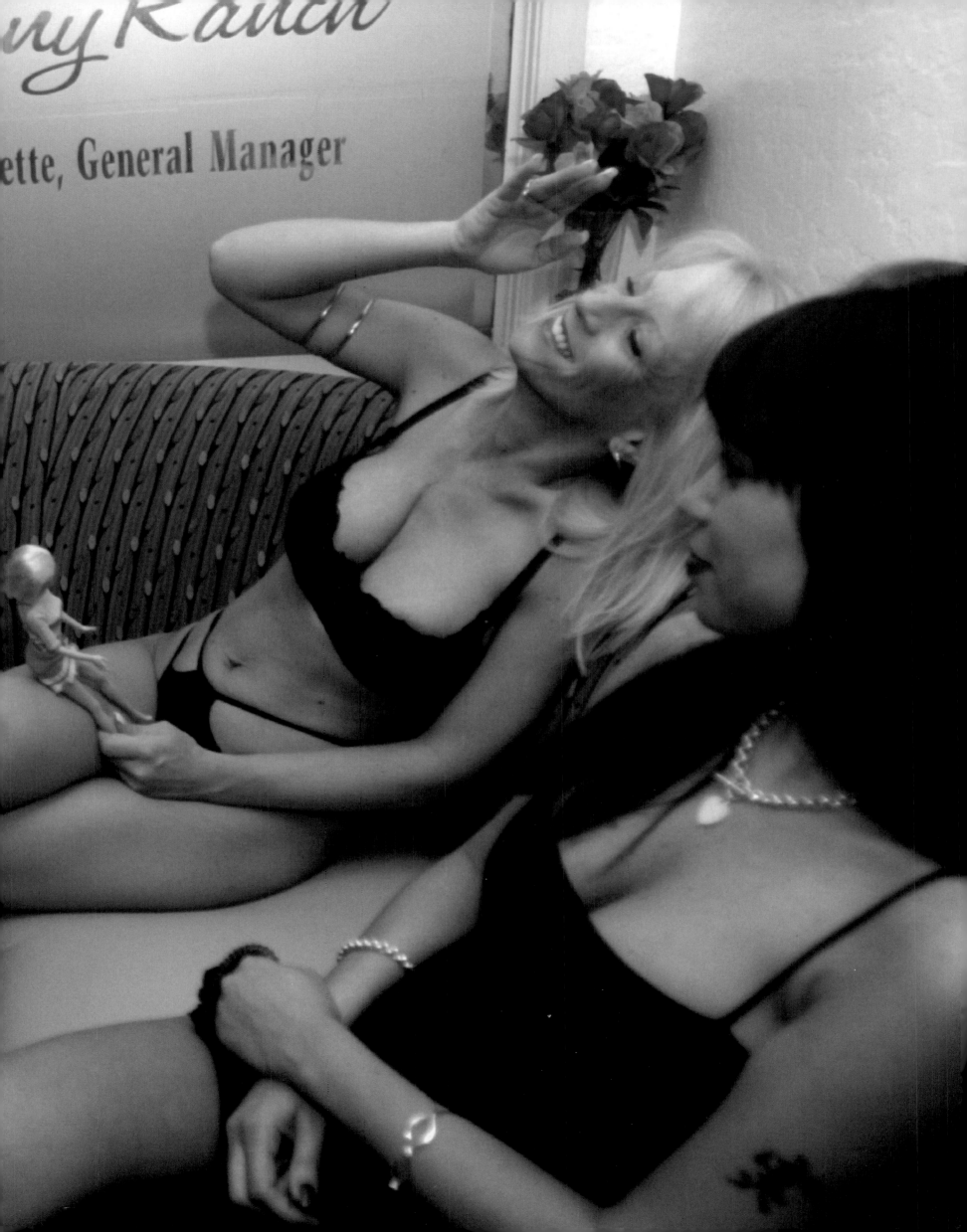

LAS VEGAS

"I'm probably considered one of the top Elvises in the world," says Tom Bartlett between shows at the Elvis-A-Rama Museum. The Alabama native and former Air Force careerist is now a full-time Elvis impersonator. He also keeps a part-time FedEx job for the benefits.

Photos by John Locher

LAS VEGAS

"He was a very loving man," says Tony La Torre, an Elvis impersonator for five years. "I want to show the heart." La Torre, performing at Elvis-A-Rama, says he was just bumped by Elvises with more seniority, but has found work singing at Elvis-themed weddings.

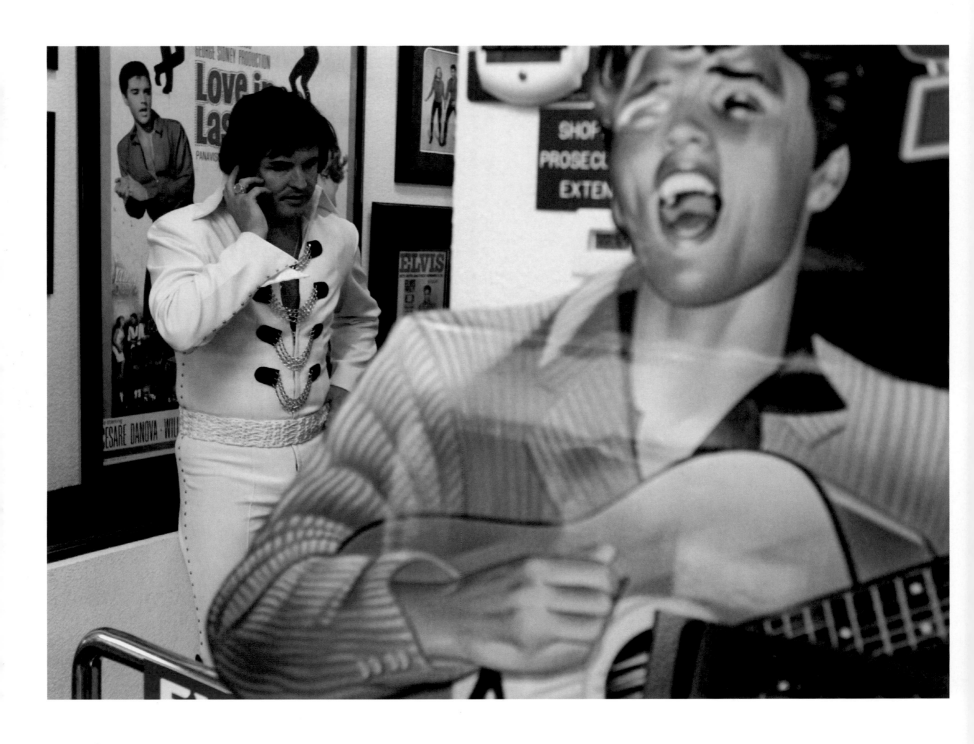

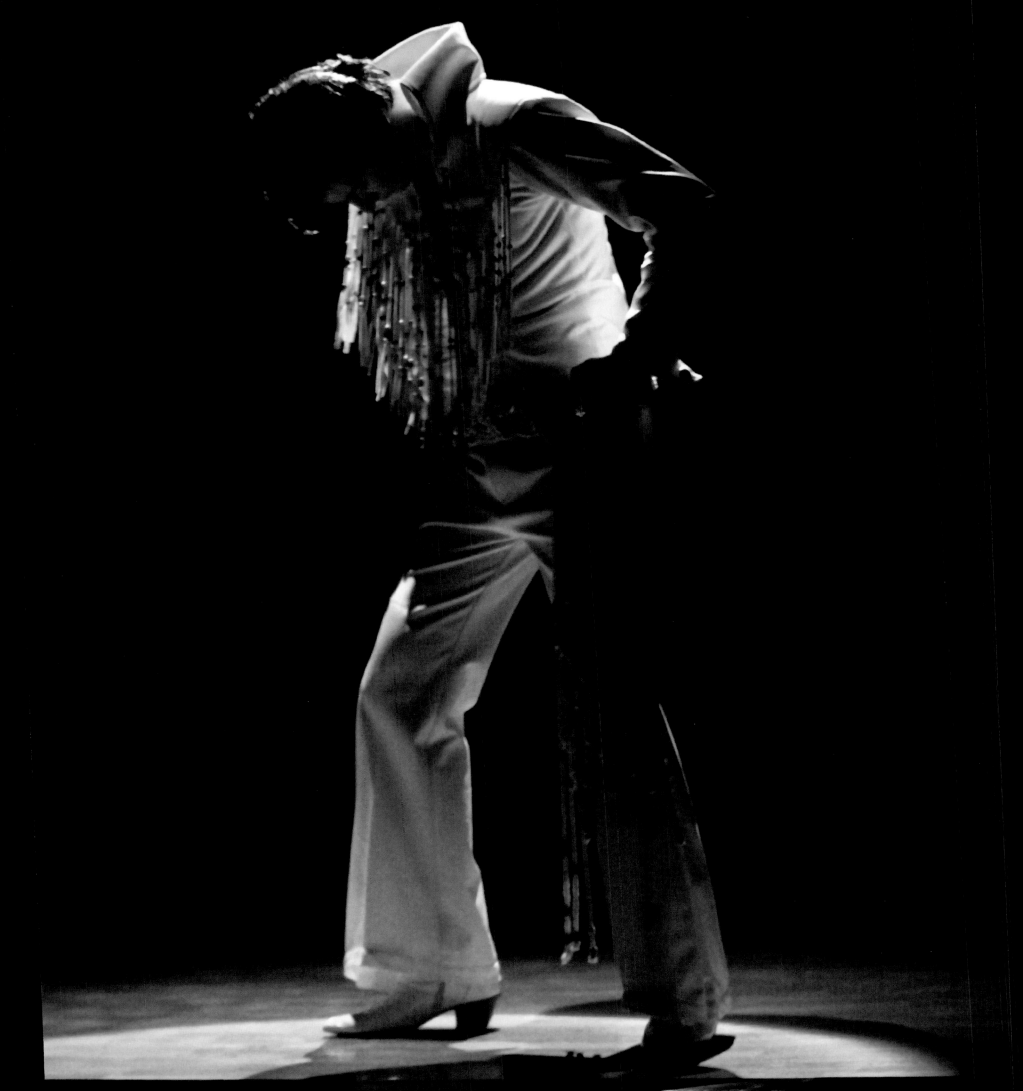

HAWTHORNE

For more than four decades, grill cook Faye William, 78, has made breakfast at Hawthorne's El Capitan Casino Restaurant. The restaurant office tallied that William has used more than four million eggs. Sounds right to her, she says, but scary. "When I die, those chickens are going to come after me for sure."

Photo by Larry Angier

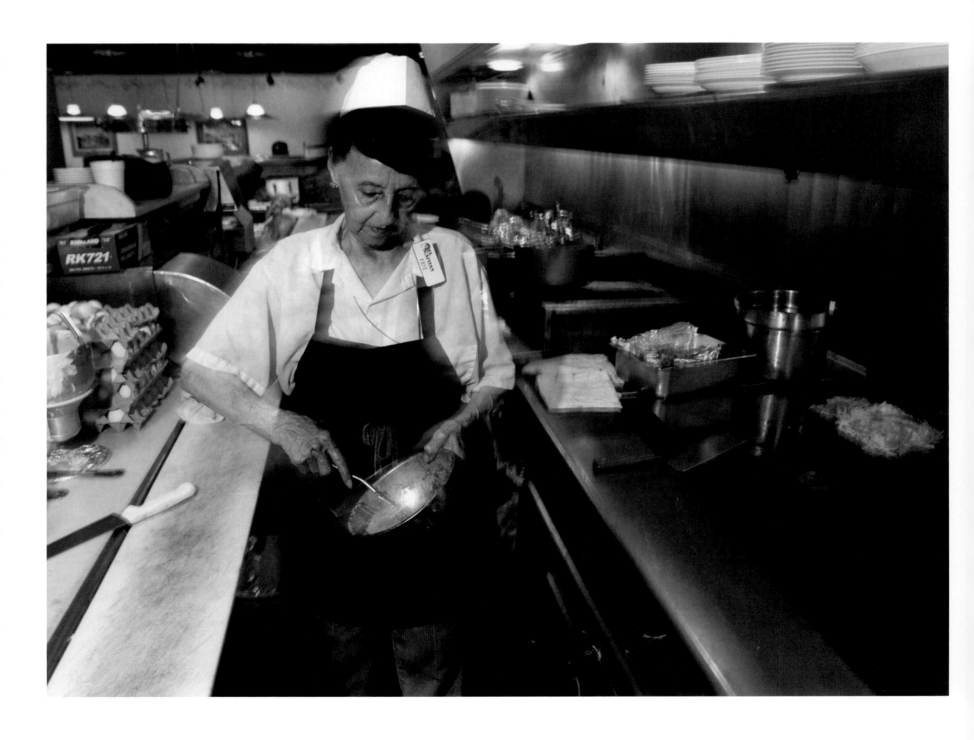

LAS VEGAS
Amy Shuey serves a midnight round at the Palms Casino Resort Hotel. Off shift, the Las Vegas native is studying to be a forensics investigator.
Photo by Naomi Harris

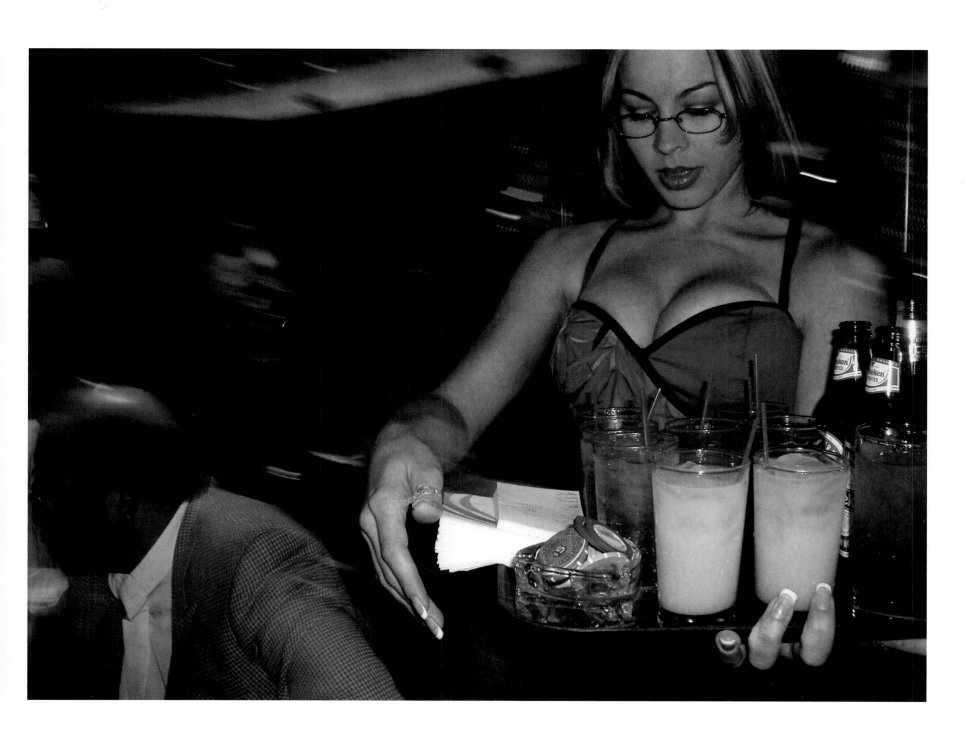

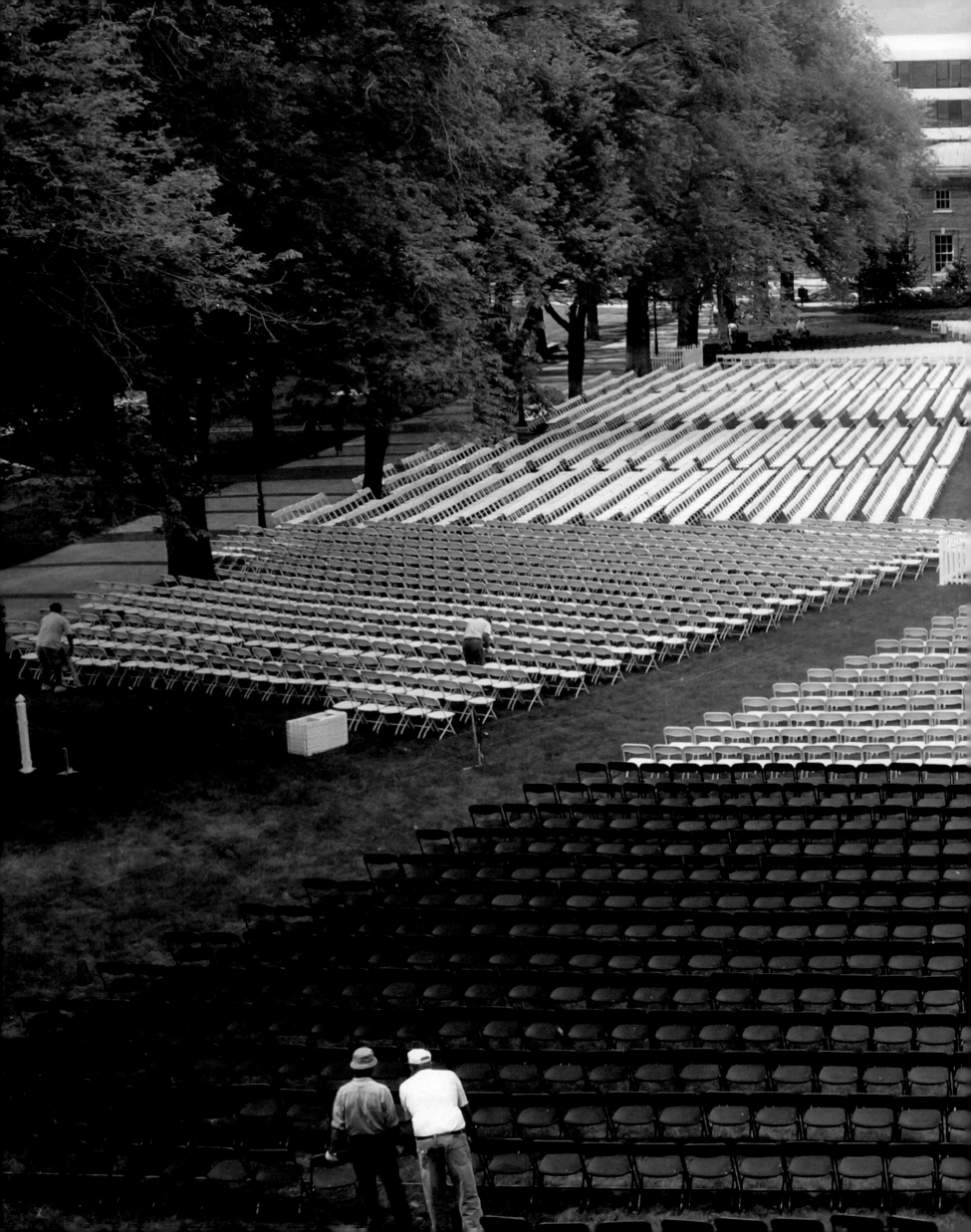

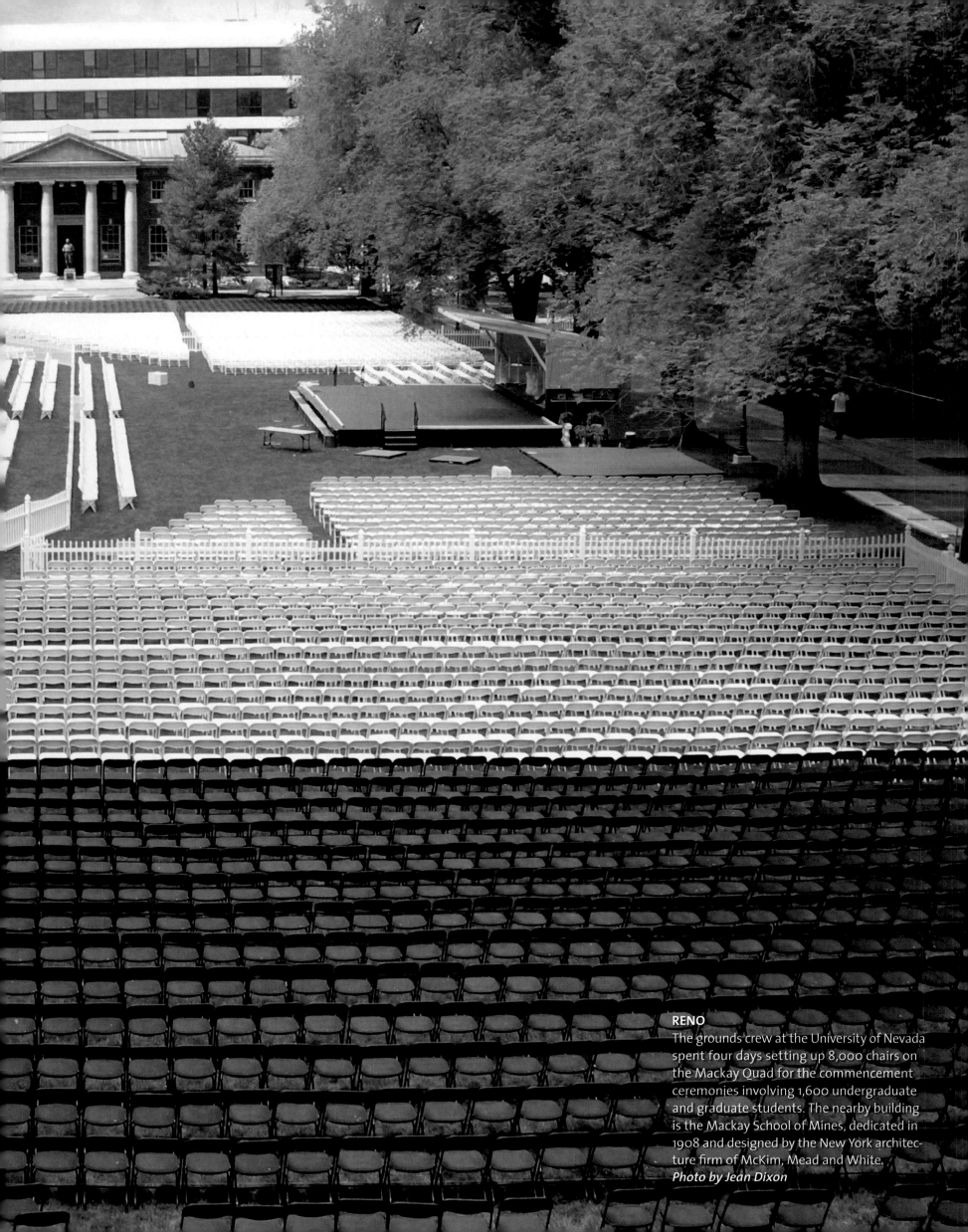

RENO
The grounds crew at the University of Nevada spent four days setting up 8,000 chairs on the Mackay Quad for the commencement ceremonies involving 1,600 undergraduate and graduate students. The nearby building is the Mackay School of Mines, dedicated in 1908 and designed by the New York architecture firm of McKim, Mead and White.
Photo by Jean Dixon

GENOA

Near South Lake Tahoe, the little town of Genoa is growing—thanks to a hot springs resort, golf courses, and gems like an 1863 enterprise now called the Old Genoa Bar: "Nevada's Oldest Thirst Parlor." As part of the bar's tradition, dayshift bartender Marielle Dean reads the *Nevada Appeal* to regulars, starting with horoscopes, ending with the police reports.

Photo by Jessica Brandi Lifland

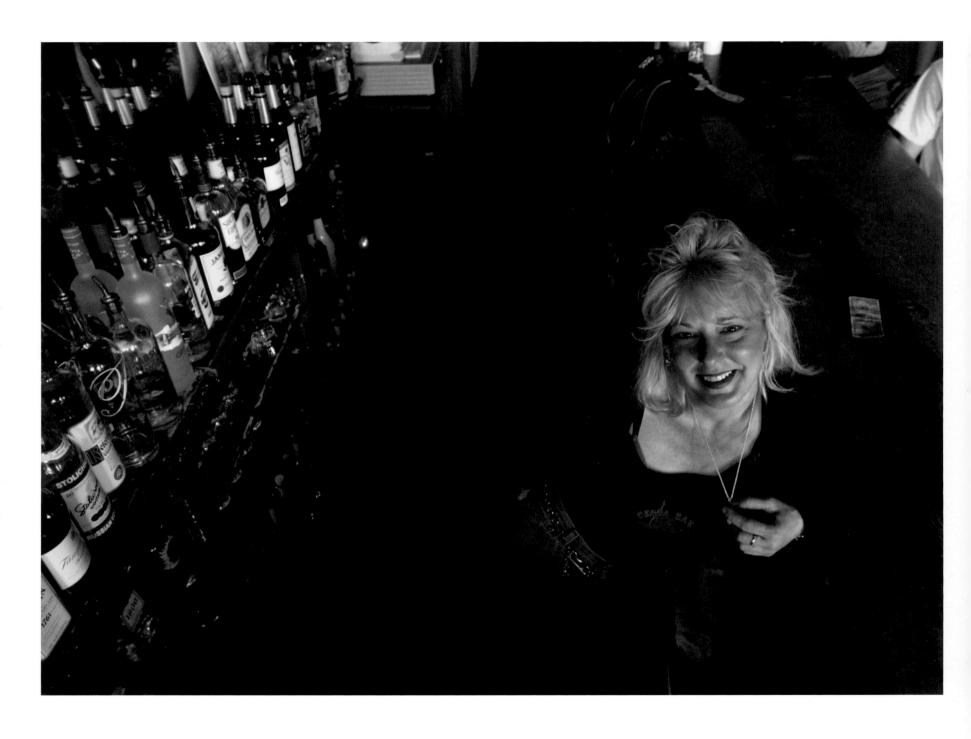

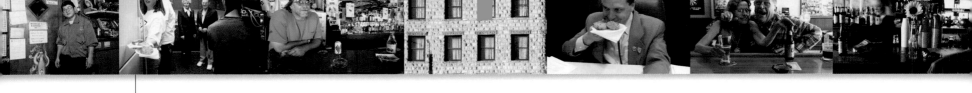

CARSON CITY

Luana Graham hands out cookies while her father, Clark County Deputy District Attorney Ben Graham (back, left) is interviewed for a local TV show. "I am a lobbyist for the district attorneys' association," says Ben. "Because it's public, I don't have the wine-and-dine money, so we bake cookies." Graham and his four children typically serve 1,400 cookies to legislators during a session.

Photo by Jean Dixon

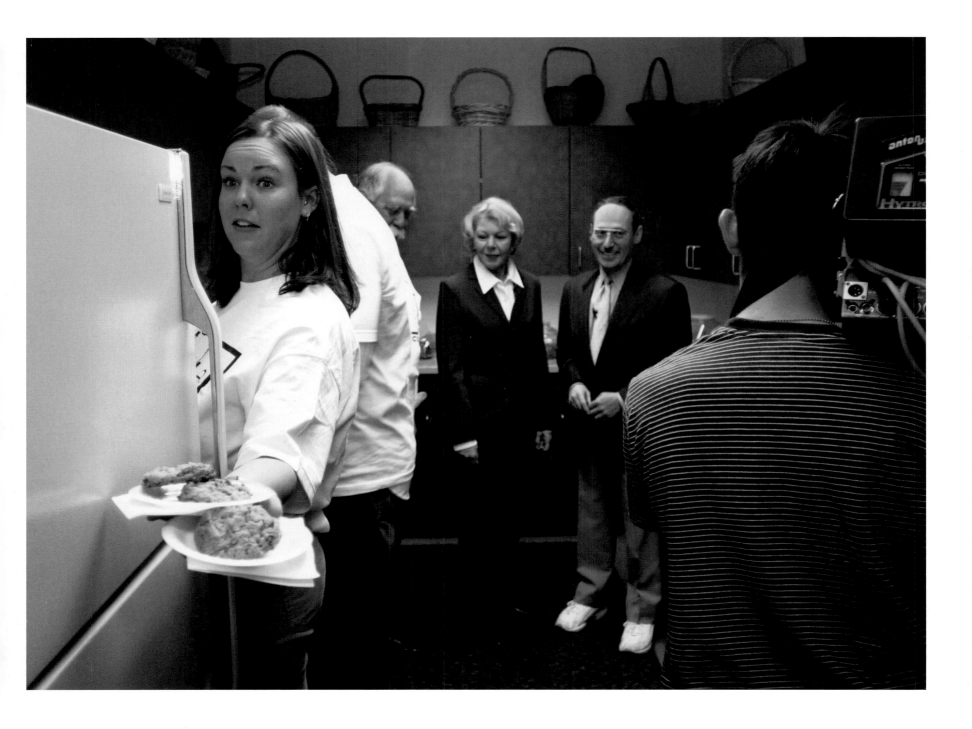

RENO
Silver Bells Wedding Chapel gets a lot of foot traffic—up to 30 couples a day. For the $75 fee, some request a "short and sweet" service. (Romantics stretch it out to 15 minutes.) Silver Bells has its rules: One minister refuses to marry couples who won't let him pray or mention God. And gay couples are turned away. "That's illegal in Nevada," explains an employee.
Photo by Jessica Brandi Lifland

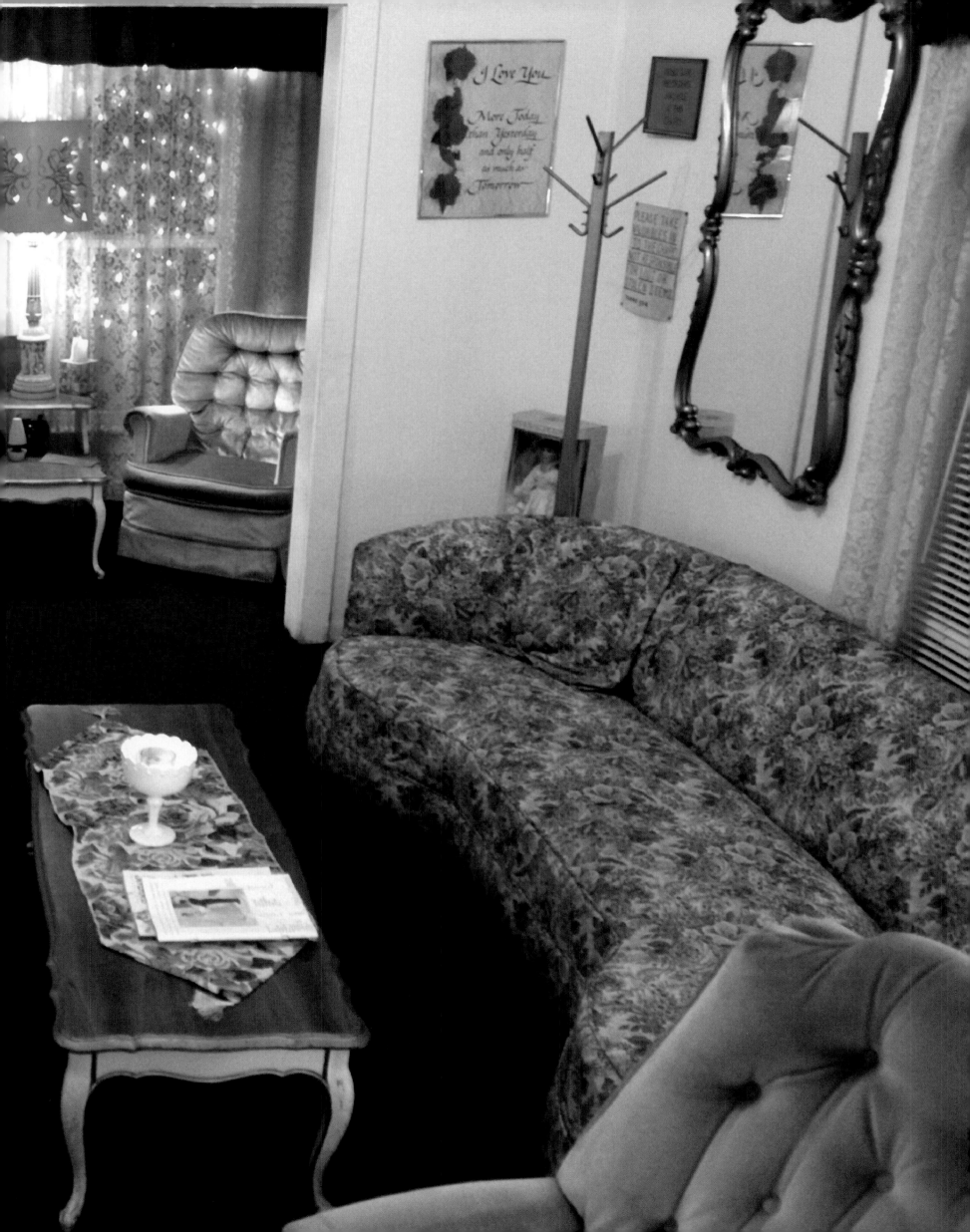

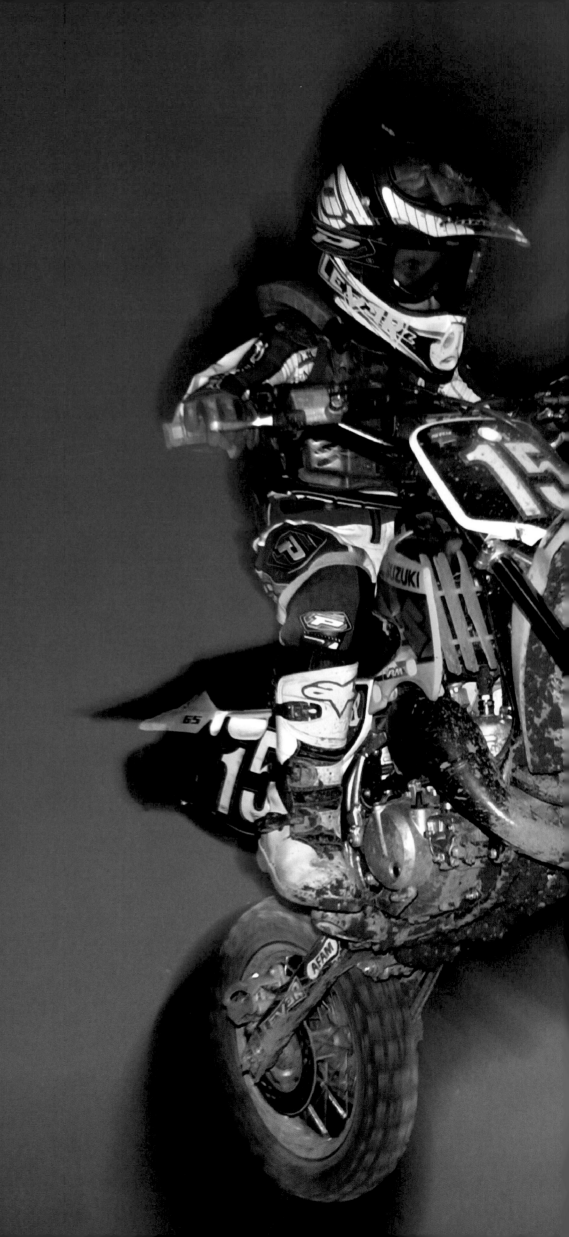

MESQUITE
To get this shot, photographer Dan Burns had to convince a crew of 14-year-old motocross racers to wake up at 4:30 a.m. so he could get the right light.
Photo by Dan Burns, nofearfotos.com

Nevada At Play

ELKO

Yee haw! Jacey Miller, a student at Treasure Valley Community College in Ontario, Oregon, hangs on for dear life in the bareback riding competition during the National Intercollegiate Rodeo Western Regional Finals. The ranch management major walked away with 67 points, earning him fourth-place.

Photos by Jim Laurie, Stephens Press

ELKO

Boots with a good heel once signified a person who owned and rode horses. Spurs date back to the first century when Romans developed them to control their horses, leaving their hands free to fight.

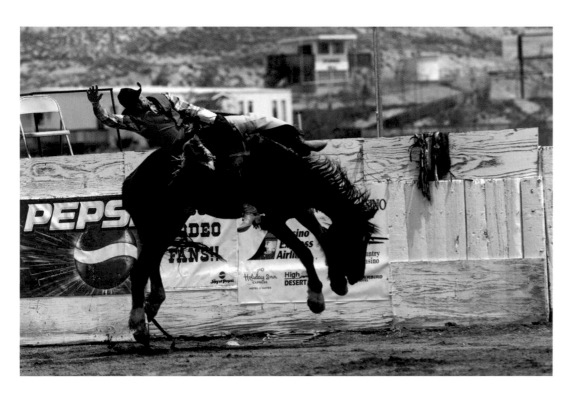

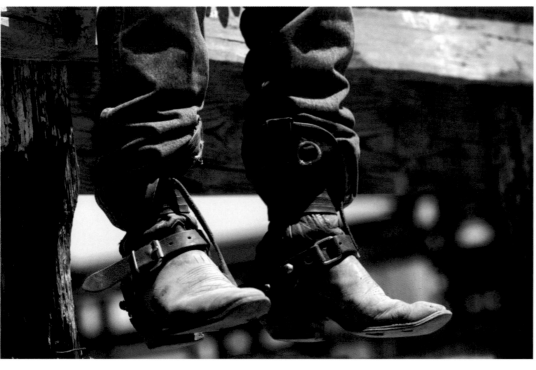

ELKO

At the National Intercollegiate Rodeo Western Finals, a cowboy hits his mark during the calf roping event. The art of calf roping was born from the need to capture and tie down sick calves for medical treatment. It's a test of skill, as well as of teamwork between the cowboy and his horse.

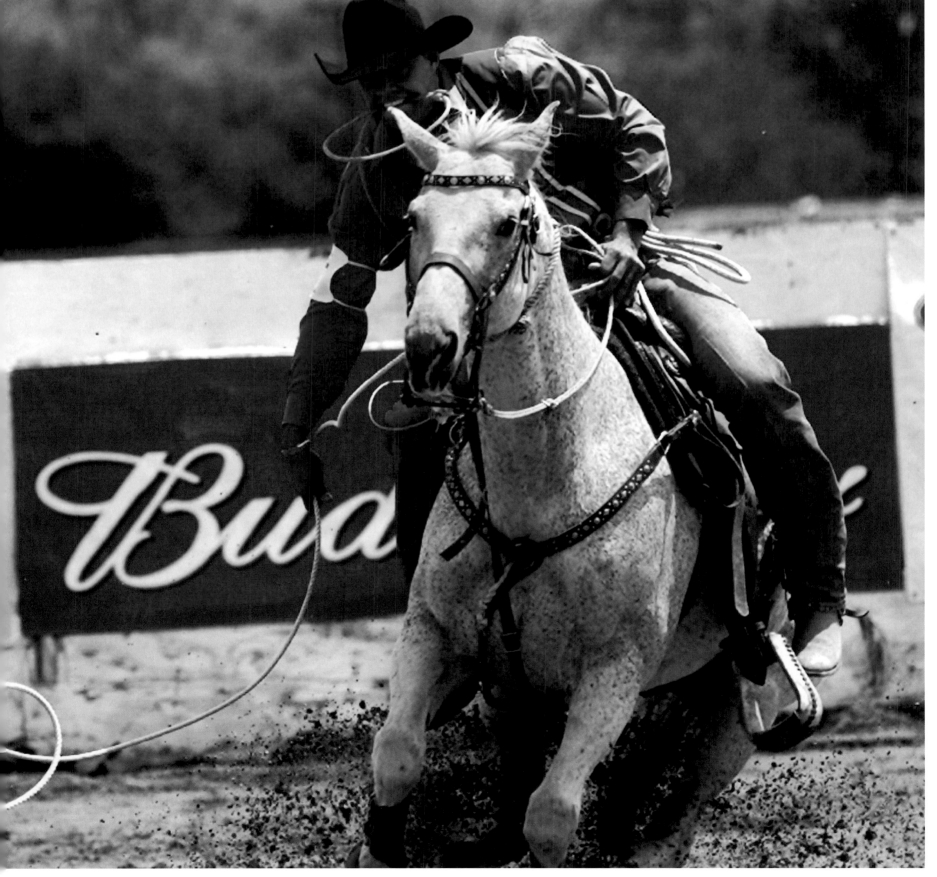

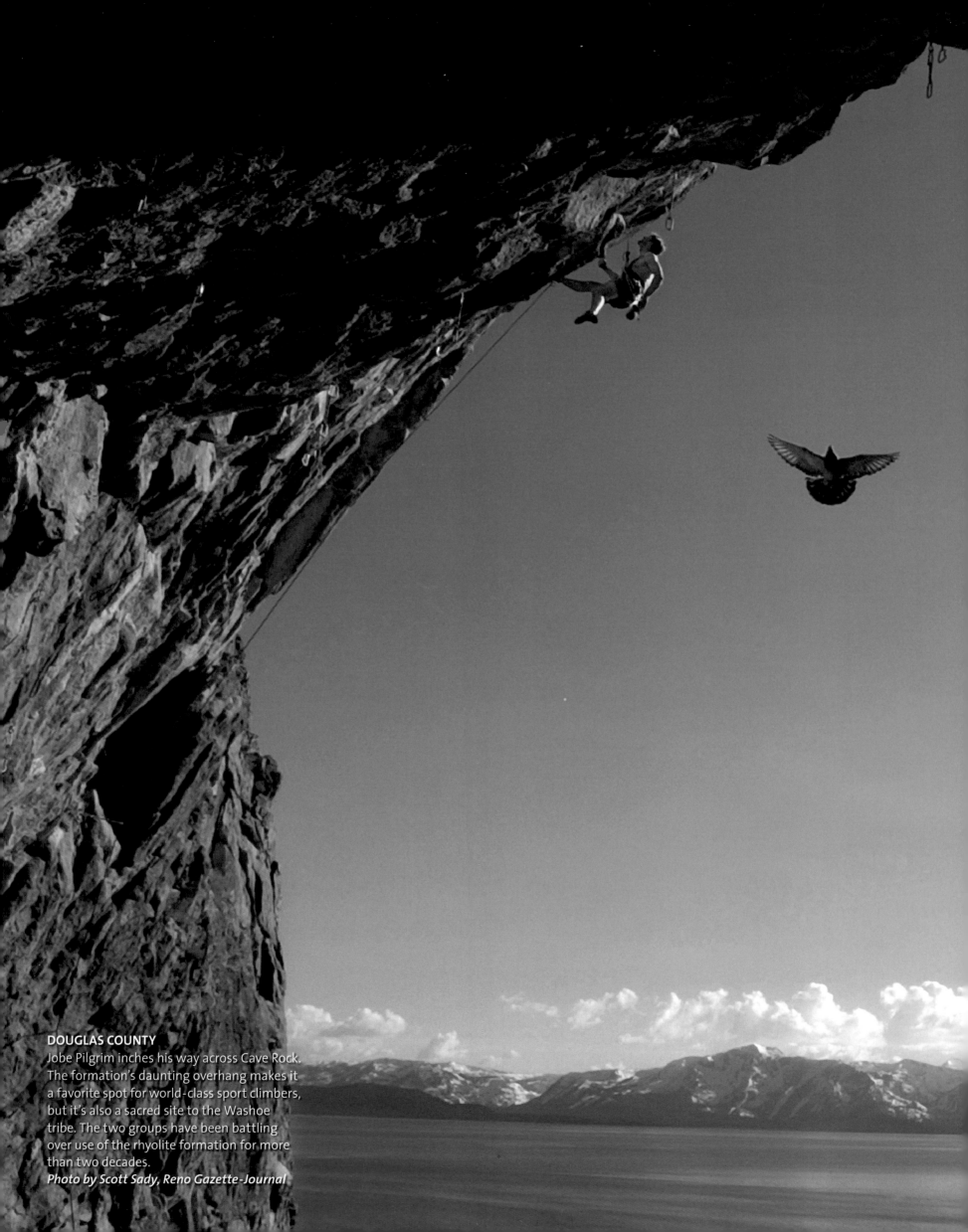

DOUGLAS COUNTY

Jobe Pilgrim inches his way across Cave Rock. The formation's daunting overhang makes it a favorite spot for world-class sport climbers, but it's also a sacred site to the Washoe tribe. The two groups have been battling over use of the rhyolite formation for more than two decades.

Photo by Scott Sady, Reno Gazette-Journal

BOULDER CITY

A wave wrangler gets bucked during a run across Lake Mead. Personal watercraft like this one provide excitement for those looking to escape the desert heat.

Photo by Dan Burns, nofearfotos.com

DOUGLAS COUNTY

Brent Kuemmerle muscles across a challenging stretch of Cave Rock. After losing his right leg in a 1995 car accident, the avid rock climber didn't miss a beat. A year after leaving the hospital, Kuemmerle was scaling cliff walls and teaching snowboarding.

Photo by Scott Sady, Reno Gazette-Journal

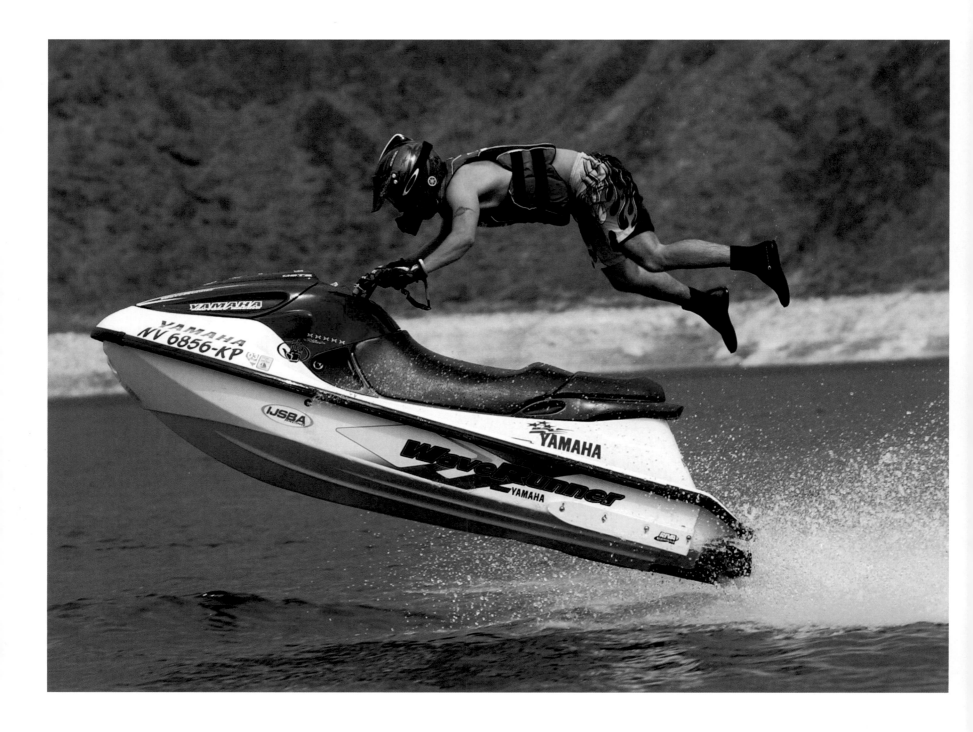

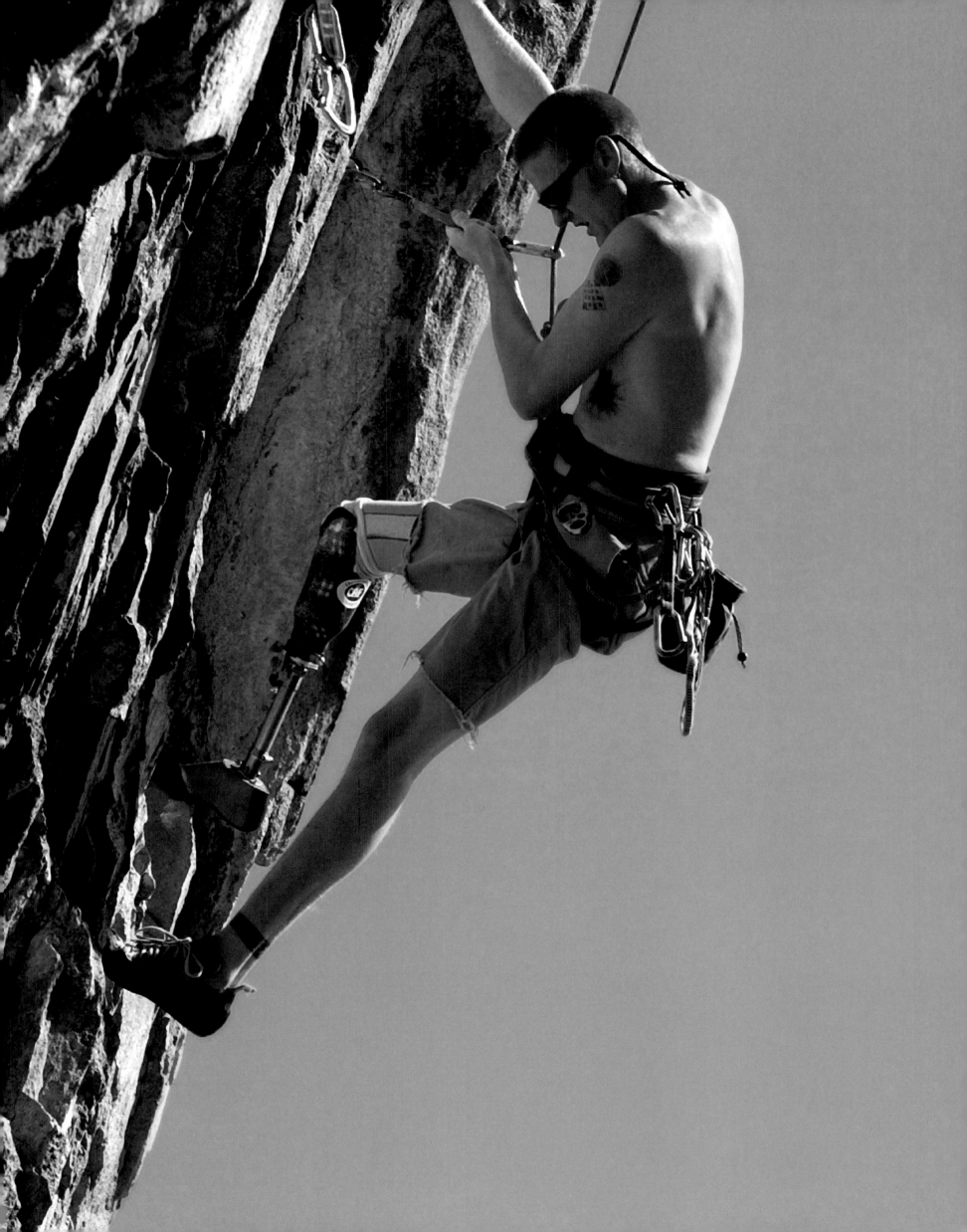

LAS VEGAS
Nine Inch Nails: Chicago cousins Virginia Storto
and Cheryl Fato soak up the desert sun poolside
at the opulent Bellagio Hotel. The 3,005-room
hotel lays out six outdoor swimming pools.
Photos by Naomi Harris

LAS VEGAS

The lure of Las Vegas slots is legendary. Some people can walk away as winners or losers. For those who cannot, there's Gamblers Anonymous. The organization offers 65 meetings a week in Las Vegas alone.

LAS VEGAS

"I have my control," says Lemy Rodello. The Philippines native says she moved from Las Vegas to Colorado in part to get away from gambling. "It became a habit." Back in town to visit a cousin, she passes time at the slots in the Palms Casino Resort Hotel. She lost $300.

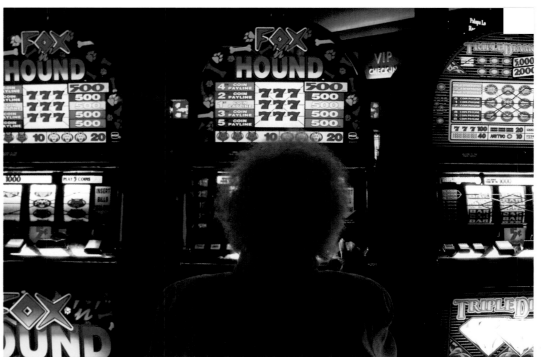

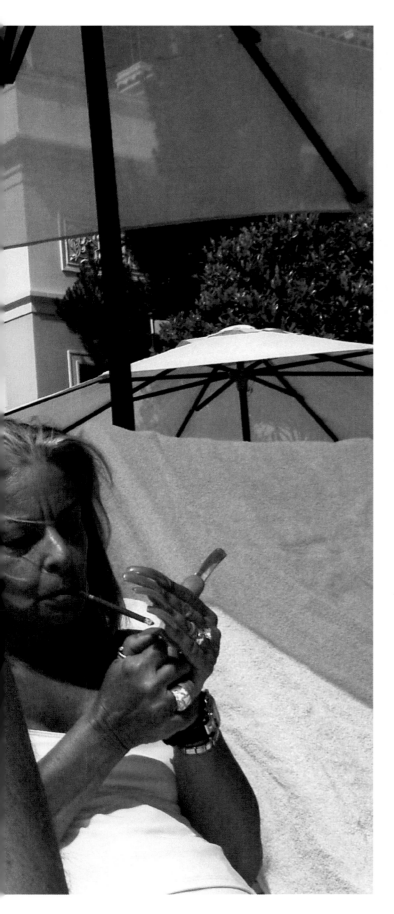

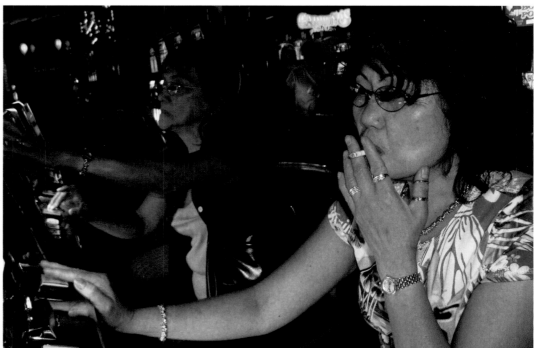

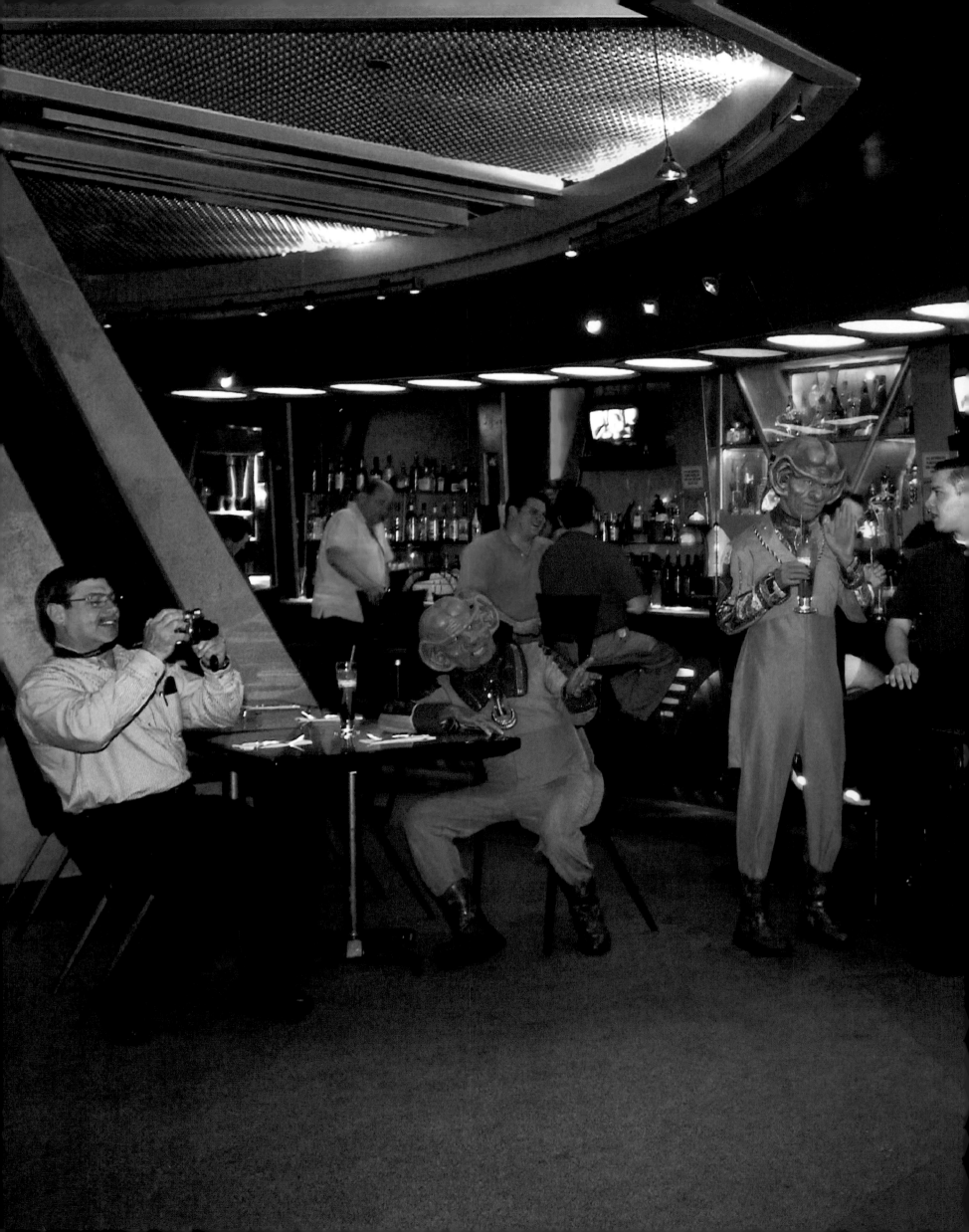

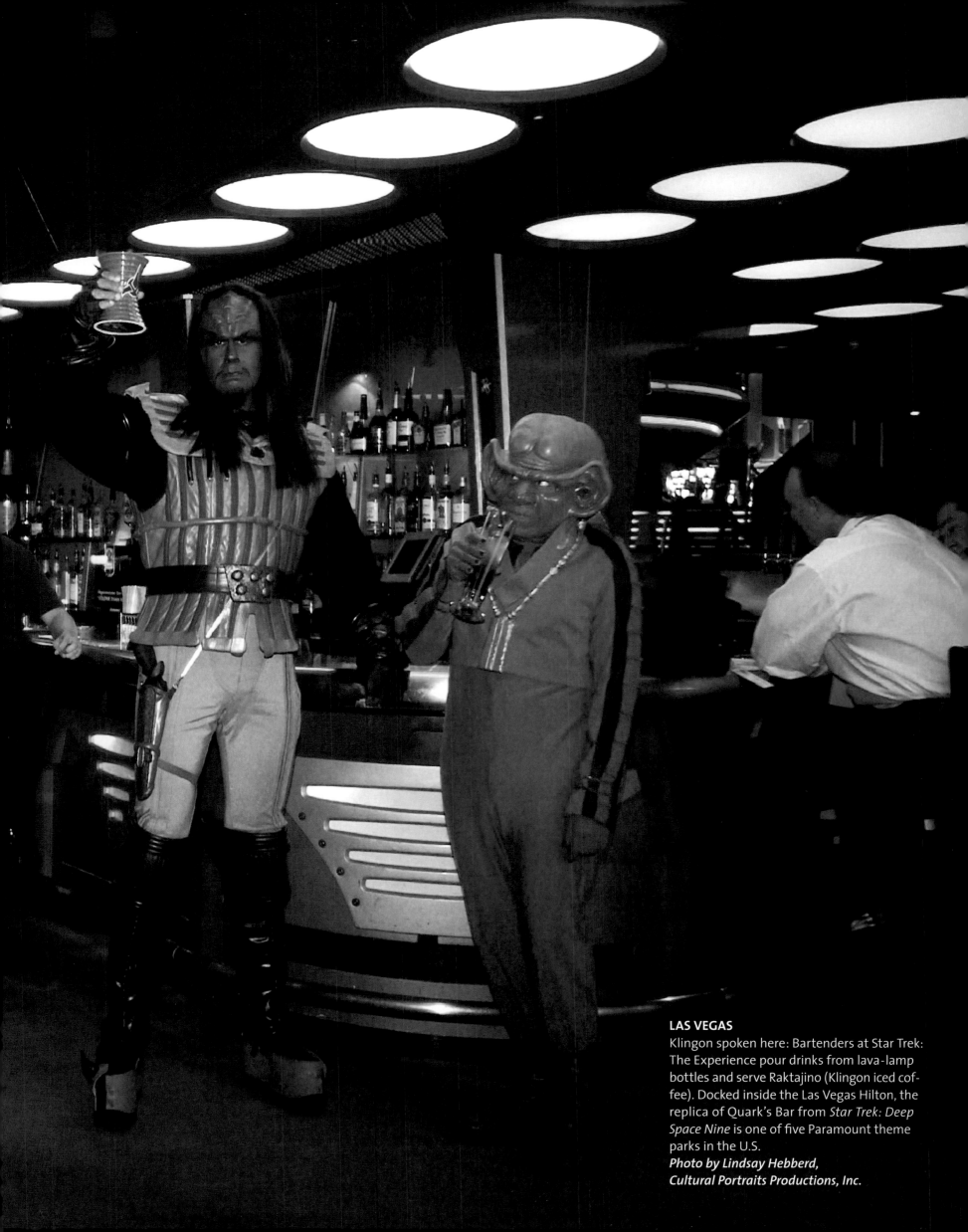

LAS VEGAS
Klingon spoken here: Bartenders at Star Trek: The Experience pour drinks from lava-lamp bottles and serve Raktajino (Klingon iced coffee). Docked inside the Las Vegas Hilton, the replica of Quark's Bar from *Star Trek: Deep Space Nine* is one of five Paramount theme parks in the U.S.
Photo by Lindsay Hebberd,
Cultural Portraits Productions, Inc.

Photographer beware: Gracian "Bubba" Salaberry, 11, is all boy, and he likes to shoot. He hunts deer with his dad, but he uses his slingshot only on in-animate things—at least his mom hasn't received any complaints from the neighbors.
Photos by Day Williams

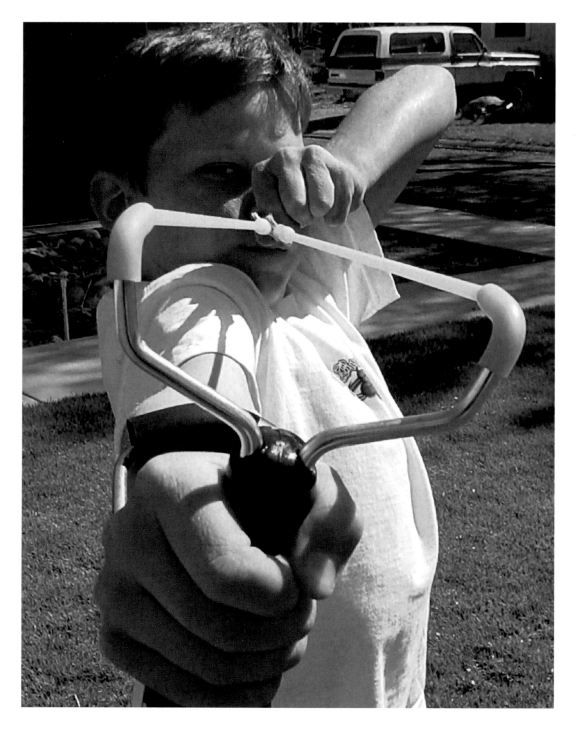

CARSON CITY

At the end of a history and culture unit on ancient Rome, third-graders in Sheila Bolton's Bethlehem Lutheran School class put on a Roman festival. Some imaginative students made their own chariots out of boxes, and the race was on.

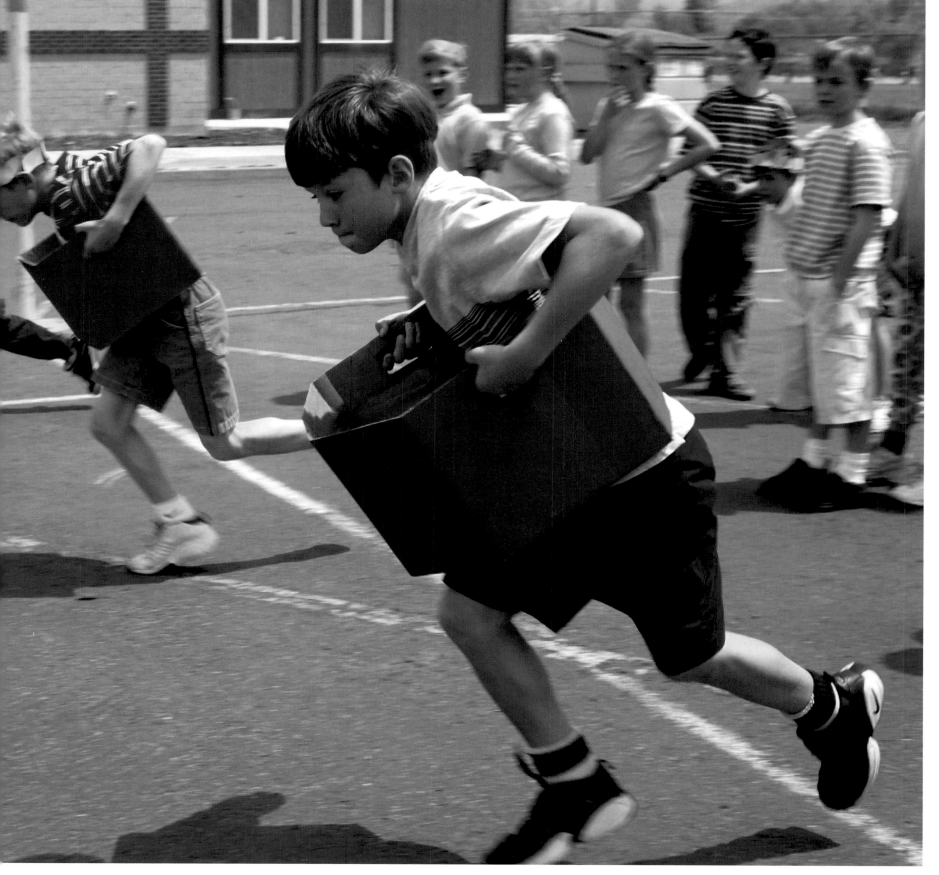

LAKE TAHOE STATE PARK
On the way to the Western States Tow Show in Reno, John Coulter and friends stopped to enjoy Lake Tahoe's fabulous water. Recent efforts to preserve the lake include limiting development and banning a type of jet ski that leaves up to 30 percent of unburned fuel in the water.
Photos by Jessica Brandi Lifland

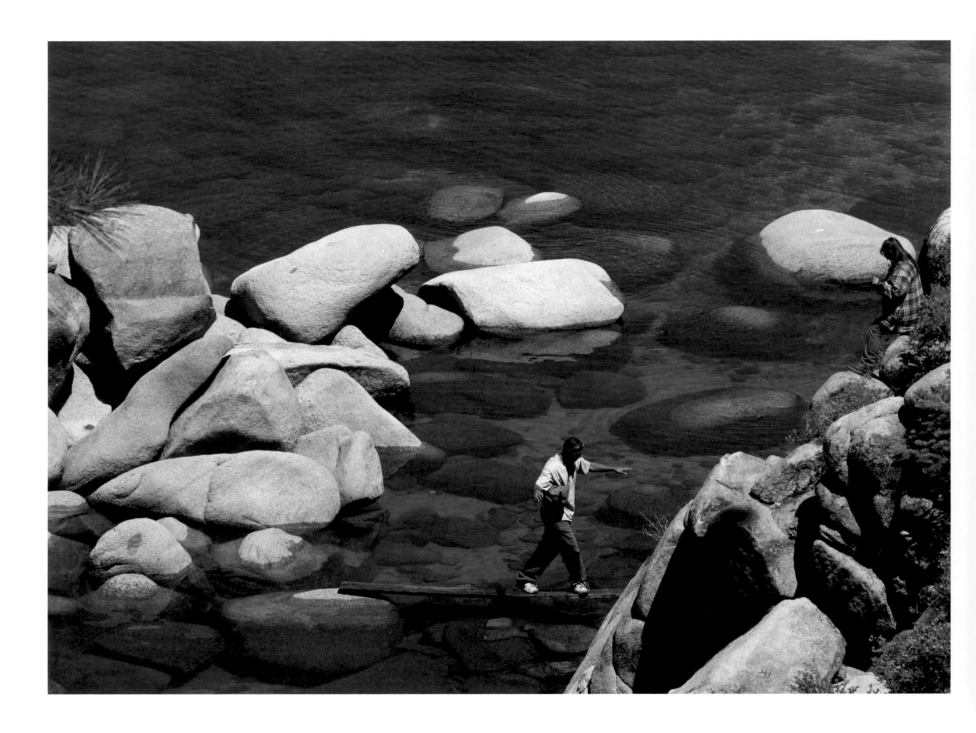

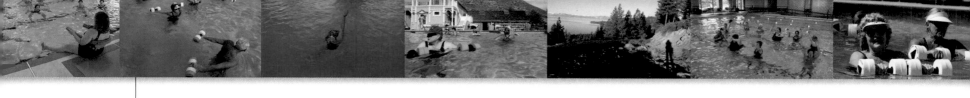

GENOA

Lynn Owens (rear left) leads water aerobics classes at David Walley's Resort. Back in 1862, New Yorker David Walley stopped in the area, felt restored by the local hot springs, and bought them. His 50-cent baths morphed over a century into a luxury spa attracting the nation's rheumatic elite. Now owned by Quintus corporation, the baths offer much more, for much more.

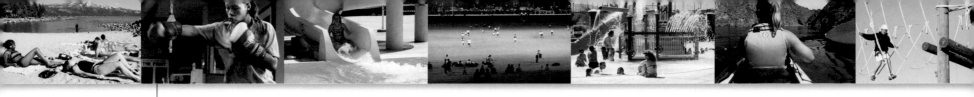

LAS VEGAS

After eight years of coaching from James Pena, left, boxing the heavy bag at The Gym is second nature to Melinda Cooper. The 117-pound 18-year-old is an undefeated batamweight boxer with five knockouts under her belt this season.
Photo by Amy Beth Bennett

LAS VEGAS

Jennifer Konrad took up tae kwon do to learn self-defense and advanced quickly through the belt levels. When her older brother Justin realized she could whup him, he took up the Korean martial art as well. "We used to fight all the time," says Jennifer. "But since we both started doing tae kwon do, we never fight anymore."
Photo by Lindsay Hebberd,
Cultural Portraits Productions, Inc.

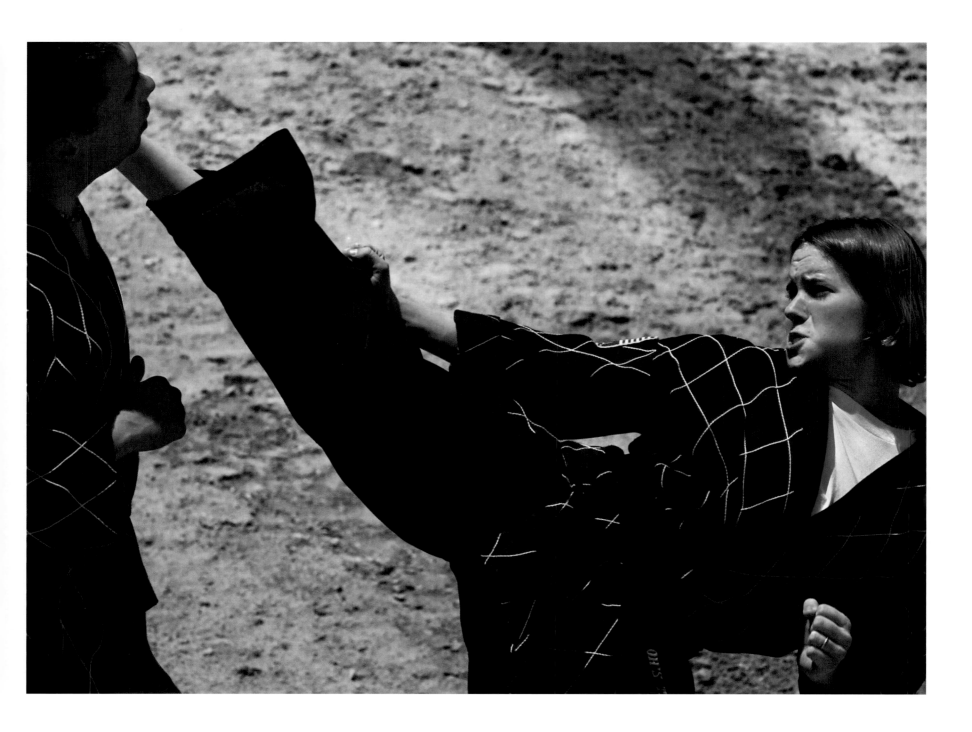

CLARK COUNTY

"It's not as desolate as it looks," says Frank Valenti, who fixes a flat tire along Blue Diamond Road (Highway 159) west of Las Vegas. "A lot of bicyclists come by." A New York transplant who cooks at Antonio's Italian restaurant in the Rio hotel, Valenti avoids the Strip on his time off, riding 20 to 50 miles through the desert most days.
Photo by Jim K. Decker, Las Vegas Review-Journal

LAS VEGAS

Shannon Skinner and Melanie Alexander beat the heat with an au naturel cruise down Old Las Vegas Boulevard. Skinner, a journeyman lineman who manages a five-person crew, says road trips on her Harley are a way to leave work behind and "get out and about and feel free."
Photo by Dan Burns, nofearfotos.com

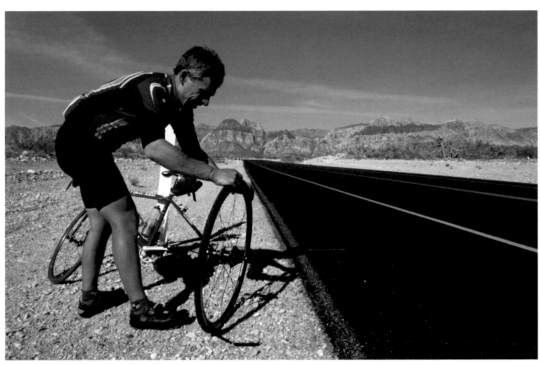

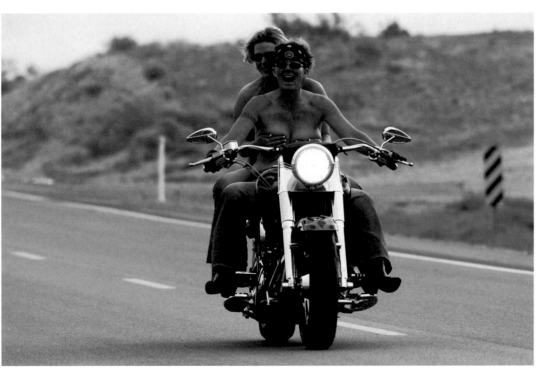

SAND MOUNTAIN RECREATION AREA
Jim Harding started tooling around in dune buggies in the 70s, following in the tracks of the Volkswagon-based vehicles that headed off-road a generation before. Harding built his buggy from scratch, fabricating the suspension and frame with welding tools and a pipe bender. "It's more technology and less VW now," he says of today's off-road vehicles, some of which can top 100 mph.
Photo by Scott T. Smith

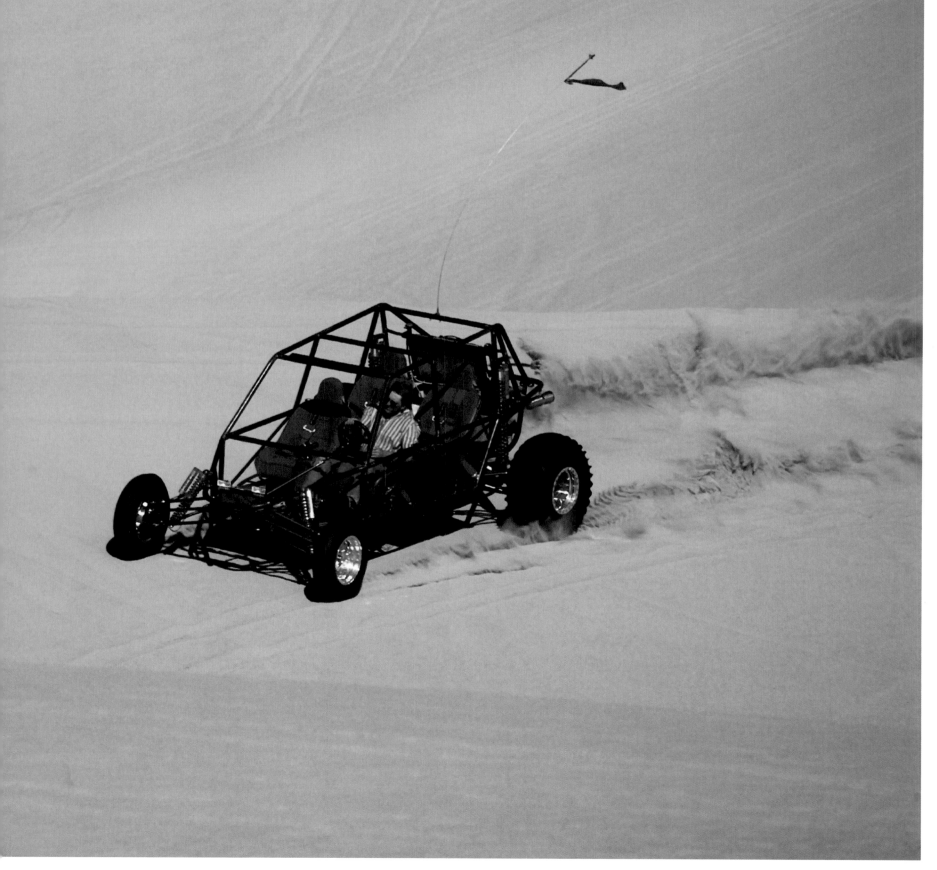

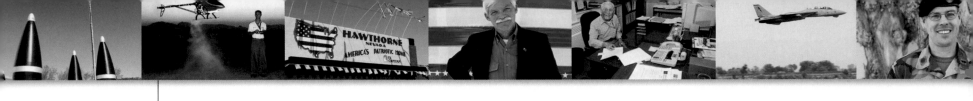

LAS VEGAS
Alan Szabo, Jr., 17, maneuvers a Raptor 90 model helicopter. Alan took third place at the 2003 radio-controlled helicopter world championship, held in England. Shortly thereafter, a Department of Defense contractor hired him as a test pilot for unmanned aerial vehicles.
Photo by Dan Burns, nofearfotos.com

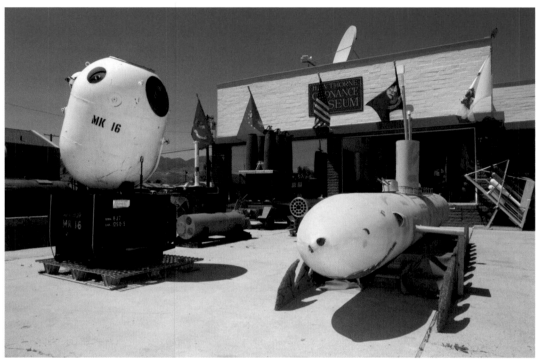

HAWTHORNE

Bombs away: The Hawthorne Ordnance Museum collects bombs and ammunition that were made at the nearby Hawthorne Army (formerly Navy) Depot. Pictured are a pair of World War II underwater mines: a contact mine sitting on its anchor, and a torpedo-shaped mine the staff made to look like a submarine.

Photo by Larry Angier

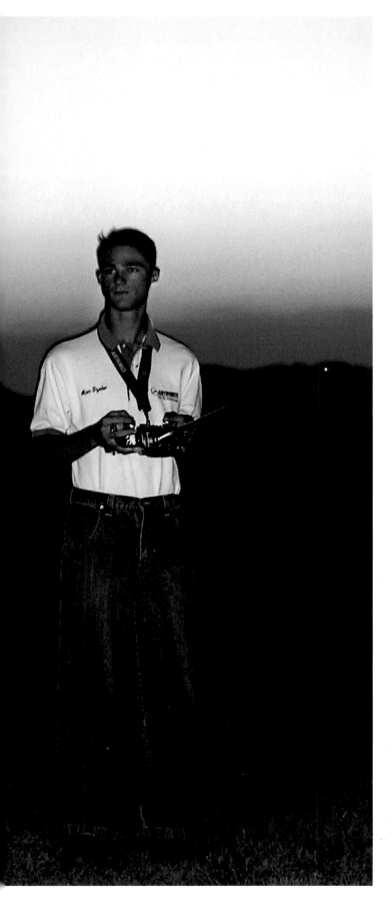

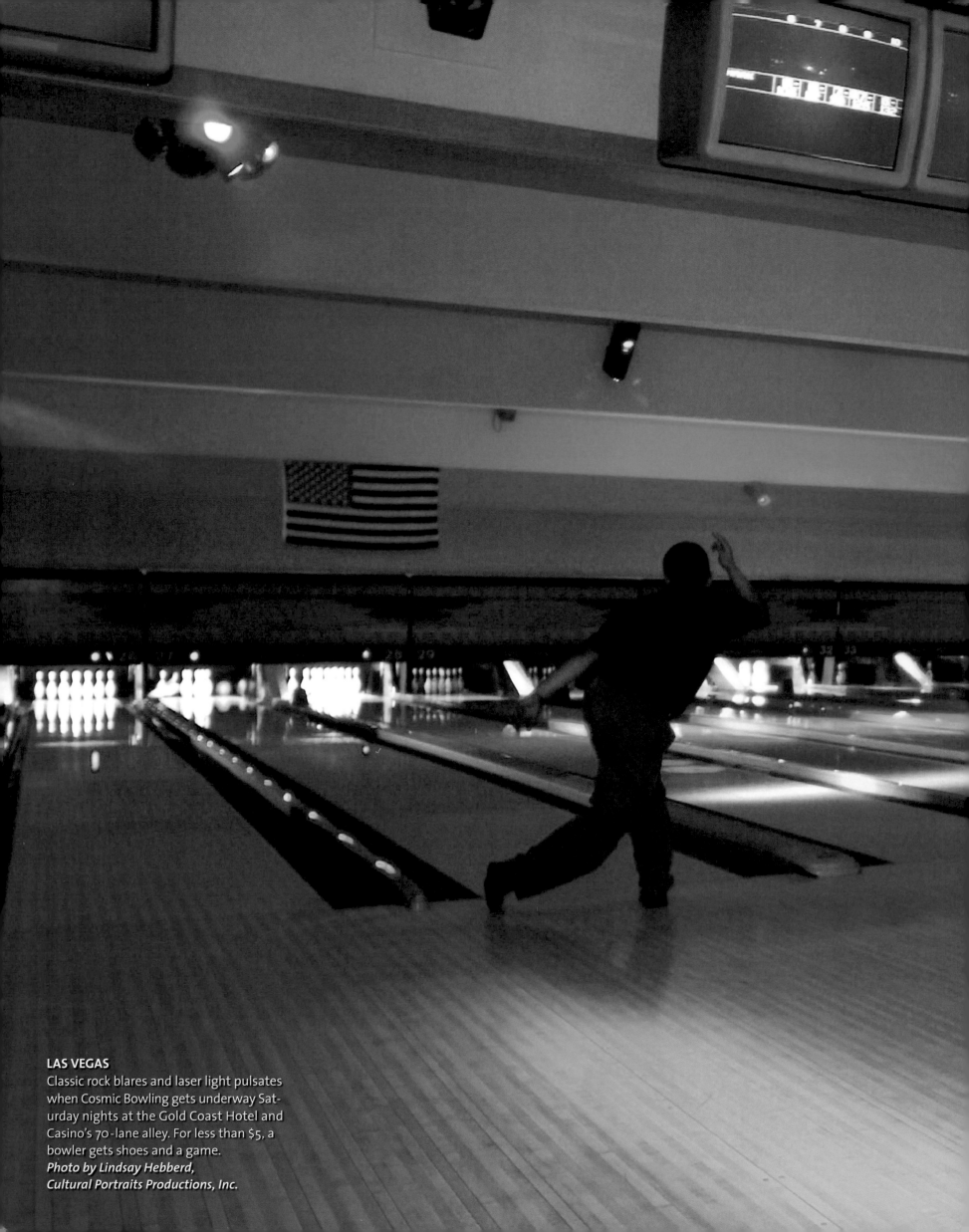

LAS VEGAS
Classic rock blares and laser light pulsates
when Cosmic Bowling gets underway Sat-
urday nights at the Gold Coast Hotel and
Casino's 70-lane alley. For less than $5, a
bowler gets shoes and a game.
Photo by Lindsay Hebberd,
Cultural Portraits Productions, Inc.

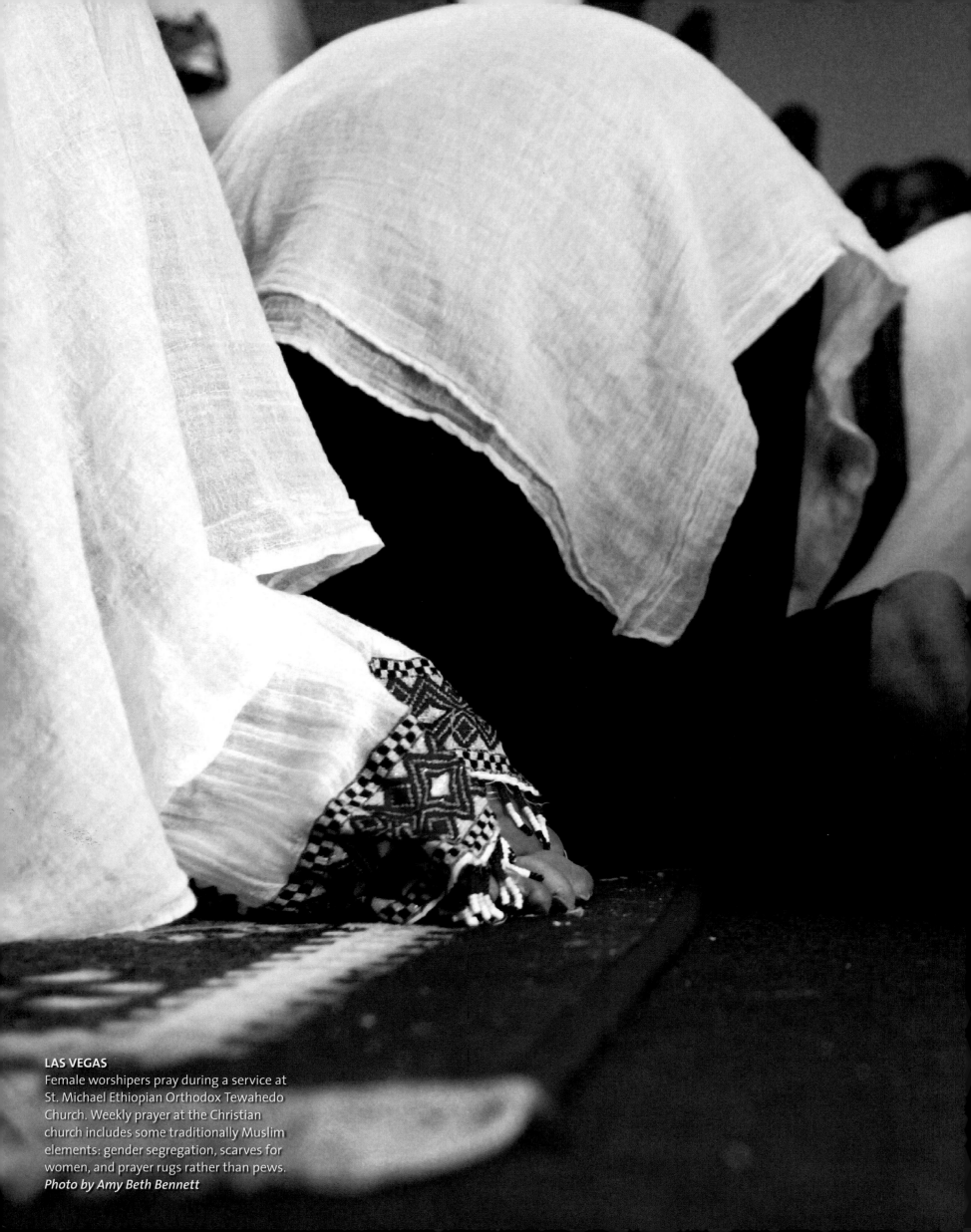

LAS VEGAS
Female worshipers pray during a service at
St. Michael Ethiopian Orthodox Tewahedo
Church. Weekly prayer at the Christian
church includes some traditionally Muslim
elements: gender segregation, scarves for
women, and prayer rugs rather than pews.
Photo by Amy Beth Bennett

Reason To Believe

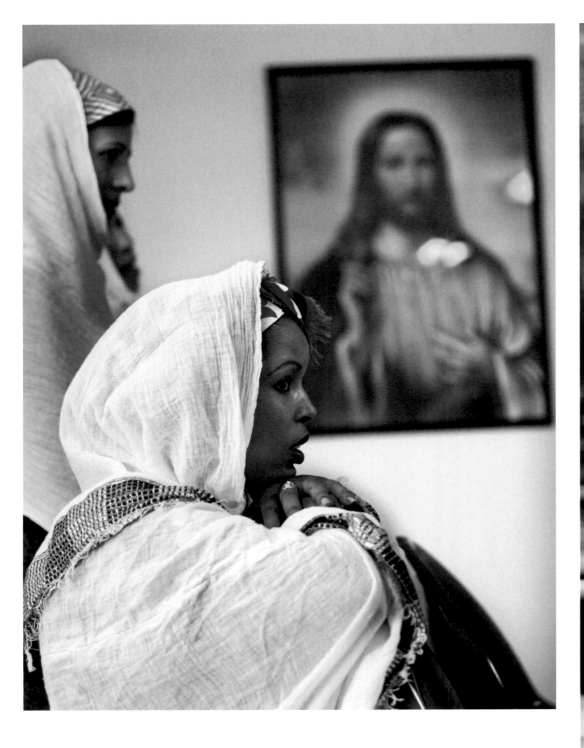

LAS VEGAS

Ethiopian immigrants are settling in Las Vegas to take advantage of abundant jobs and a low cost of living. The Ethiopian Mutual Association of Nevada estimates that 5,000 Ethiopians live in the greater Las Vegas area, 100 of whom worship at St. Michael Church on Thursdays.
Photos by Amy Beth Bennett

LAS VEGAS

Roble Ayanaw gets a scolding from Mulu Hilufe. The 2-year-old nearly disrupted service by rapping on the church choir's *kebero*, or traditional drum. But before he got a chance to show off his percussionist's prowess, 3-year-old Mulu stepped in to keep the toddler in line.

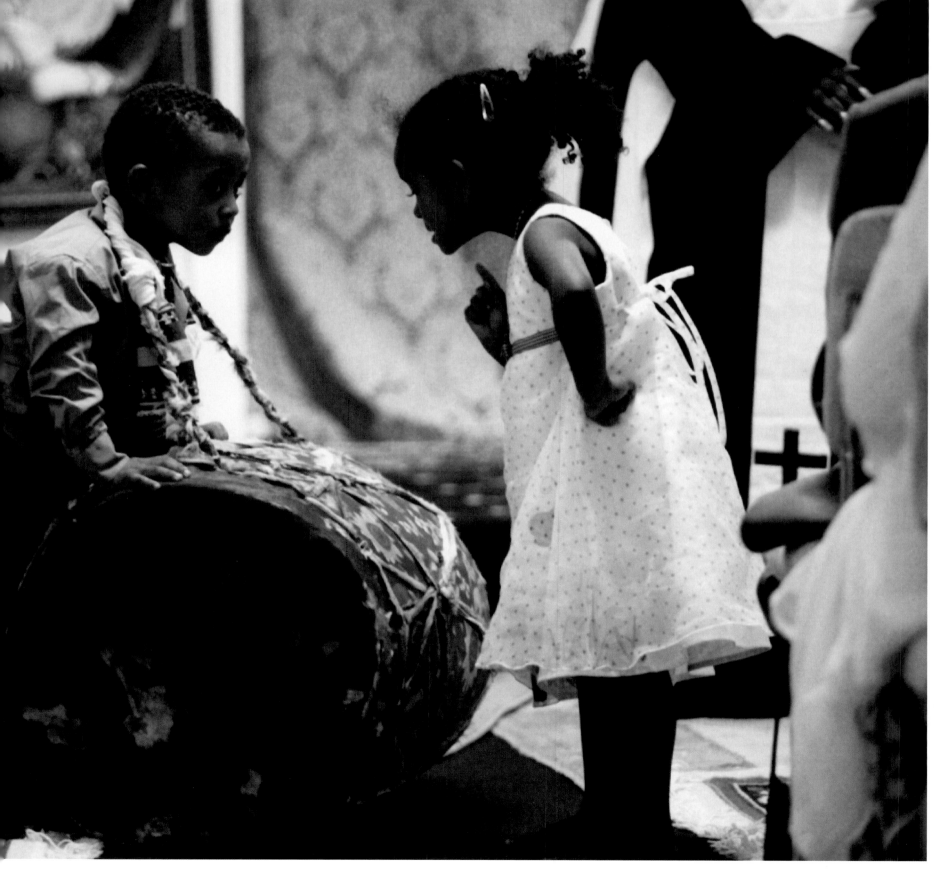

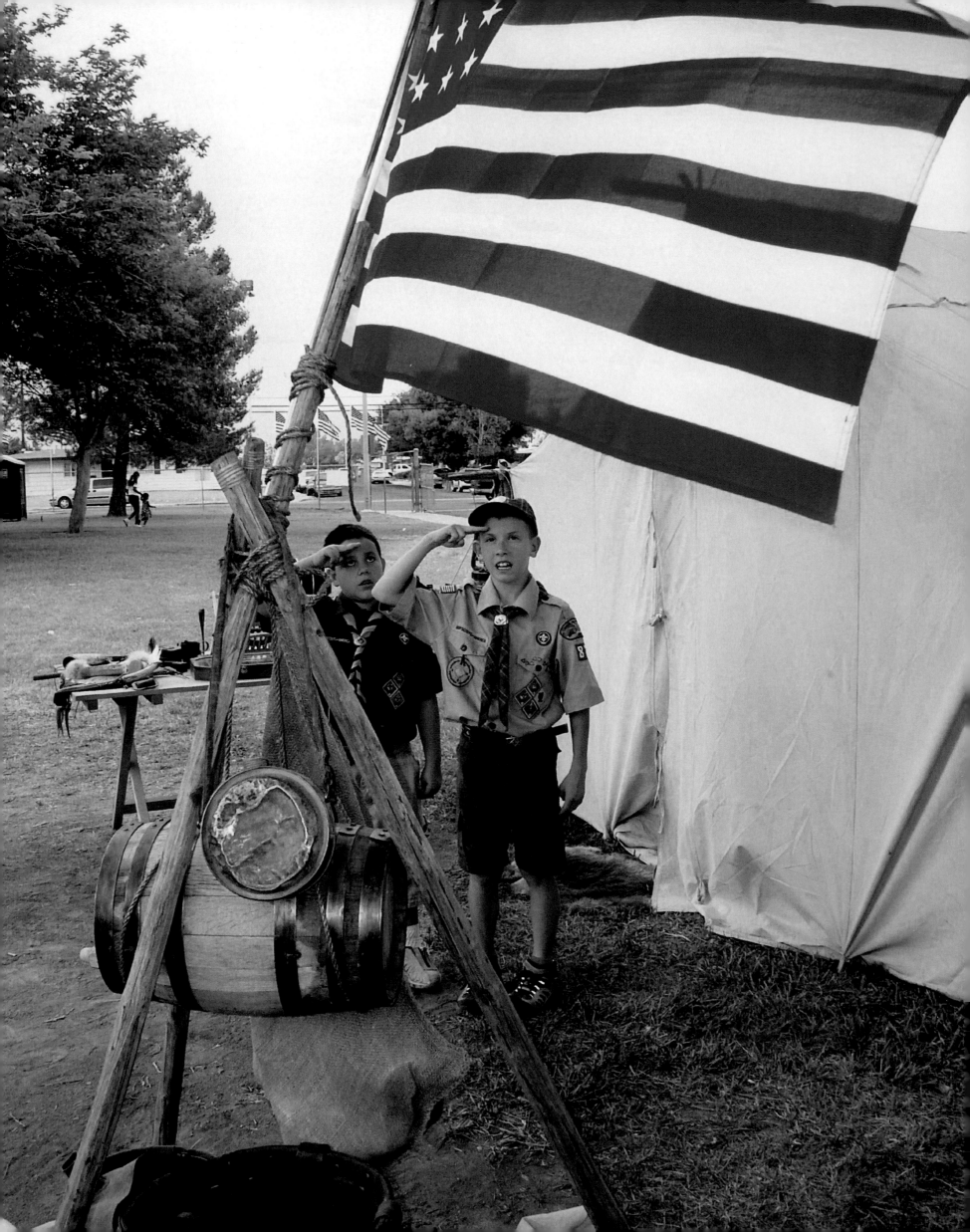

LAS VEGAS

Two Scouts salute a flag at their "pioneers' camp" at the Scout Expo in Lorenzi Park. Each spring, the Boulder Dam Area Council invites 150 Scouting units from Nevada, Arizona, and California to demonstrate their skills to the public.
Photo by Lynn Hrnciar

BAKER

John Woodyard built his Shoshone sweat lodge out of straw, clay, and willow. The desired effect: a warm, dark place that feels like a womb. A retired social worker, Woodyard comes here to ponder various spiritual traditions, including Buddhism, Yoga, and Wicca.
Photo by Lin Alder, alderphoto.com

BEATTY

At Angel's Ladies Brothel, 115 miles northwest of Las Vegas—shuttle service available—Angel, left, her ladies, and staff members say grace before dinner. The women stay at the brothel for two weeks at a time and take their meals in a private dining room away from the clientele.

Photo by Joe Cavaretta

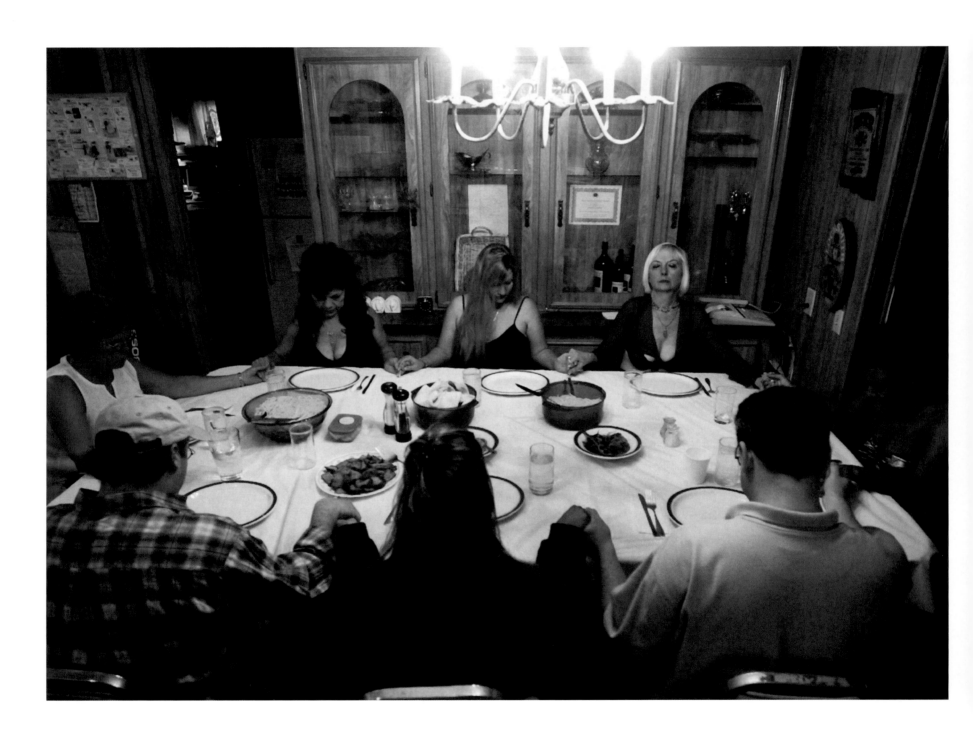

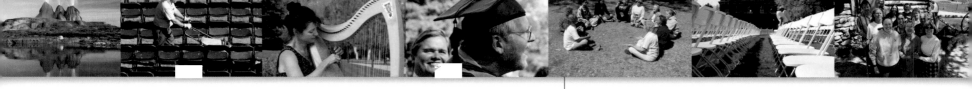

BAKER

At its zenith in the 1970s, 30 people lived communally on the Home Farm School of Natural Order's 320-acre property, farming vegetables, raising livestock, and growing fruit. Just 12 residents remain, including this group, which gathered to meditate in the commune's front yard.
Photo by Lin Alder, alderphoto.com

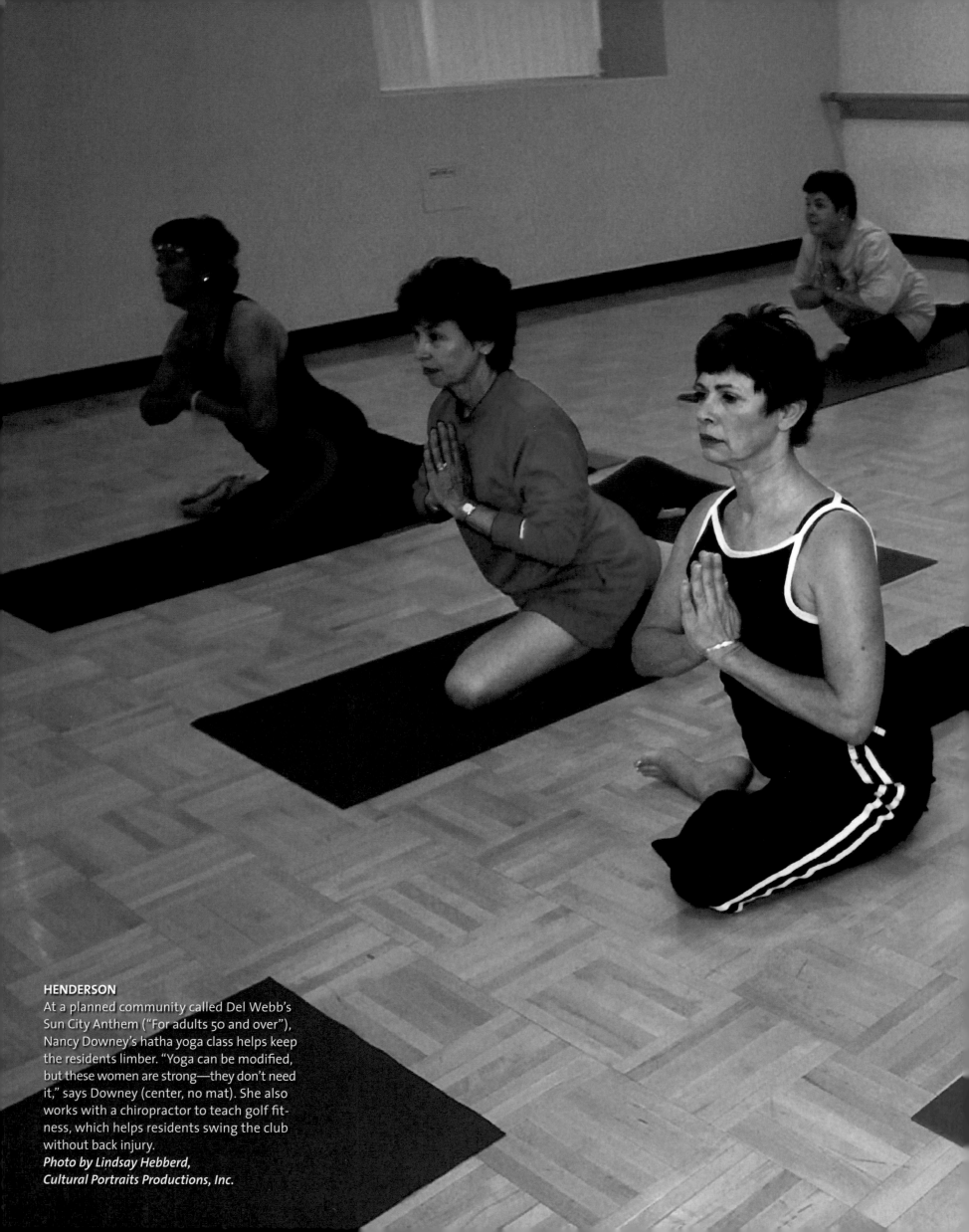

HENDERSON
At a planned community called Del Webb's Sun City Anthem ("For adults 50 and over"), Nancy Downey's hatha yoga class helps keep the residents limber. "Yoga can be modified, but these women are strong—they don't need it," says Downey (center, no mat). She also works with a chiropractor to teach golf fitness, which helps residents swing the club without back injury.
Photo by Lindsay Hebberd,
Cultural Portraits Productions, Inc.

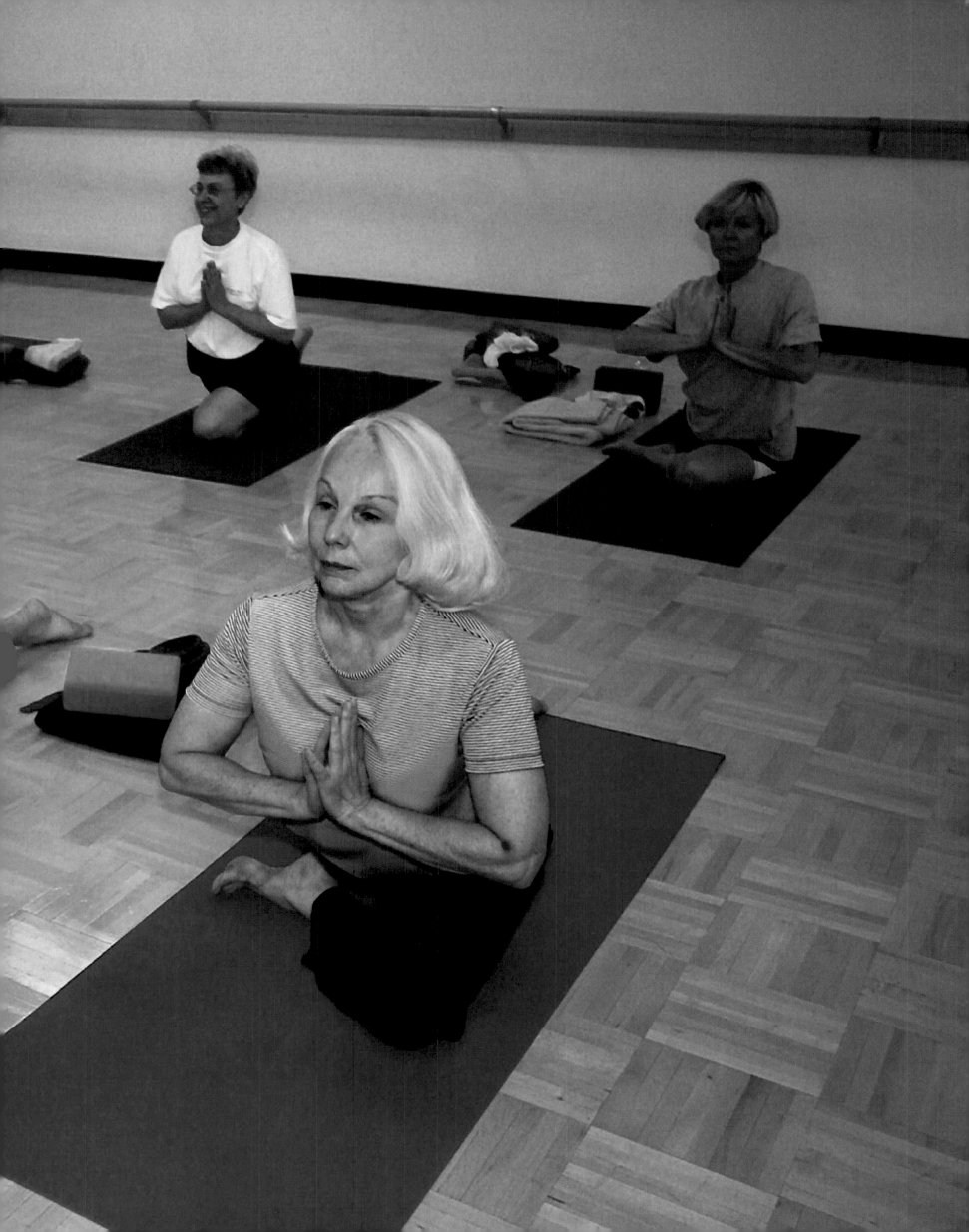

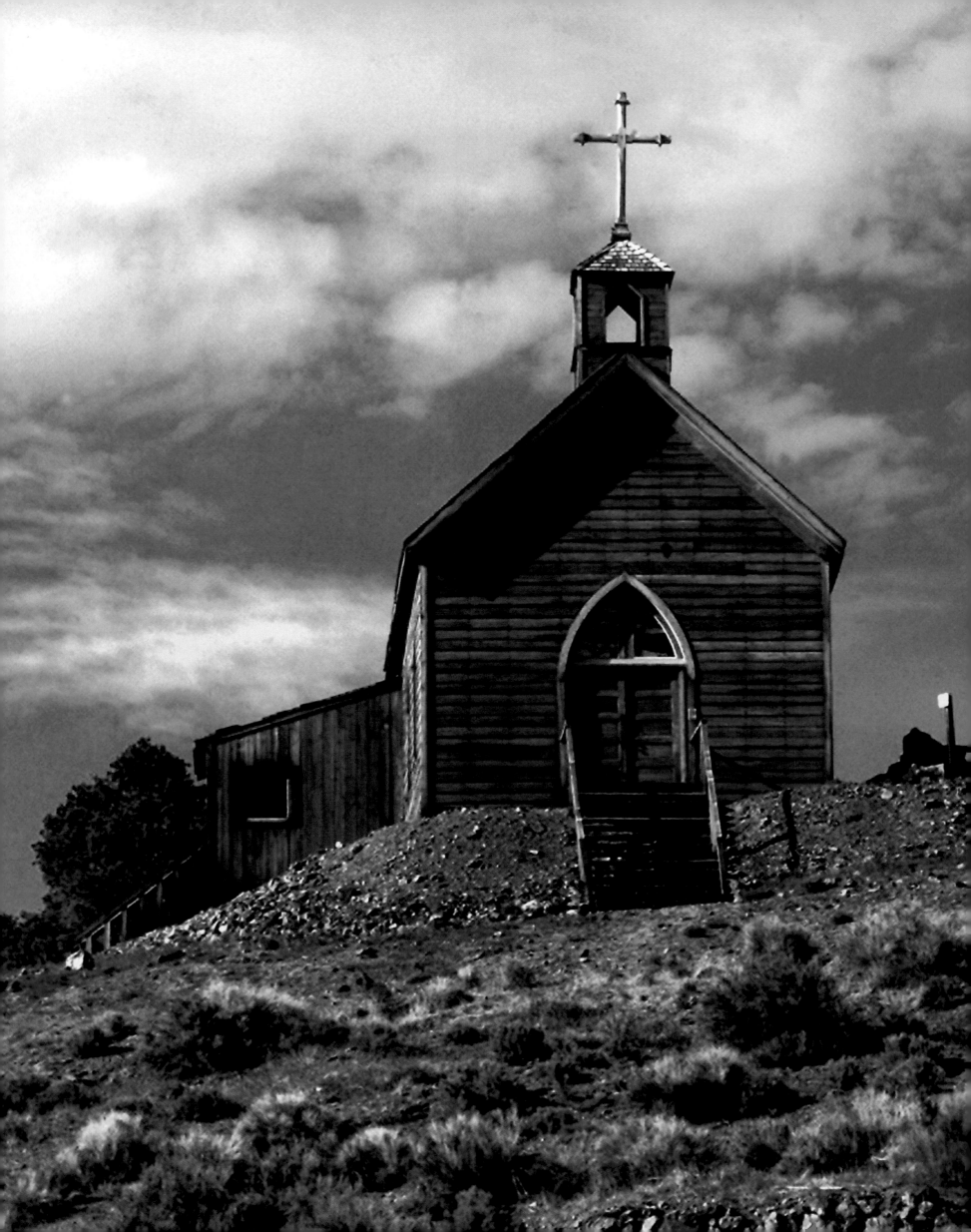

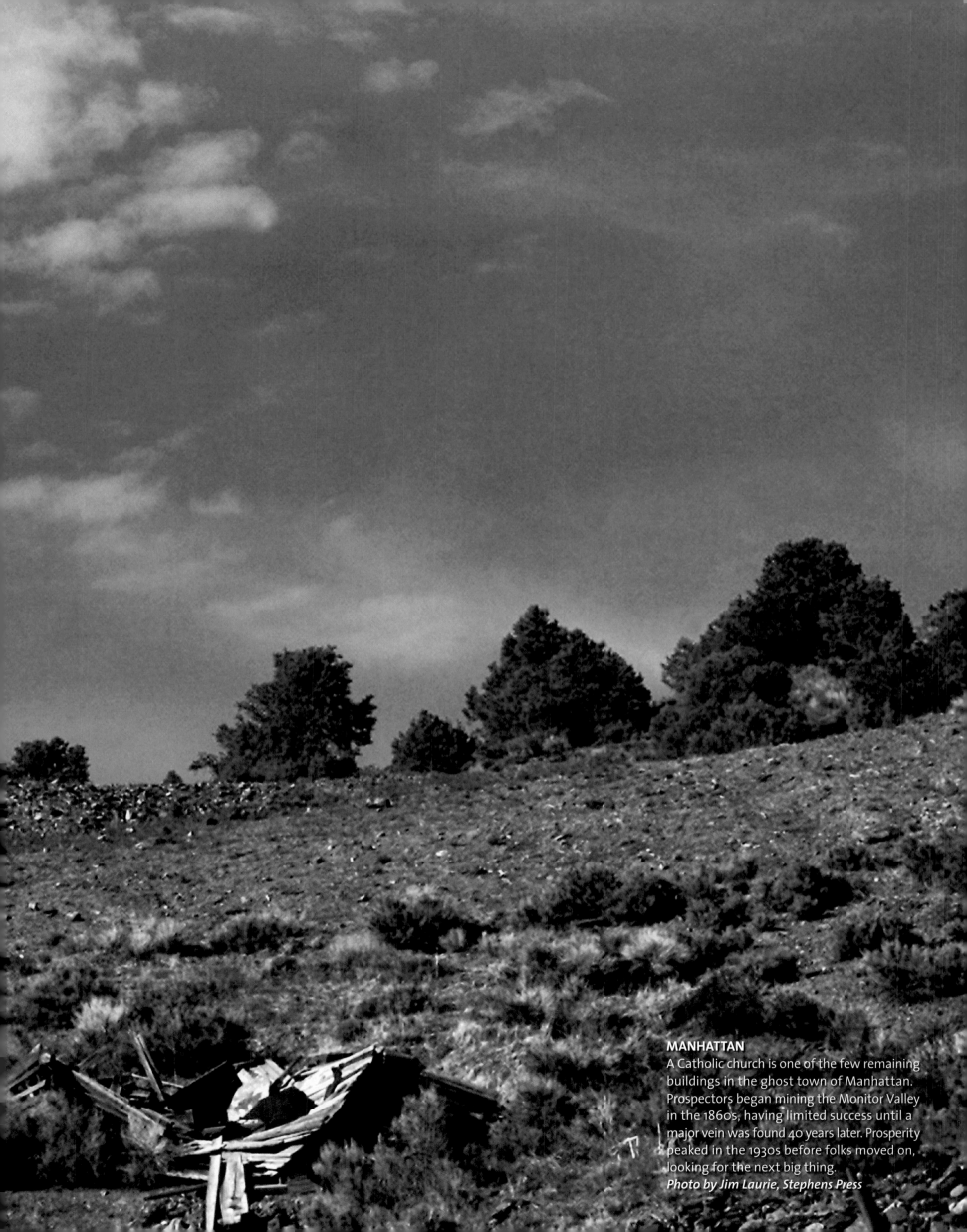

MANHATTAN
A Catholic church is one of the few remaining buildings in the ghost town of Manhattan. Prospectors began mining the Monitor Valley in the 1860s, having limited success until a major vein was found 40 years later. Prosperity peaked in the 1930s before folks moved on, looking for the next big thing.
Photo by Jim Laurie, Stephens Press

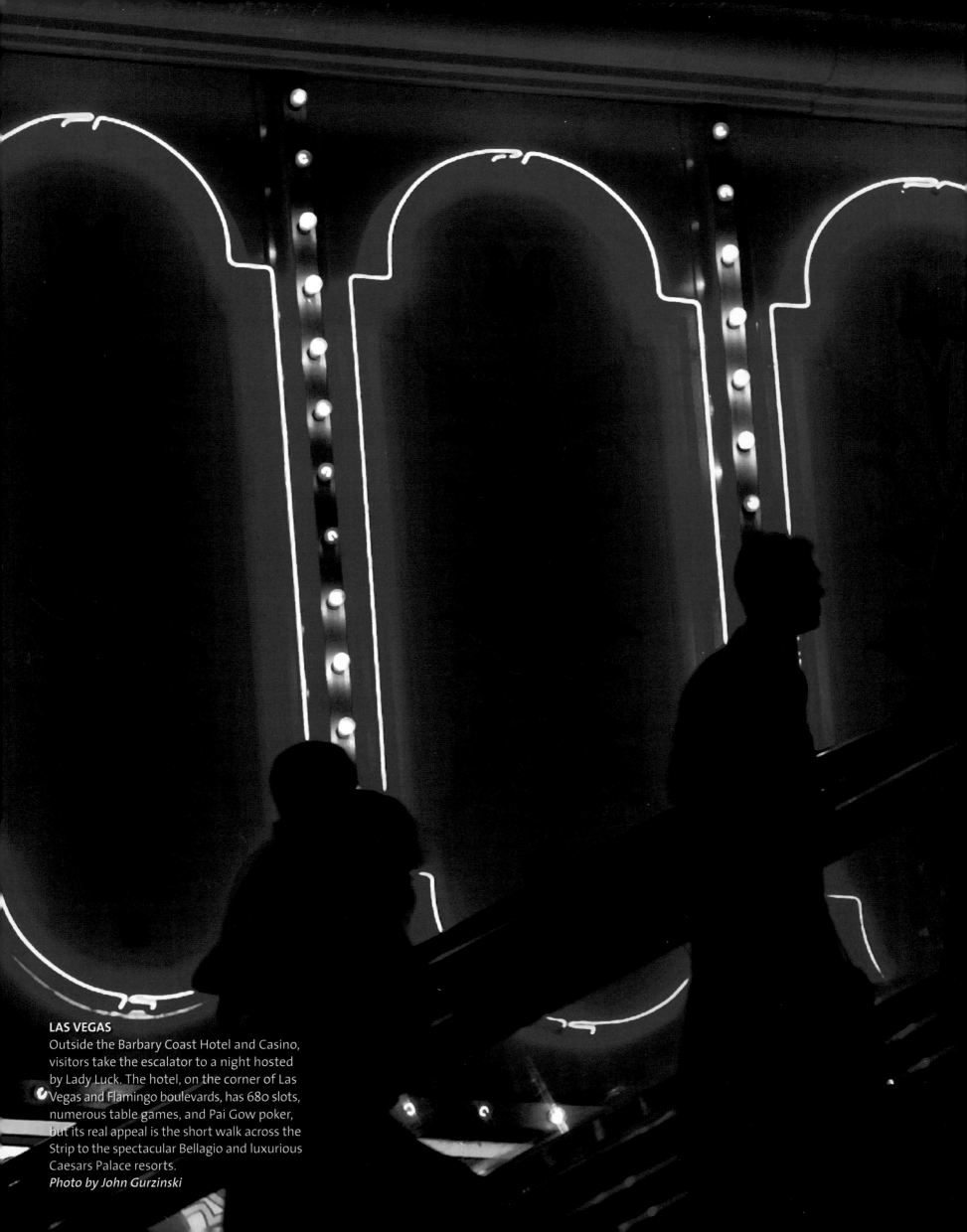

LAS VEGAS
Outside the Barbary Coast Hotel and Casino,
visitors take the escalator to a night hosted
by Lady Luck. The hotel, on the corner of Las
Vegas and Flamingo boulevards, has 680 slots,
numerous table games, and Pai Gow poker,
but its real appeal is the short walk across the
Strip to the spectacular Bellagio and luxurious
Caesars Palace resorts.
Photo by John Gurzinski

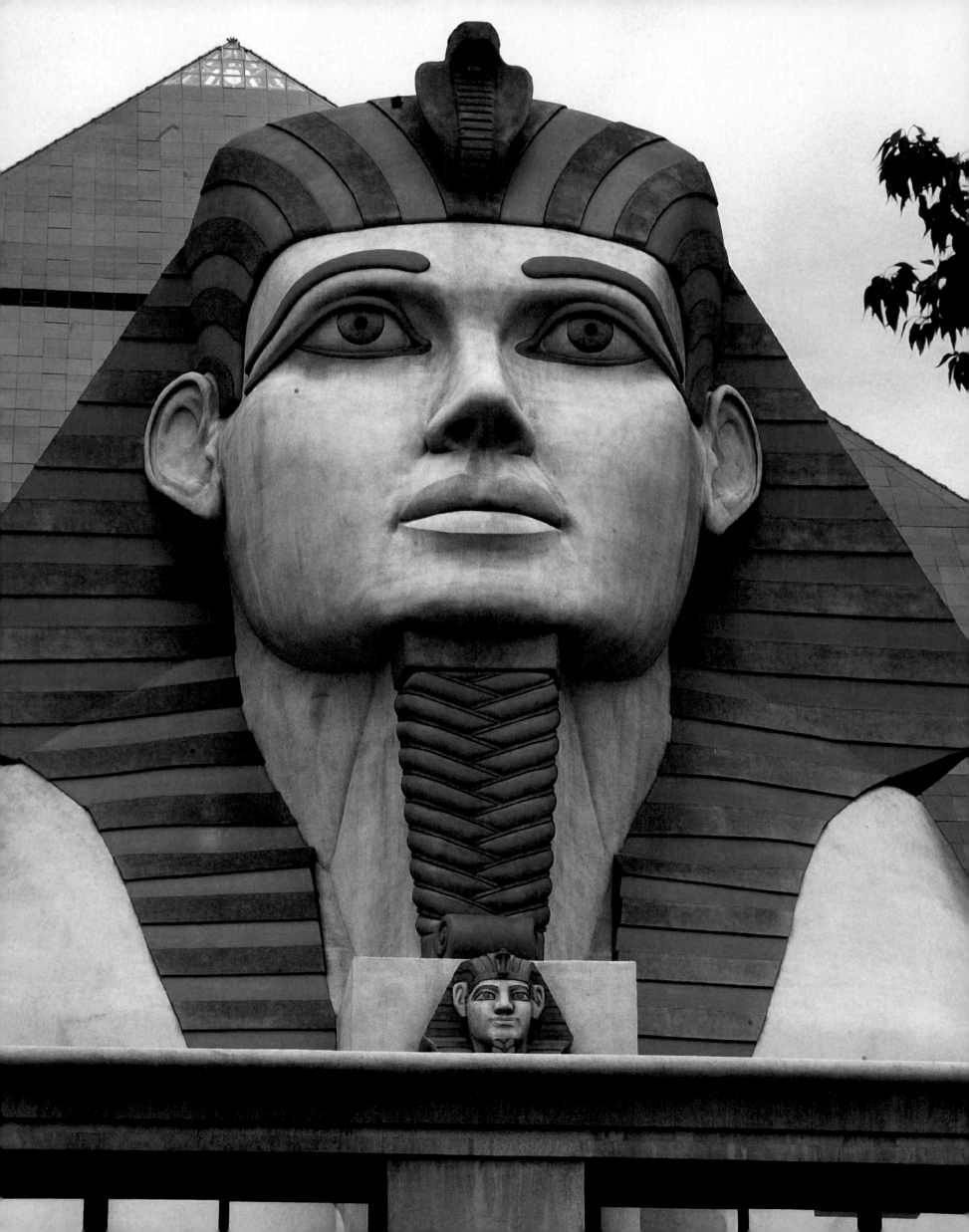

LAS VEGAS
Under the watchful gaze of the Sphinx, gamblers and tourists arrive by car, taxi, and limo at the Luxor Hotel and Casino.
Photo by Misha Erwitt

BEATTY
A vintage casino displays little of the glitz that lights up Las Vegas, 115 miles south.
Photo by Jim Laurie, Stephens Press

LAS VEGAS
The comic Strip: Outside the MGM Grand hotel on a Saturday morning, photographer Misha Erwitt happened to have his camera in hand when this duo cruised by. Meep meep.
Photos by Misha Erwitt

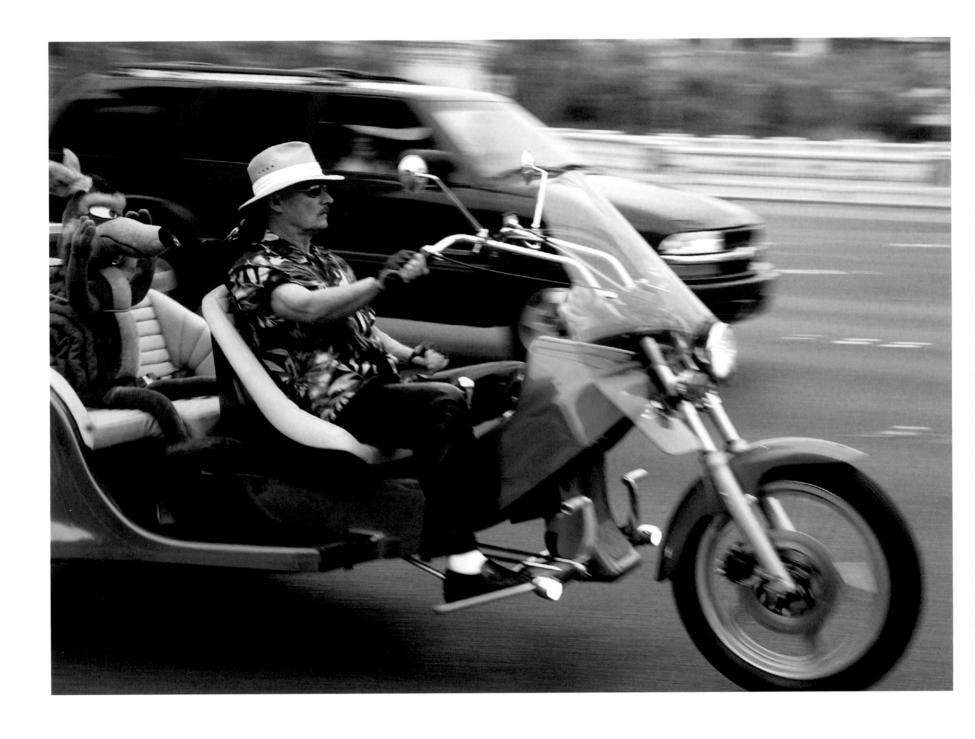

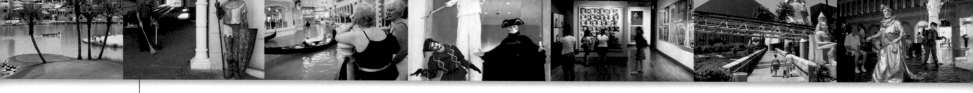

LAS VEGAS

Cleanliness is next to King Arthur: Under the watchful eyes of a Middle-Aged guard, the Excalibur Hotel/Casino's pavement is swept clean.

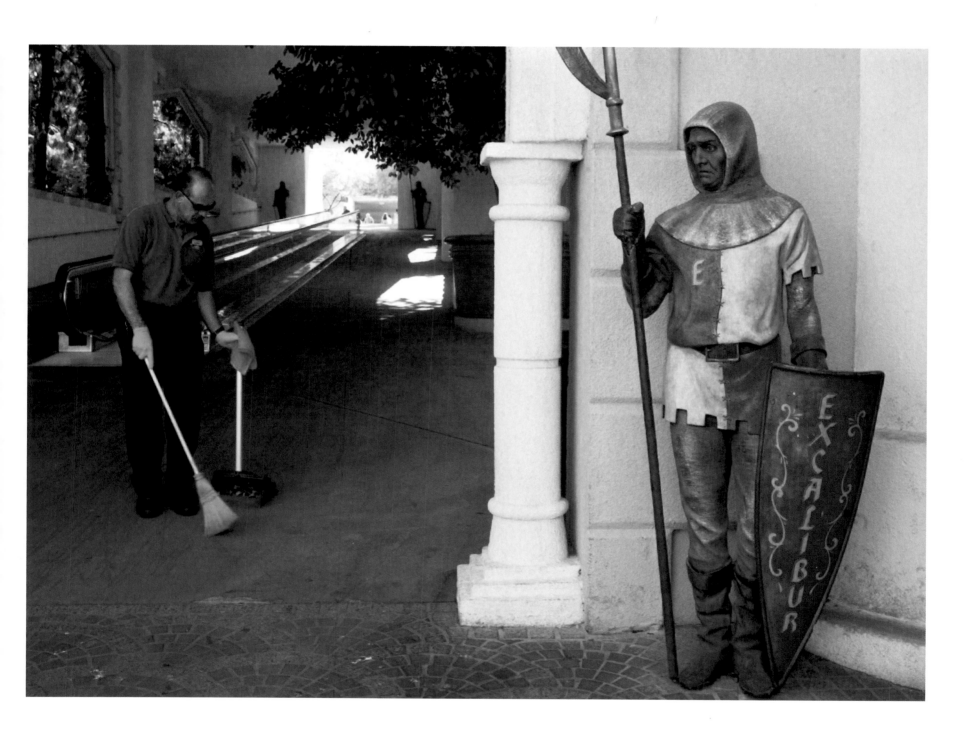

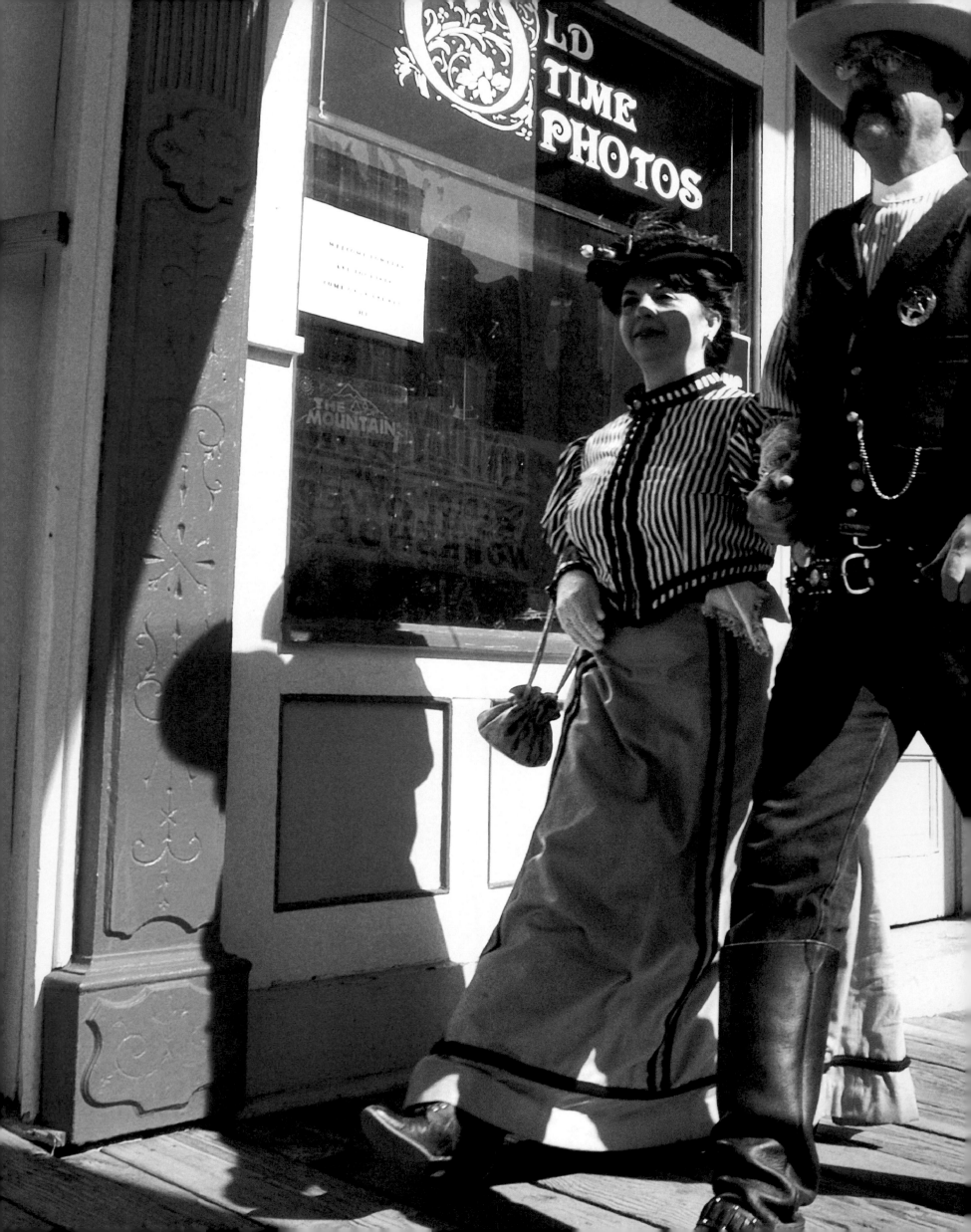

VIRGINIA CITY
Members of the Guns and Gals of Old Virginia City stroll down the former mining metropolis' wooden sidewalks. The group puts on skits at charity events, performs at weddings, and has been known to rob a tour bus or two. The club's lofty ambition? "To keep the Old West alive and kicking," says the white-hatted Andy Hughes.
Photo by Marilyn Newton,
Reno Gazette-Journal

ELY

After starring as Bo Duke in *The Dukes of Hazzard*, John Schneider made several country music records, starred in the TV drama *Smallville*, and recorded a patriotoic song with Senator Orrin Hatch. In his spare time, he races the General Lee in the Silver State Open at speeds reaching 140 mph.

Photo by Lin Alder, alderphoto.com

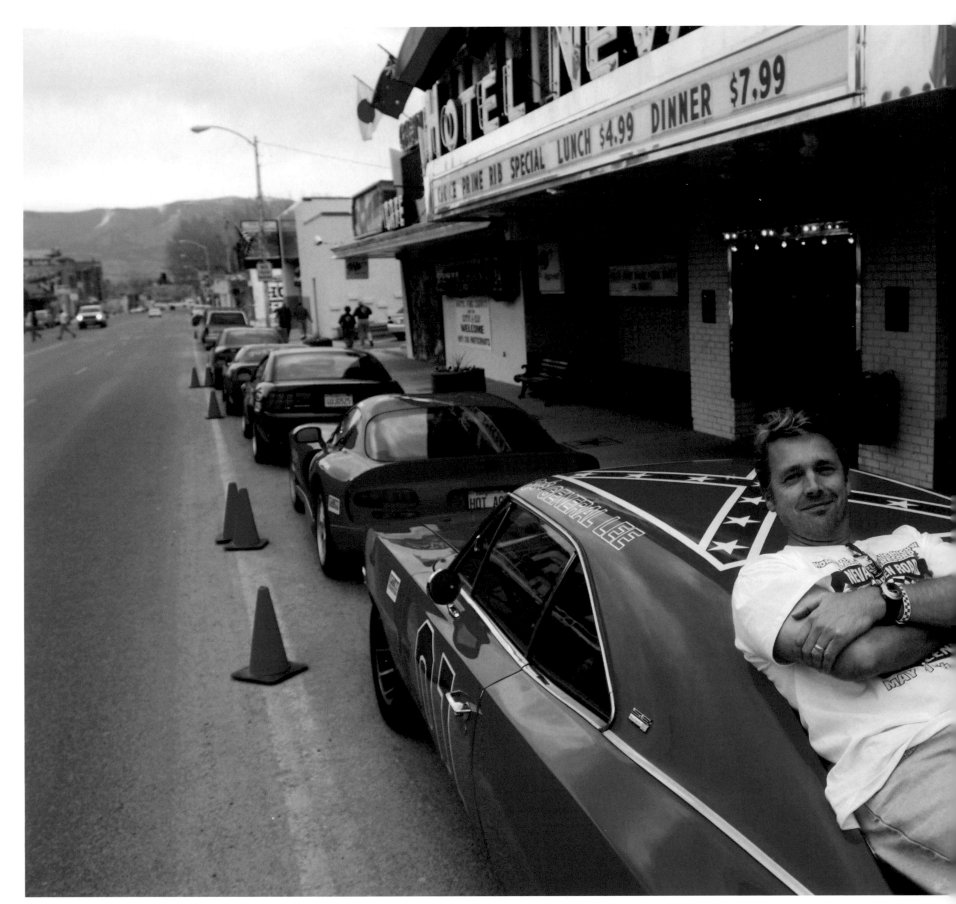

LAS VEGAS

Thunder From Down Under: That's what the blokes call their all-male dance troupe, headlining at the Excalibur Hotel and Casino. The all-beef imports from Australia and New Zealand are a hit with bachelorette parties and girls-night-out gangs.
Photo by Lindsay Hebberd,
Cultural Portraits Productions, Inc.

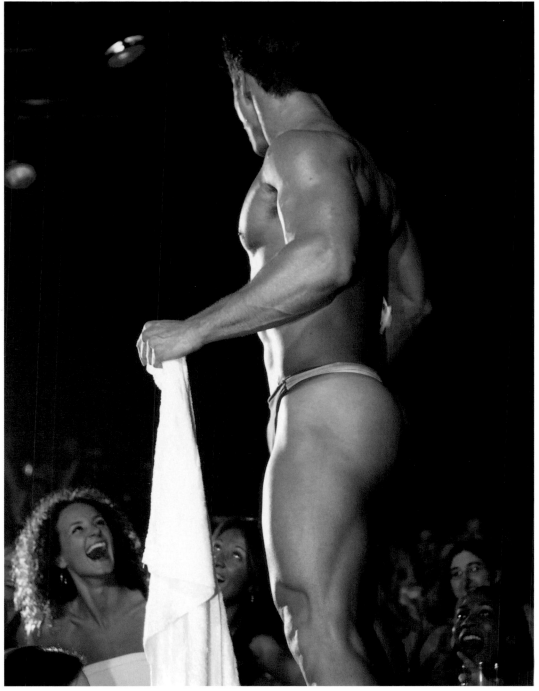

LAS VEGAS
Patrons grab some quick slot action at Jay's Convenience Store on Las Vegas Boulevard, aka the Strip. Businesses with fewer than 15 gambling machines were unregulated until 2000, when the Nevada Gaming Commission began licensing them. Nevada receives taxes and quarterly fees but no direct income from its 1,800 restricted licensees.
Photo by Lindsay Hebberd,
Cultural Portraits Productions, Inc.

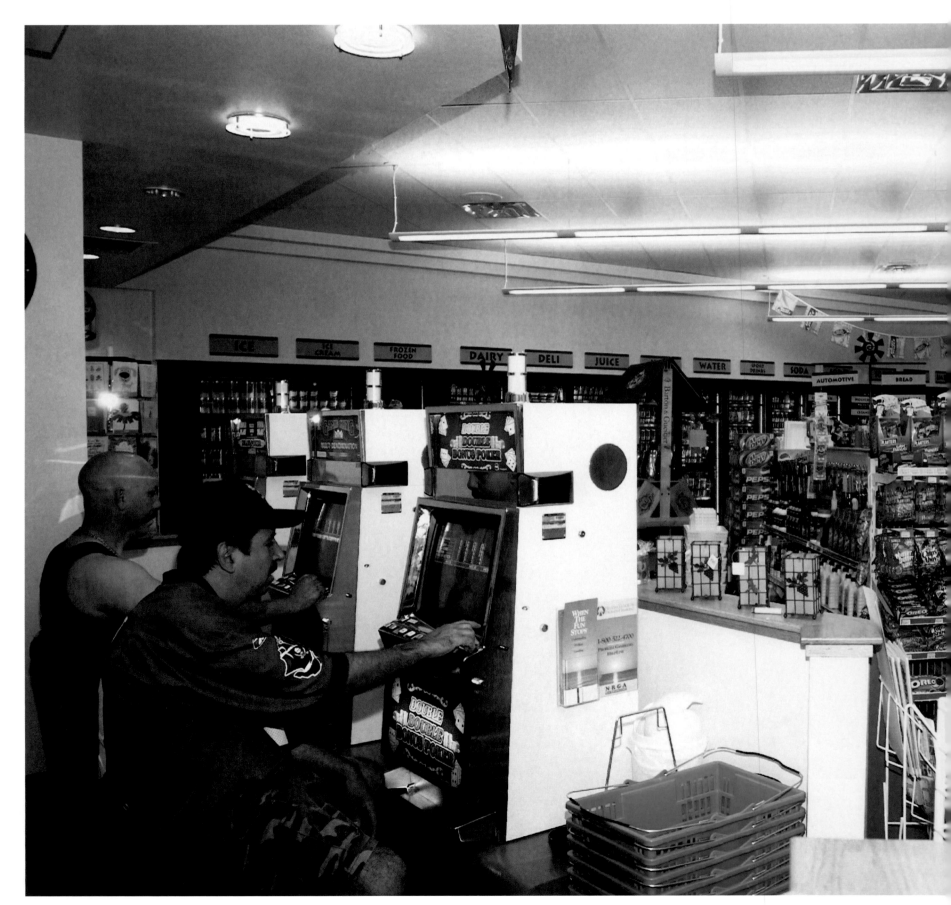

LAS VEGAS

Rick Spolinas, who is living in his truck while looking for construction work, passes the time with video poker at the Wizard of Suds Laundromat and market.

Photo by Naomi Harris

LAS VEGAS

Glo Hebberd from Scottsdale, Arizona, contemplates the slots at the Luxor. "I never spend more than $2," says Hebberd, in Las Vegas to visit her daughter. The average vistor spends $503 a day gambling.

Photo by Lindsay Hebberd,
Cultural Portraits Productions, Inc.

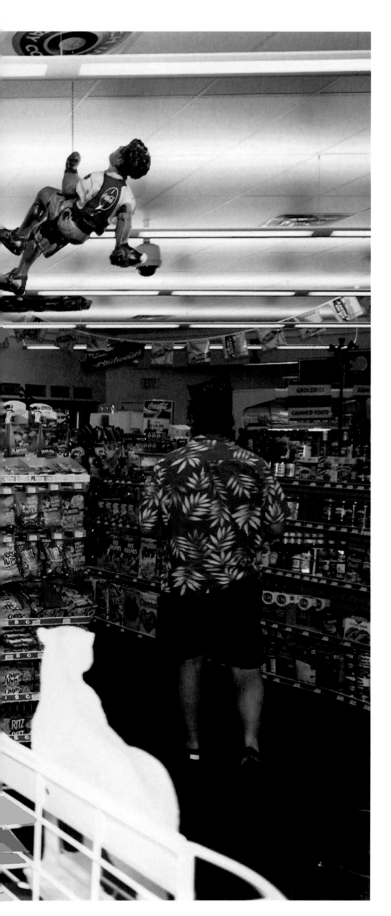

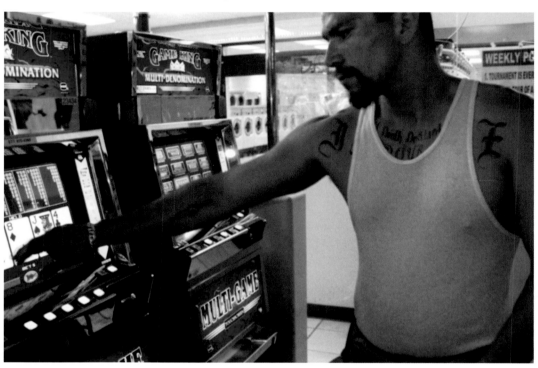

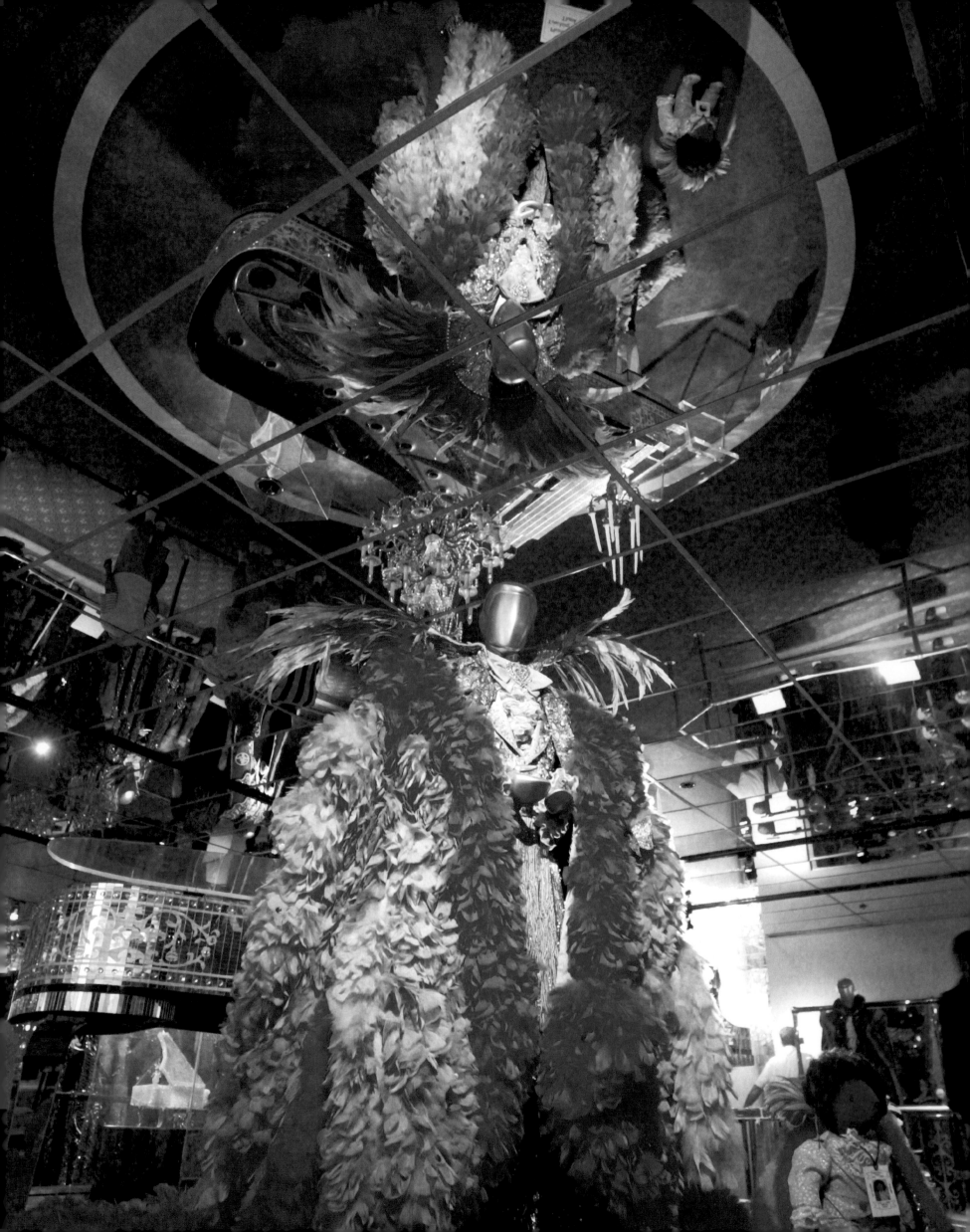

LAS VEGAS

The Liberace Museum houses the flamboyant pianist's elaborate costumes, including this ostrich feather cape, which he wore as he emerged onstage from a 28-foot Fabergé-style egg. Money was no object—Liberace was the highest-paid pianist in the world until his death in 1987.

Photo by Sam Morris

LAS VEGAS

Joshuwa John Gilbert lays on the schmaltz for the Liberace Play-A-Like competition at the Liberace Museum. The annual event draws impersonators from across the country who compete for a crystal miniature baby grand trophy.

Photo by Amy Beth Bennett

LAS VEGAS

Liberace's rhinestone-encrusted Duesenberg roadster sparkles in the museum's auto showroom. The vehicle was designed to match the rhinestone-covered Baldwin grand piano the maestro used for his final Radio City Music Hall performance in 1986.

Photo by Sam Morris

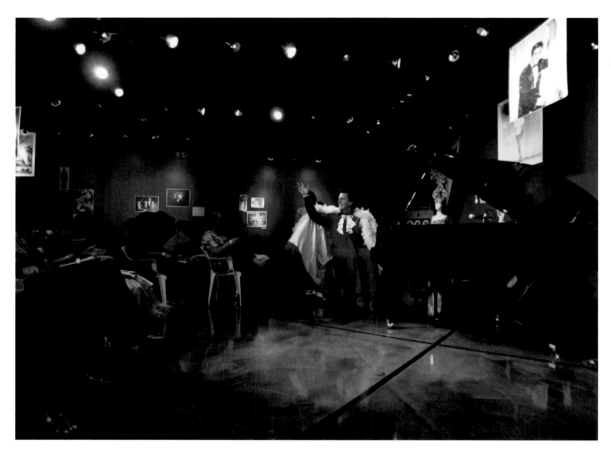

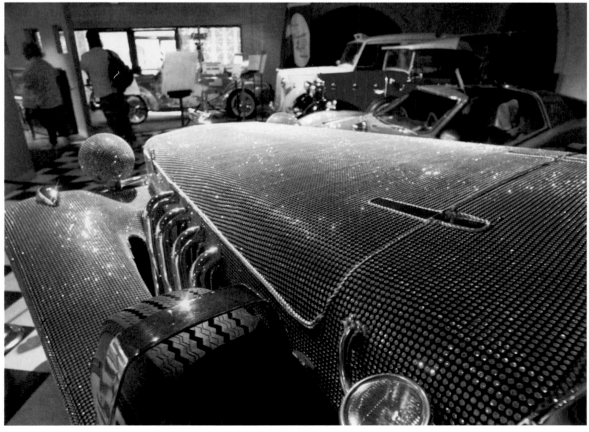

BAKER

Freelance art installations along Highway 488 between Baker and Great Basin National Park leave passersby wondering just who is out there. Down the road from the missing unicyclist, a horse skeleton drives an old car and further on, a TV set sports a weird antenna. Only the mask knows the identity of the artist.

Photo by Scott T. Smith

RACHEL

Ever since an area resident claimed he schmoozed with aliens at Papoose Lake, UFO watchers have flocked to the nearby desert town of Rachel. For a good night's sleep, an alien burger, or UFO shop talk, earthlings head to the Little A'Le'Inn, where owner Pat Travis is always ready for a paranormal chat.

Photo by Joe Cavaretta

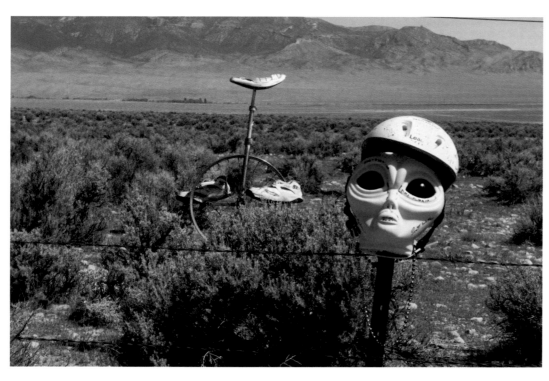

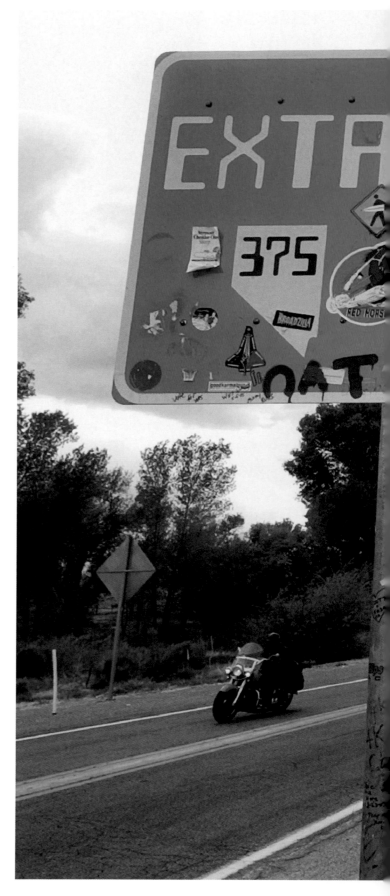

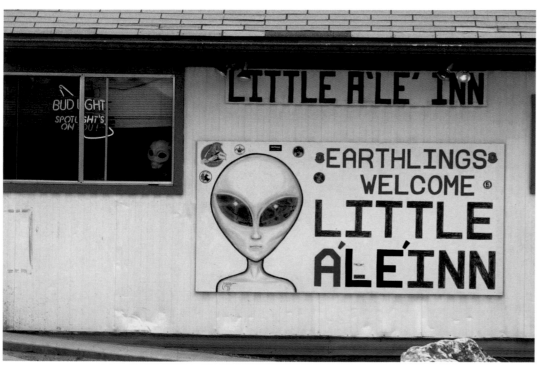

ALAMO

In April 1996, just before the blockbuster movie *Independence Day* opened, Nevada officially named State Highway 375 the "Extraterrestrial Highway." The desolate two-lane road stretches 111 miles from Crystal Springs to Warm Springs and cuts through Area 51, the rumored Air Force holding ground for crashed intergalactic spaceships.
Photo by Joe Cavaretta

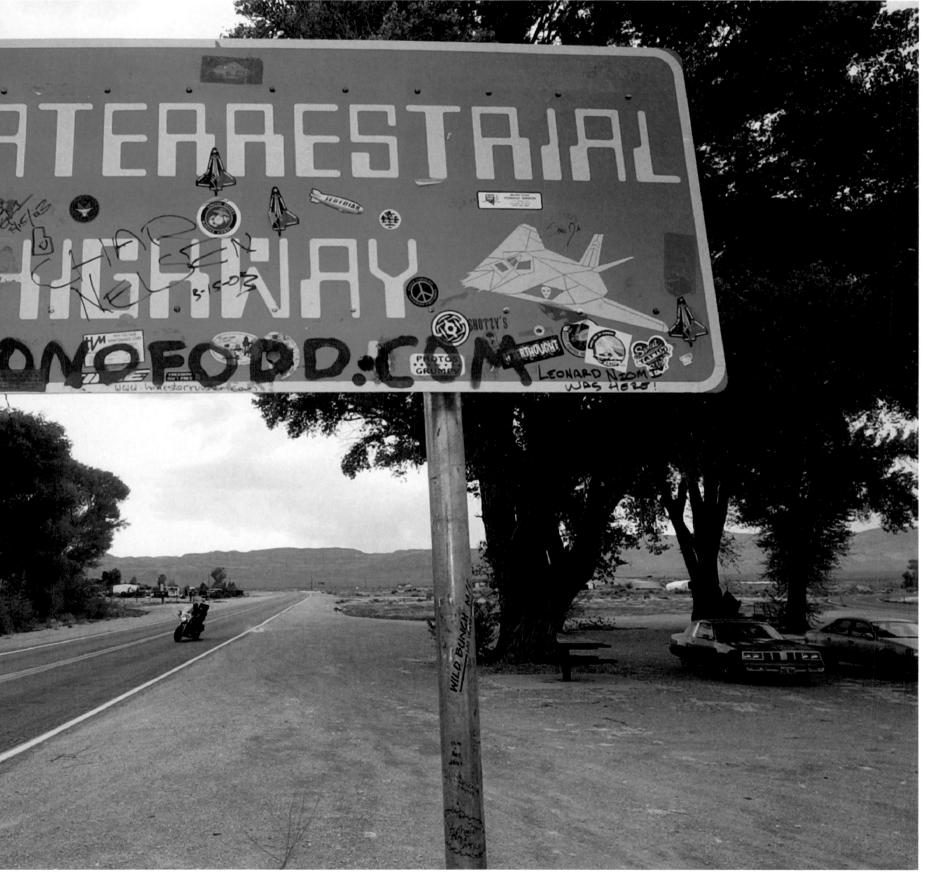

LAS VEGAS
The Valley of Fire in the Mojave Desert gets its name
from these red sandstone formations, remnants
of 150-million-year-old Jurassic sand dunes.
Photo by Jim K. Decker, Las Vegas Review-Journal

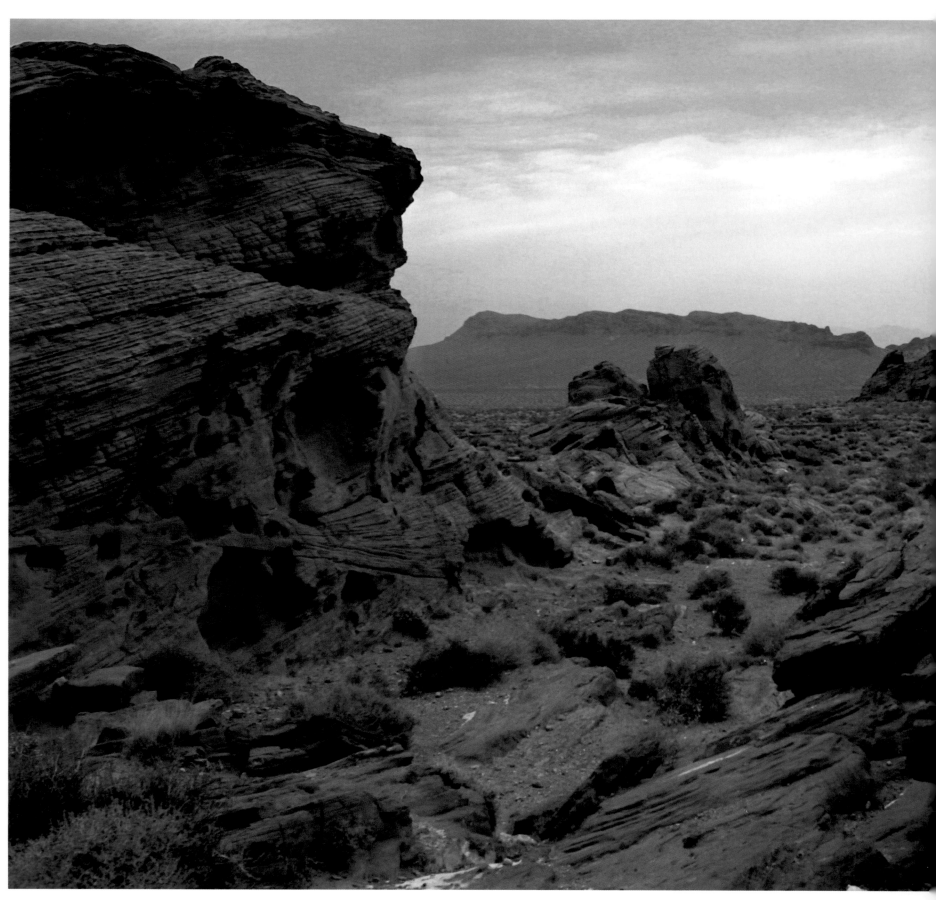

ELKO COUNTY
Lamoille Canyon Road winds through the Ruby Mountains, whose 6,000 to 11,000-foot peaks are known as the "Alps of Nevada."
Photo by Jim Laurie, Stephens Press

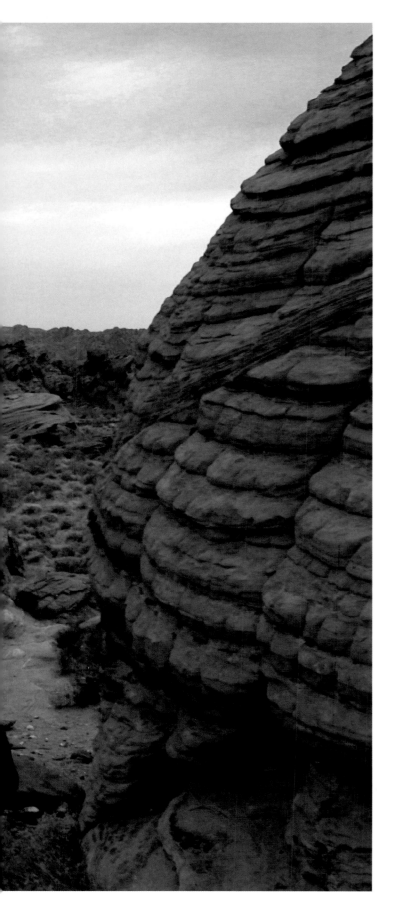

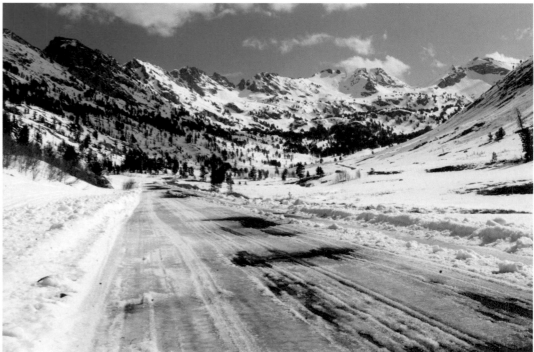

PYRAMID LAKE PAIUTE RESERVATION

Tyler Sumpter feels the heat during a powwow dance competition. The sympathetic observer is her 1-year-old cousin, Michaela King. Both are members of the Pyramid Lake Paiute Nation, which hosts the annual event. The powwow commemorates a 19th-century battle against white settlers.

Photos by Jessica Brandi Lifland

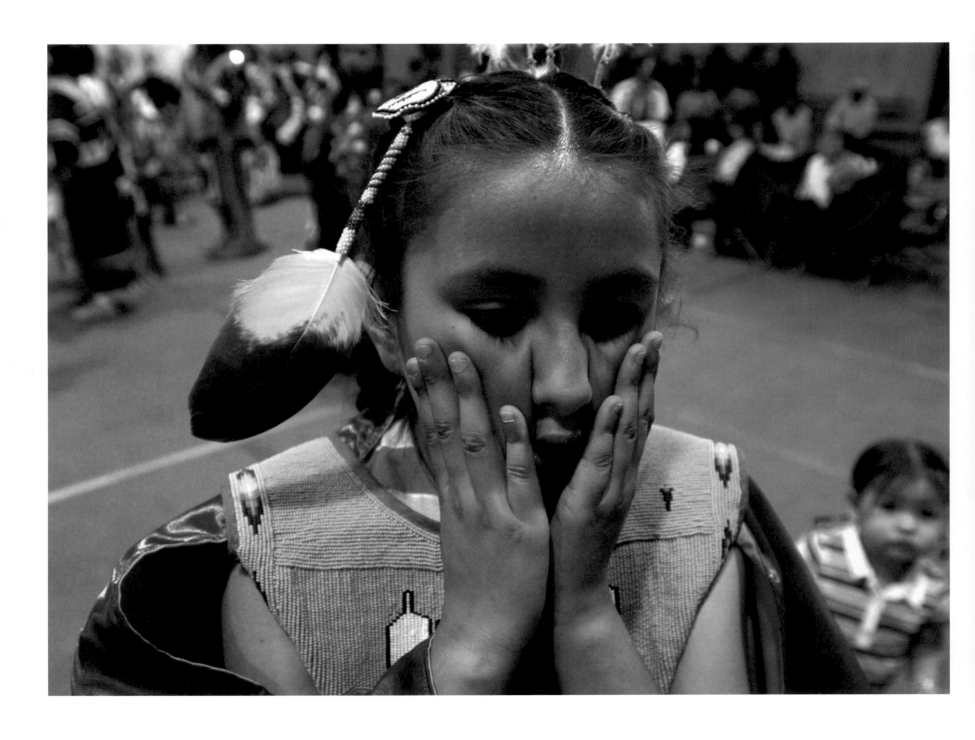

PYRAMID LAKE PAIUTE RESERVATION
Dylan McCabe collars her Head Start classmate as the grads adjust their gowns before the commencement ceremonies.

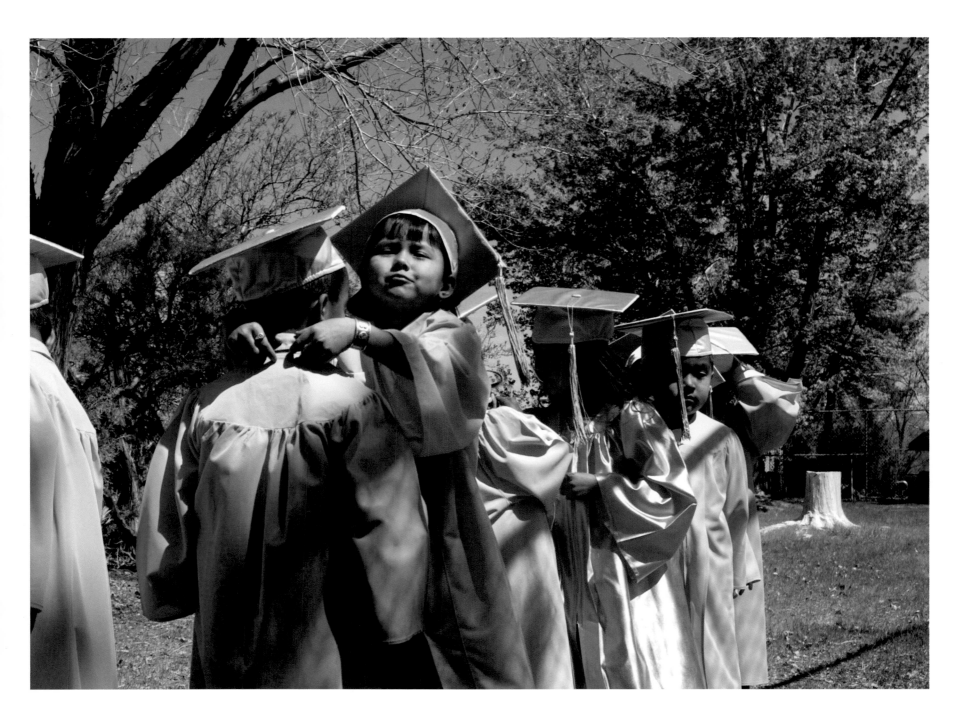

OVERTON

An ongoing drought has lowered Lake Mead's water level by 80 feet, exposing remnants of the town of St. Thomas. One of several colonies founded by Mormons in the area, St. Thomas was settled in 1865 on the Virgin River. The valley was flooded by the Hoover Dam in 1939, just after the 500 residents of St. Thomas moved on.

Photo by Jim K. Decker, Las Vegas Review-Journal

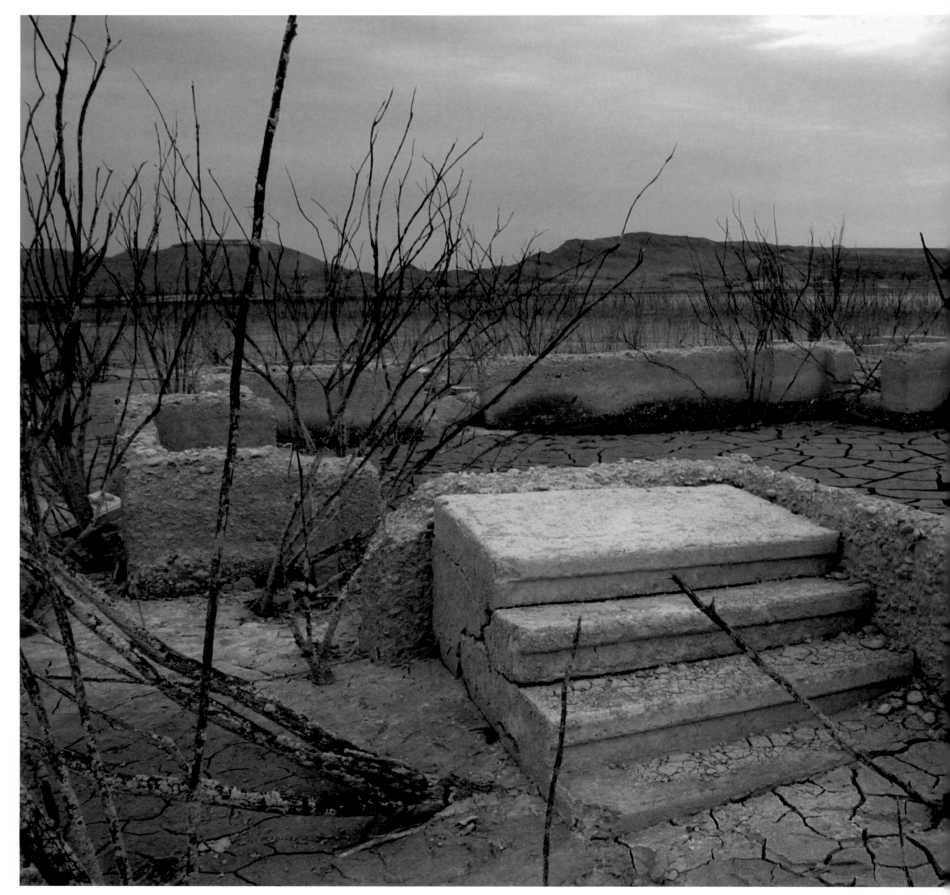

WHITE PINE COUNTY

First a Shoshone village, then a fort, then a stage-coach stop and mail station on the Pony Express route, then a mining town, Schellbourne today isn't much: a few abandoned machines, some foundations and walls, and two cemeteries hidden away on a private ranch.
Photo by Jim Laurie, Stephens Press

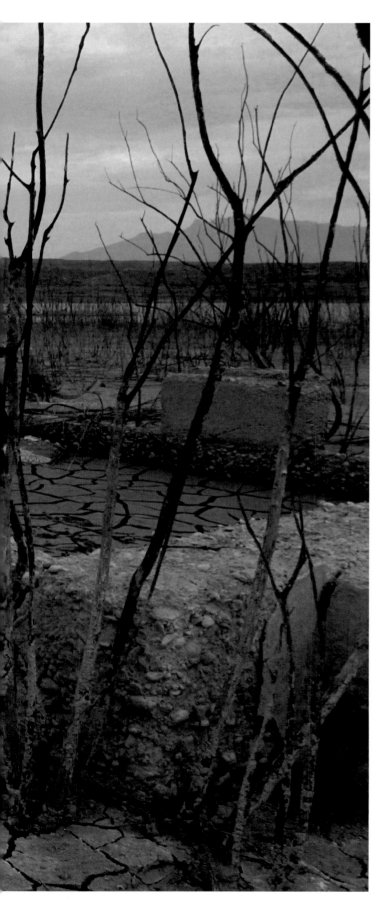

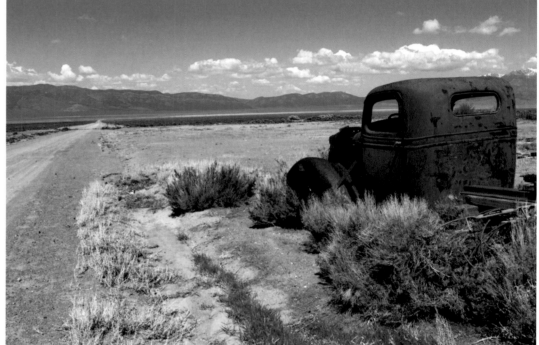

Everybody in the comedy class at the Las Vegas Academy of International Studies, Performing, and Visual Arts has to take a pie in the face. "You can't graduate from a comedy class without getting pied," says teacher Gerry Born, who got the worst of it. Unfortunately for Born, it's not whipped cream, it's soap suds.
Photo by Lindsay Hebberd,
Cultural Portraits Productions, Inc.

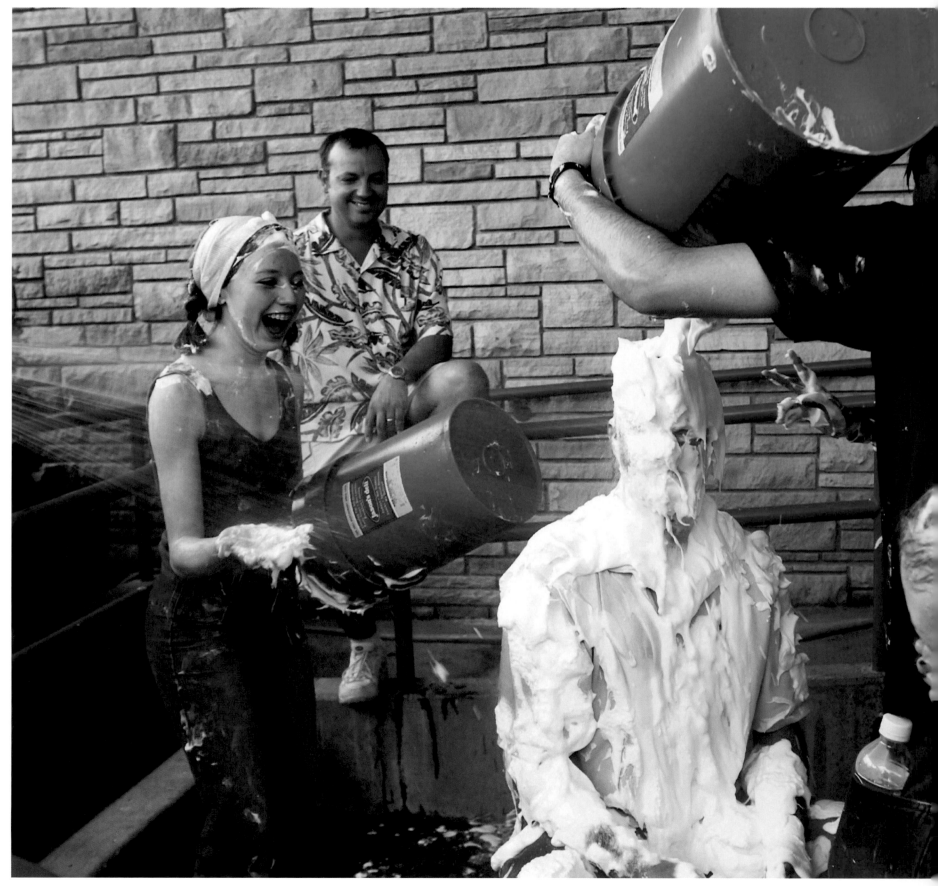

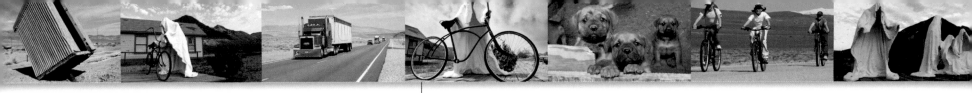

NYE COUNTY
"Conveniently located in the middle of nowhere,"
say promoters of the Goldwell Open Air Museum,
though it's actually on the way to Rhyolite, a ghost
town attraction 115 miles north of Las Vegas. The
museum opened in 1984 under the direction of
Charles Albert Szukalski, a Polish-born sculptor
whose work includes *Ghost Rider.*
Photo by Brian D. Schultz

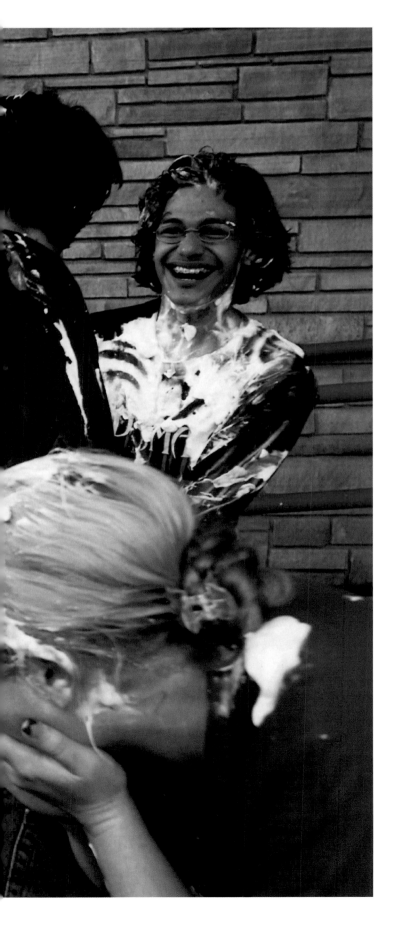

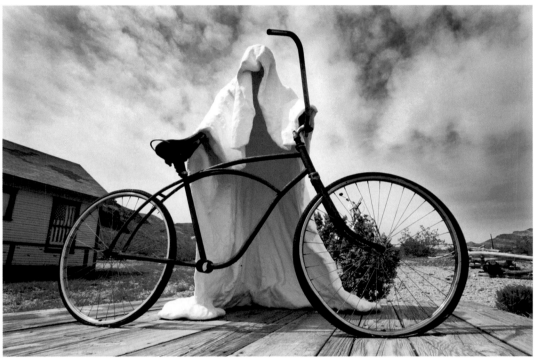

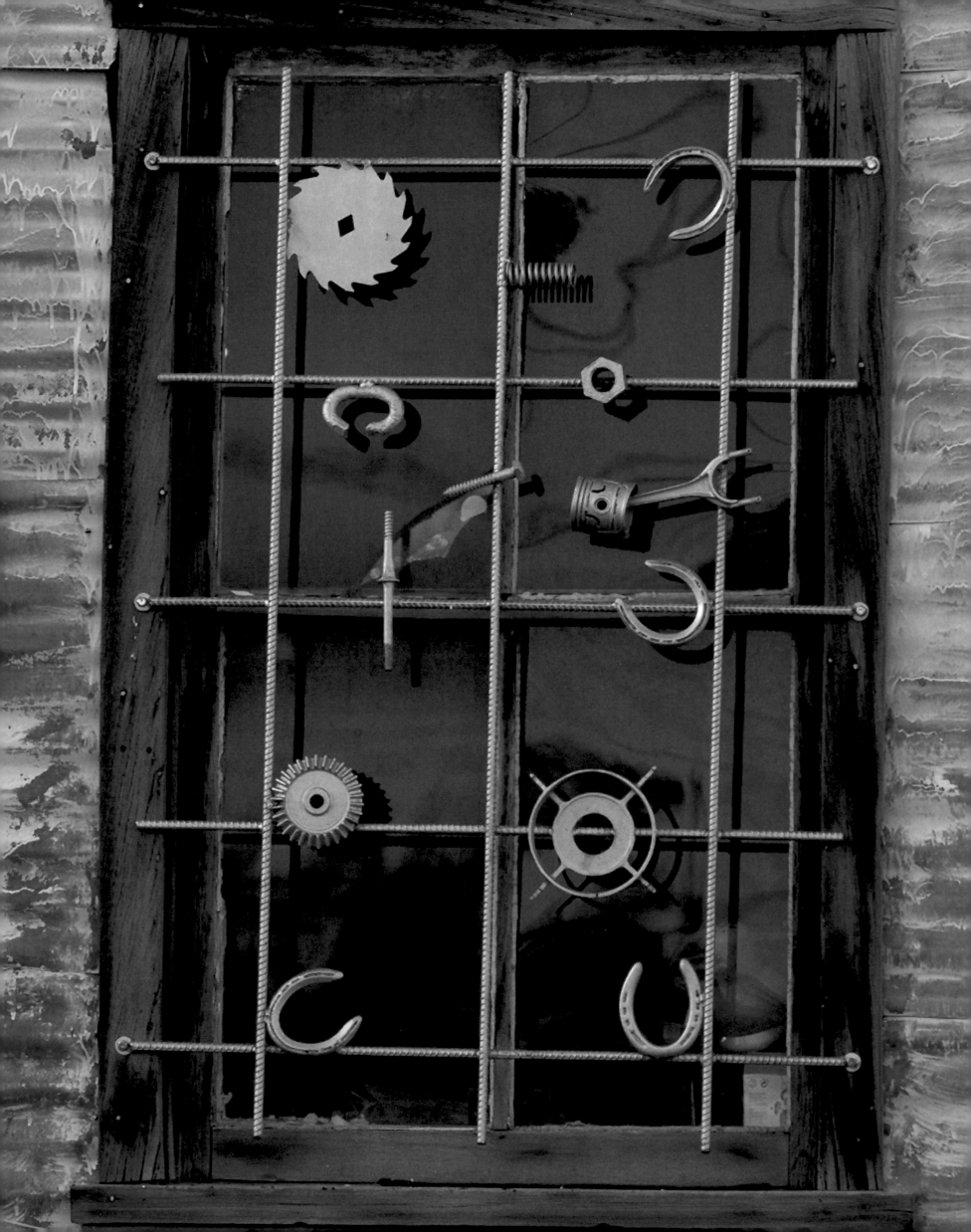

TONOPAH

"I sell the rusty stuff," says Andria Williams of Final Frontier Supply, an antique shop in Tonopah. Built in 1912, the tin-sided former Chevy dealership is on the National Register of Historic Places. Her husband welded bits from their yard onto the window bars. "Out here in the desert," she says, "there's 150 years worth."

Photo by Jim Laurie, Stephens Press

LAS VEGAS

The largest of the yuccas, the Joshua tree grows only in the Mojave Desert. Without the pollination of the female pronuba moth, this stand in the Red Rock Canyon National Conservation Area could not reproduce. Mormon pioneers named the plants, seeing in the branches the upraised arms of the Old Testament prophet Joshua.

Photo by Jim K. Decker, Las Vegas Review-Journal

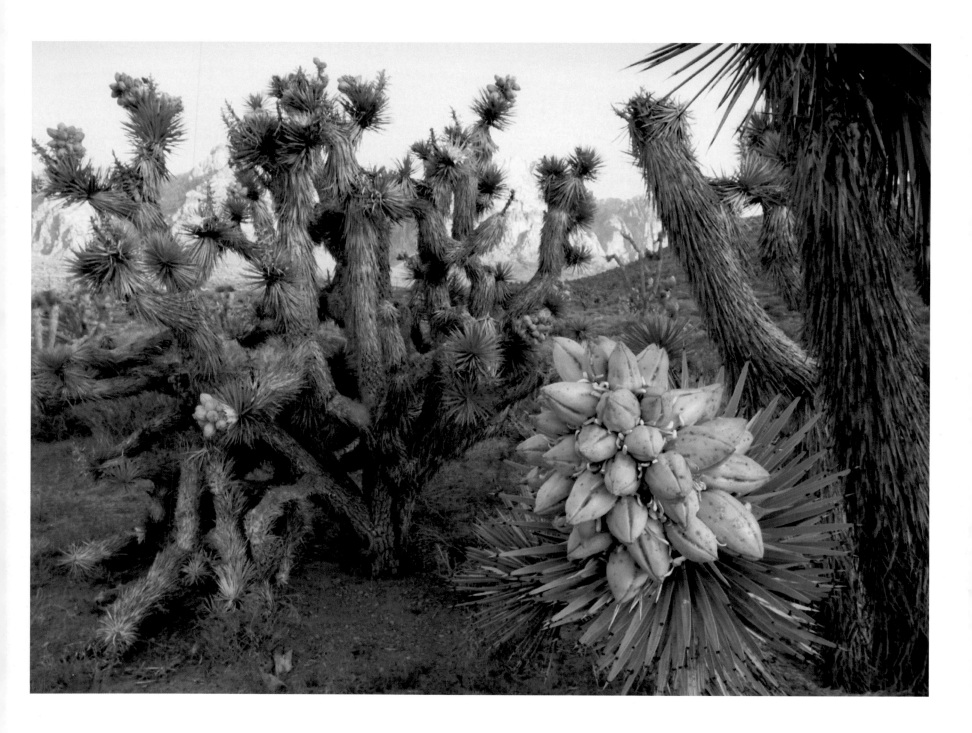

STATELINE

Jump for joy: Kika loves nothing better than to hang out on Lake Tahoe's Nevada Beach. His favorite sport? Catching sand. When someone throws a handful, the Hungarian Vizsla leaps for it, sometimes nearly five feet straight up.
Photo by Eric Jarvis

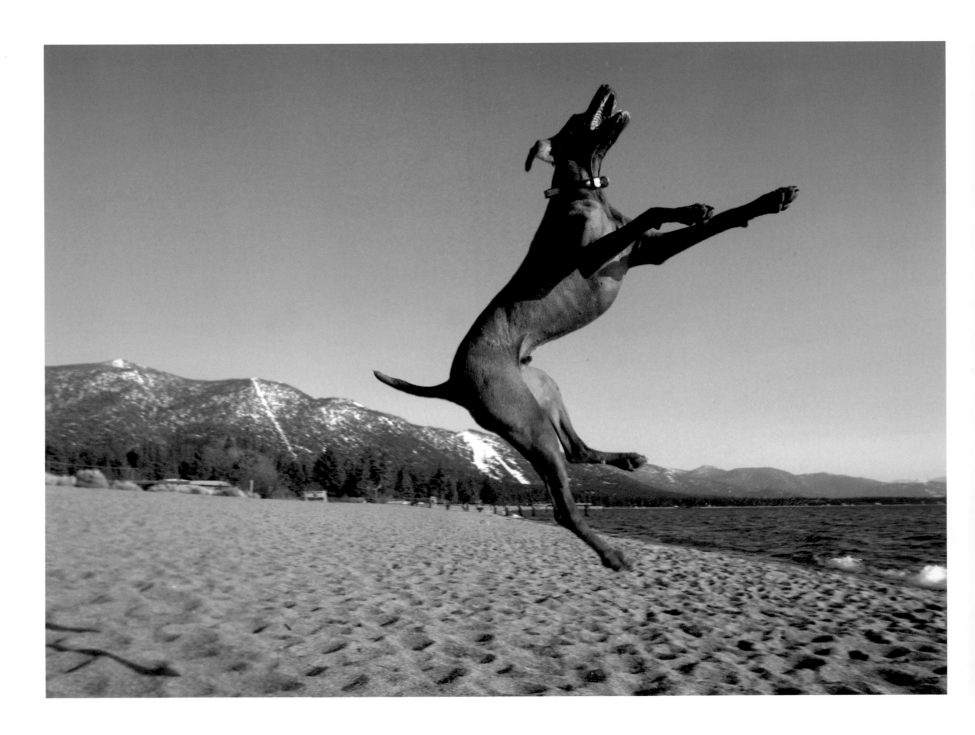

WHITE PINE COUNTY

A mustang stallion defends his herd against a lone intruder near Cold Creek on the edge of the Toiyabe National Forest. Nevada is home to about half of America's wild horses.

Photo by John Gurzinski

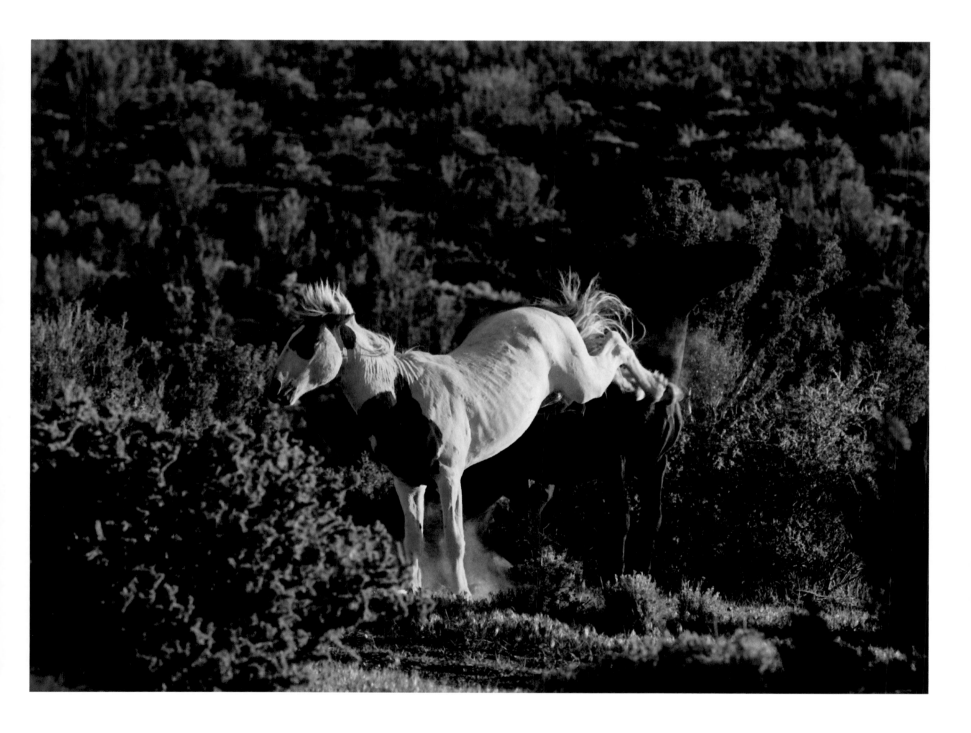

GARDNERVILLE

Two or three afternoons a week, Alice Islander and her husband Dave (next to her) stop by the French Bar, an old saloon in Gardnerville. Over beers, they watch a little television with the bartender. The couple began their let's-go-have-a-drink-and-reconnect routine decades ago, when he was an engineer and she stayed home with the five kids.
Photos by Jessica Brandi Lifland

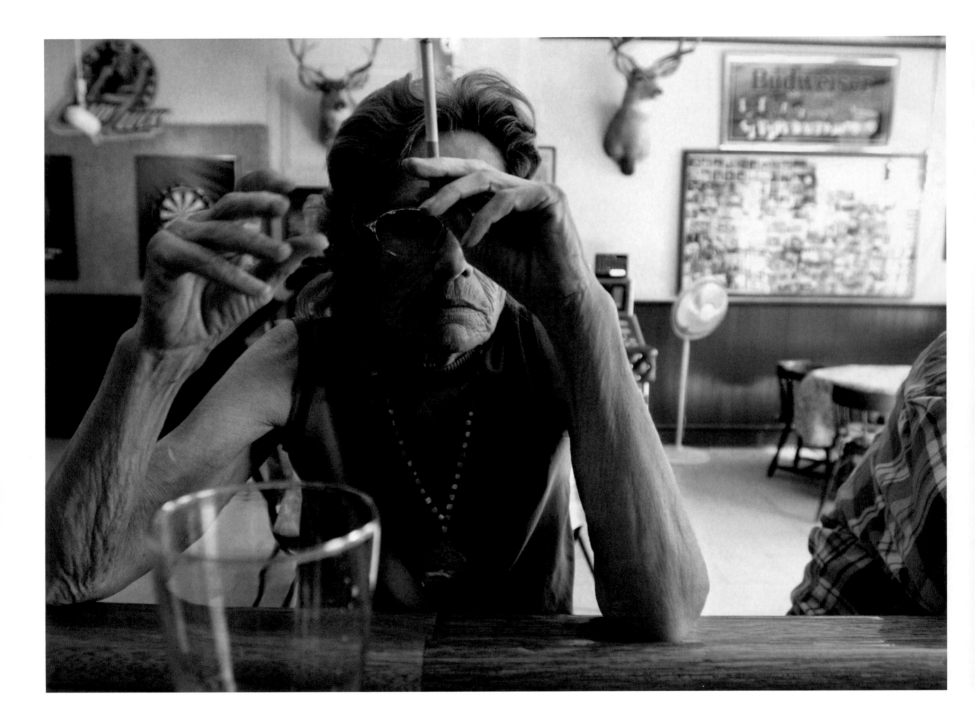

MARIETTA

Like everywhere in Nevada, a winning pair is always welcome. These await customers in Marietta. The discovery of borax in nearby Teel's Marsh led to the town's birth and boom; the local stagecoach gct robbed 30 times in 1880 alone. But a decade later, the borax business moved to Death Valley, and Marietta's decline quickly followed.

Photo by Larry Angier

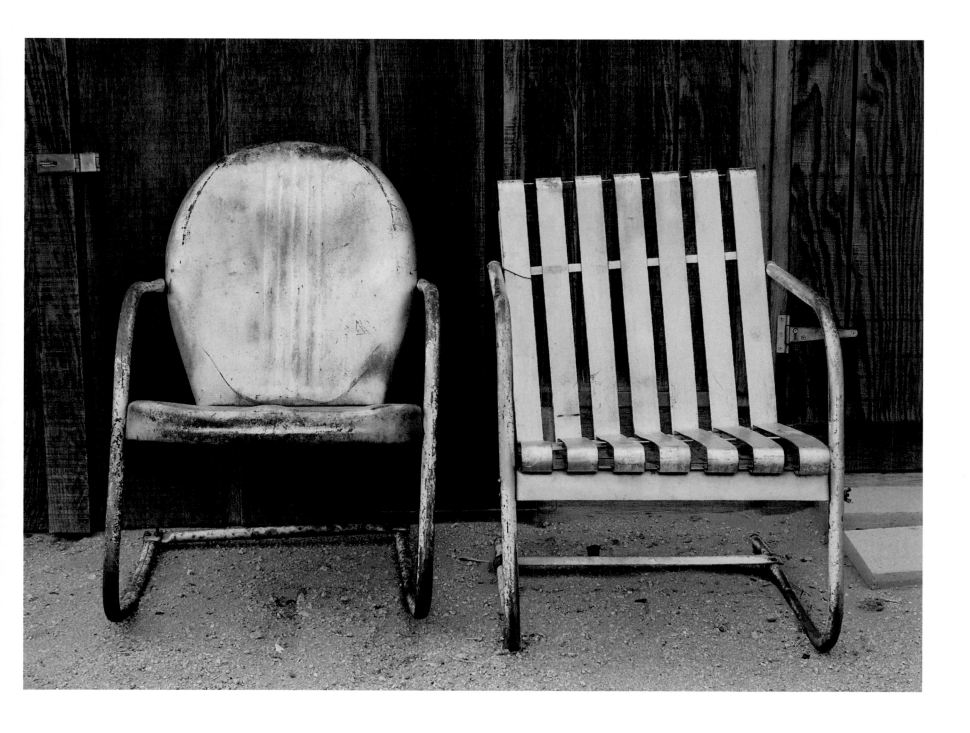

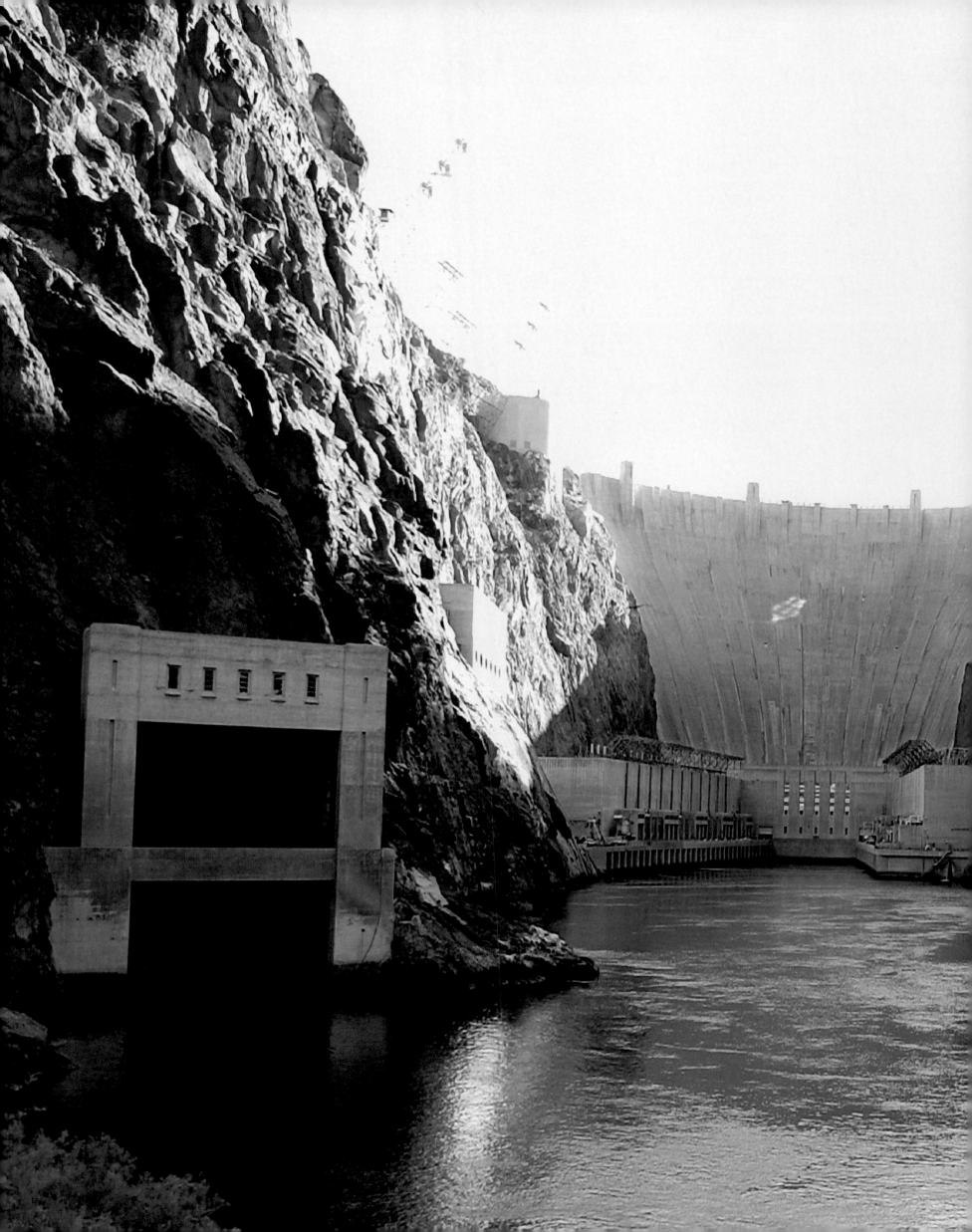

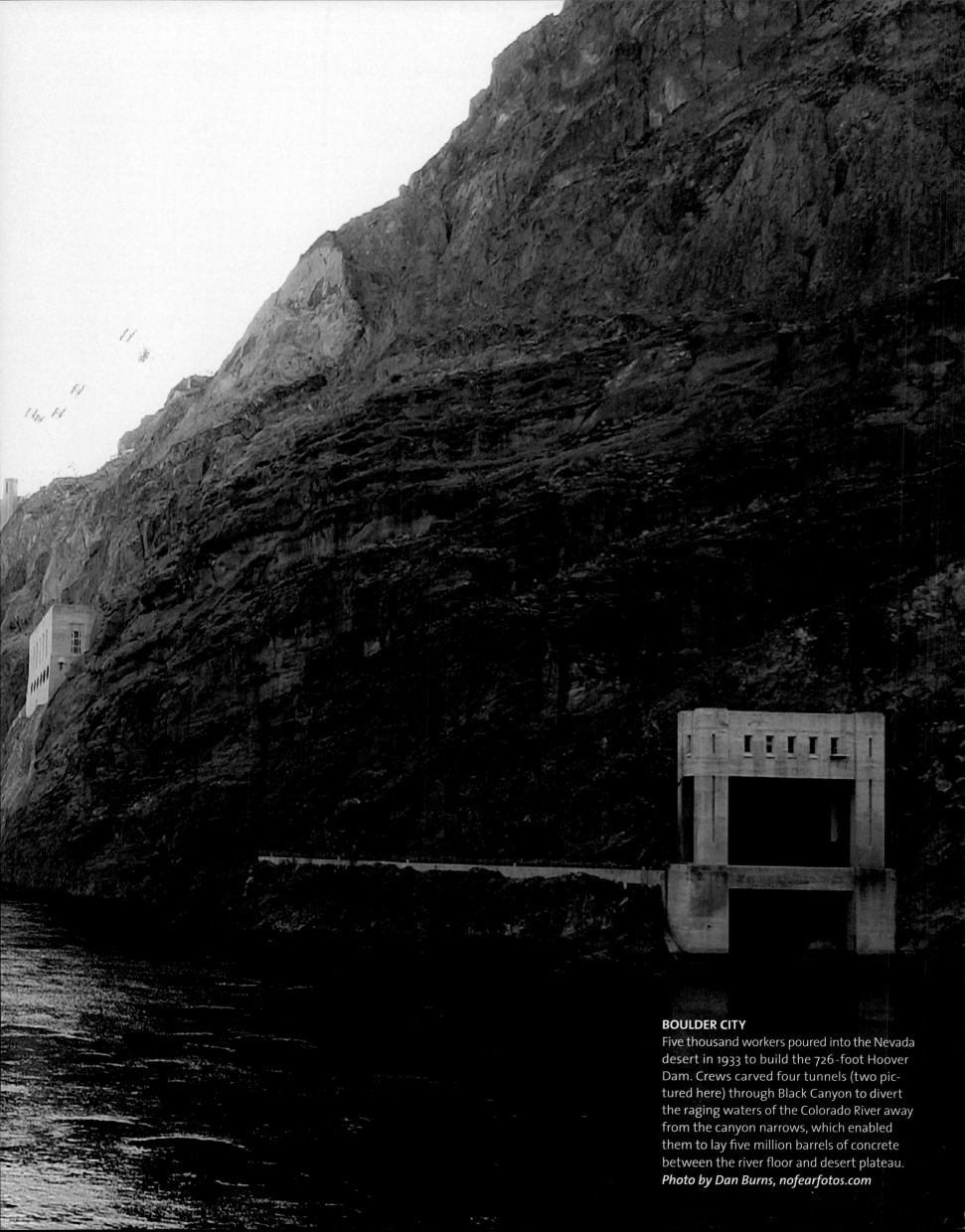

BOULDER CITY

Five thousand workers poured into the Nevada desert in 1933 to build the 726-foot Hoover Dam. Crews carved four tunnels (two pictured here) through Black Canyon to divert the raging waters of the Colorado River away from the canyon narrows, which enabled them to lay five million barrels of concrete between the river floor and desert plateau.
Photo by Dan Burns, nofearfotos.com

Professional boxer Melinda Cooper (left) shelved her gloves and mouth guard for her senior prom held at the Silk Purse Ranch. Some 800 Palo Verde High School students attended the event, so Cooper stuck close to her friend Stacy Pena. After the prom, the girls fueled up at the Cheesecake Factory before heading to a hotel-room party at the Aladdin.
Photo by Amy Beth Bennett

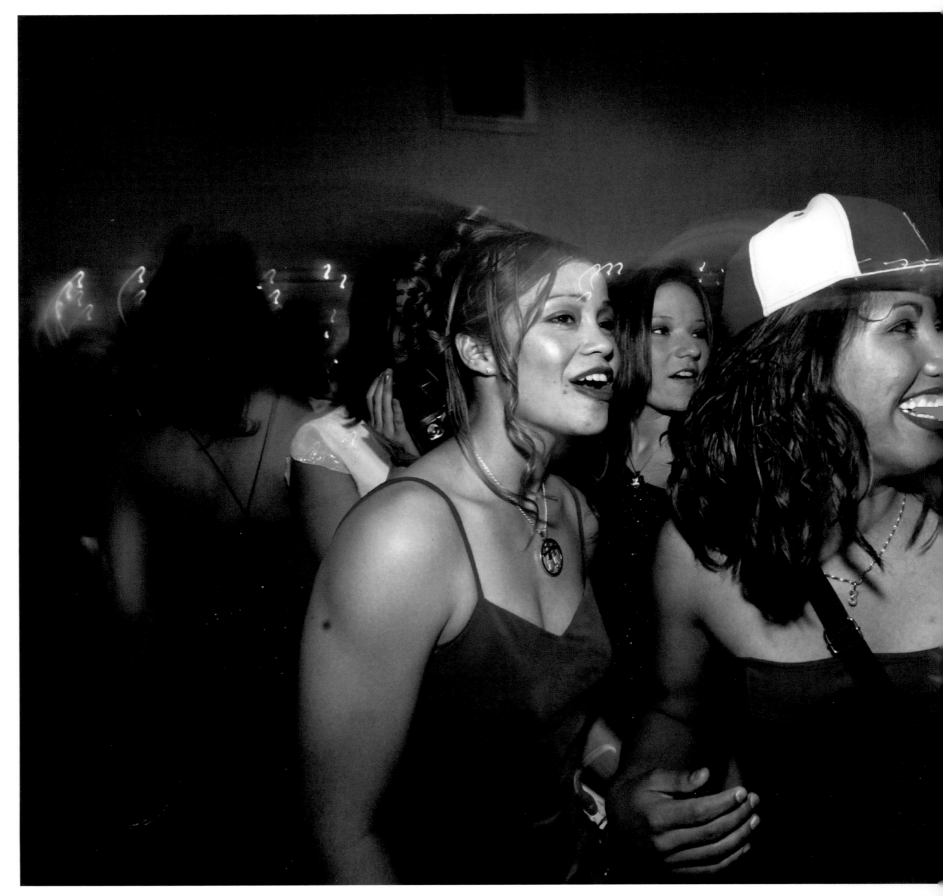

Local resident Lisa Alcott often stops by the Old Genoa Bar to visit, help out, or shoot pool. How good a player is she? She answers that she and her girlfriends usually need about an hour to clear the table.
Photo by Jessica Brandi Lifland

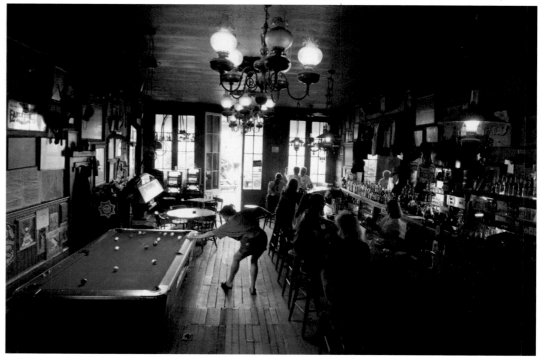

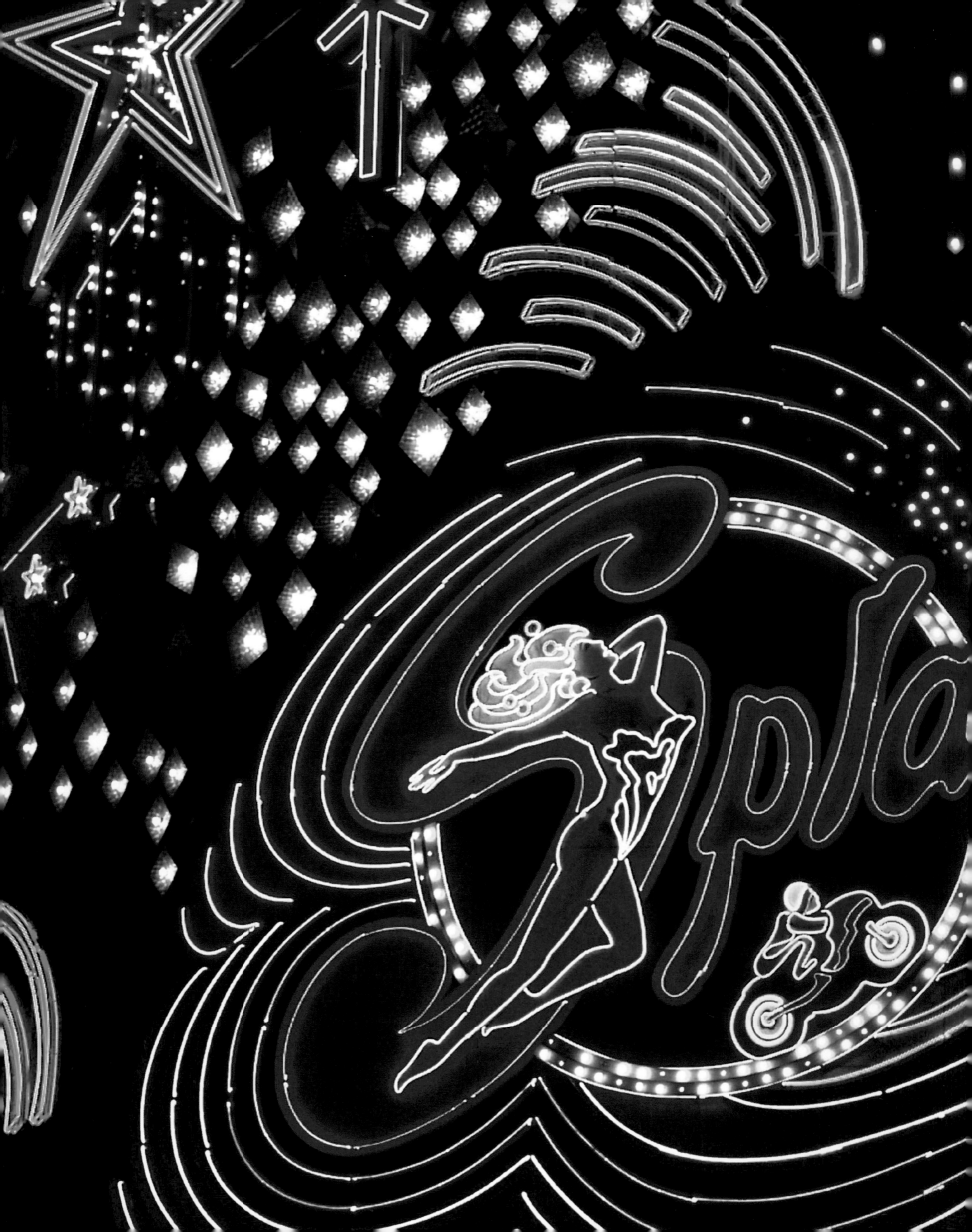

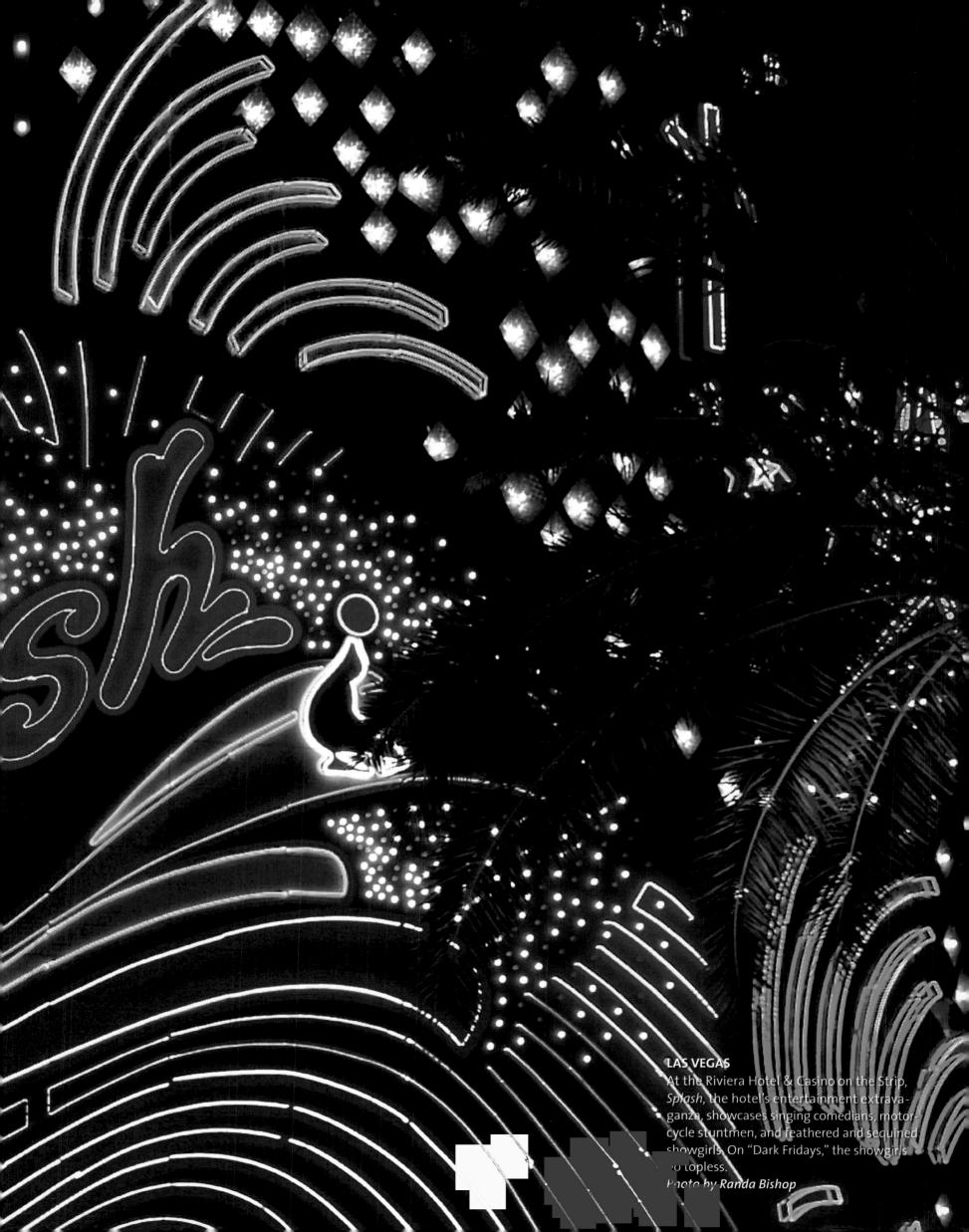

LAS VEGAS
At the Riviera Hotel & Casino on the Strip, *Splash*, the hotel's entertainment extravaganza, showcases singing comedians, motorcycle stuntmen, and feathered and sequined showgirls. On "Dark Fridays," the showgirls go topless.
Photo by *Randa Bishop*

LAS VEGAS

Can't afford the Stardust? Head down to Third Street and the Star Motel. For $48.70 a night, a fraction of the cost of a hotel on the Strip, a visitor will get a room with a view of the Stratosphere Casino Hotel and Tower.

Photos by John Gurzinski

LAS VEGAS

Signs of the times: Neon Graphics lights up a street corner just off the Strip. The shop makes and sells attention-grabbing mini-mart signage, as well as customized light sculptures for home-owners—and anyone else who loves the surreal gas light, indoors or out.

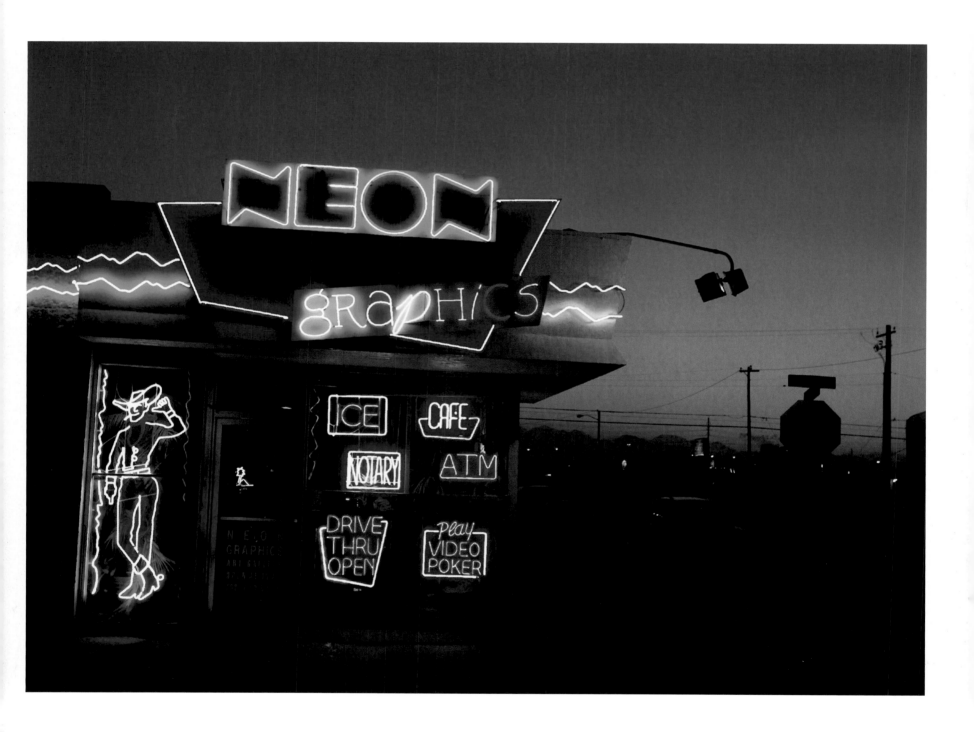

LAS VEGAS

Spectators stand atop a pedestrian overpass to watch the twice-daily Fountains of Bellagio water show at the Bellagio Hotel on the Las Vegas Strip. Traffic often comes to a standstill as rubberneckers slow to catch a glimpse of the dancing waters.
Photo by John Gurzinski

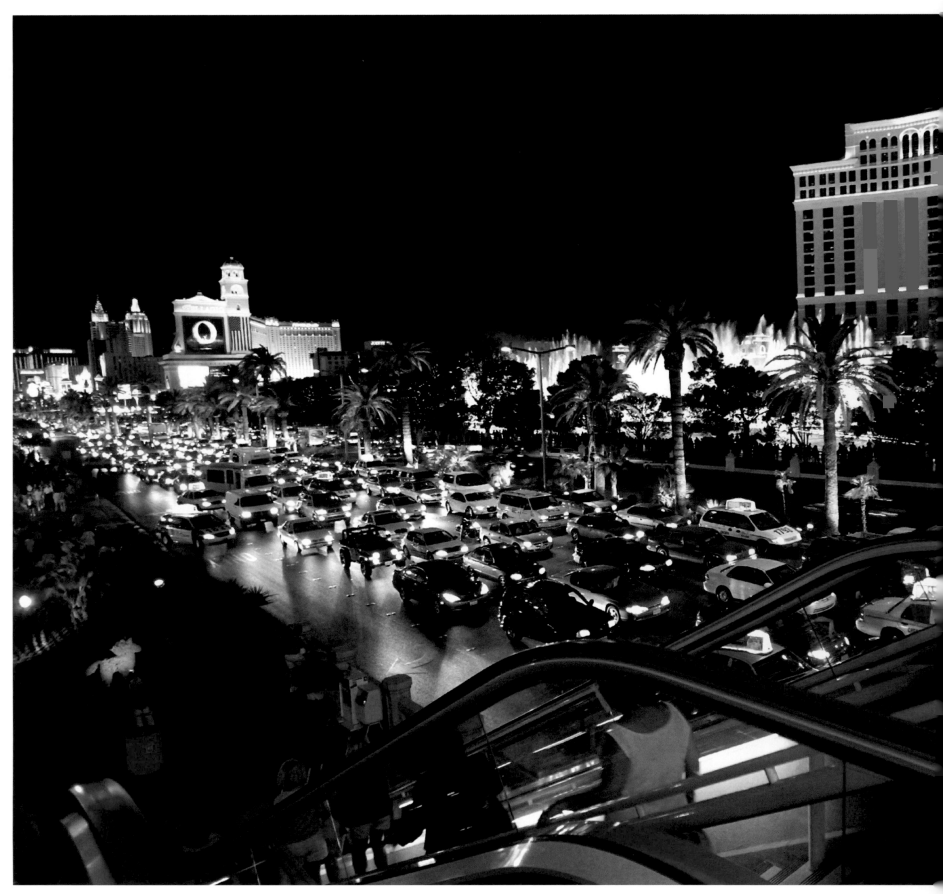

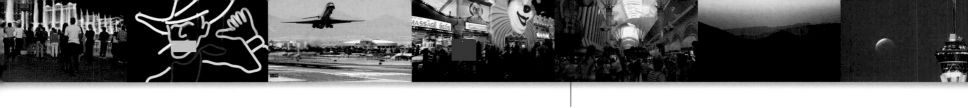

LAS VEGAS
After dusk, more than two million lights draw promenading visitors to the downtown Fremont Street Experience. The free music and light show cost the city and private backers $70 million to build.
Photo by Randa Bishop

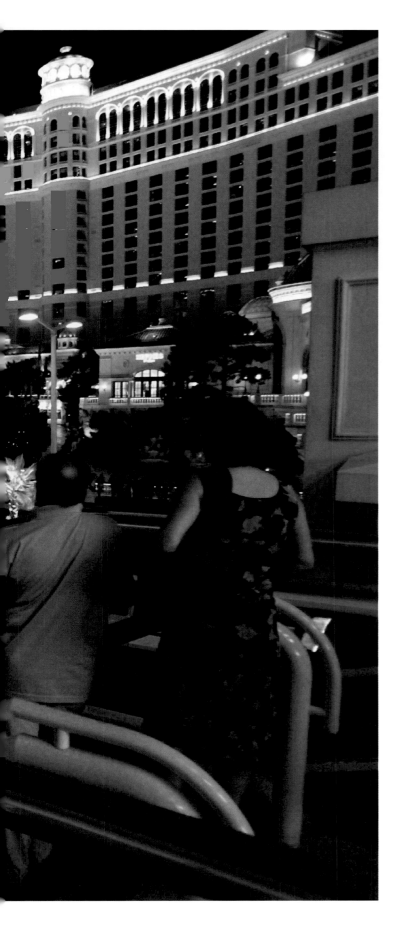

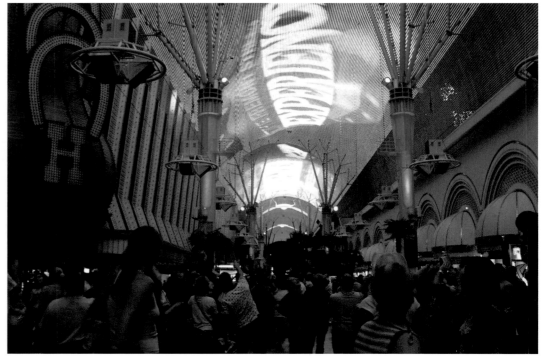

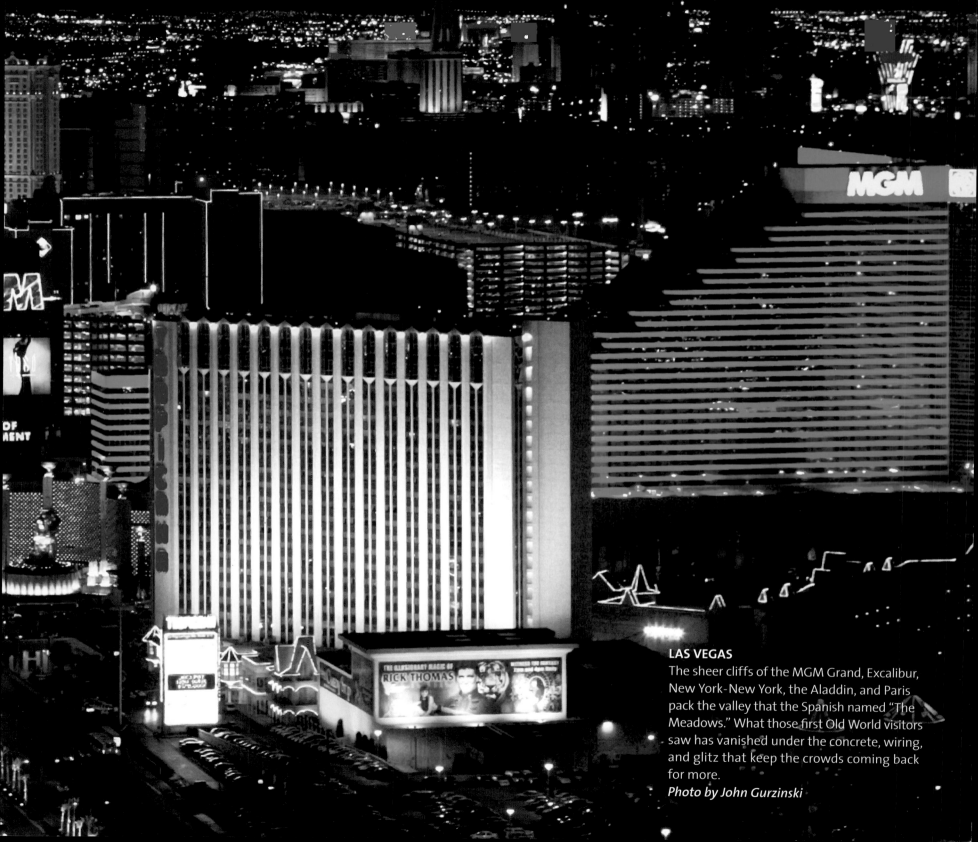

LAS VEGAS
The sheer cliffs of the MGM Grand, Excalibur, New York-New York, the Aladdin, and Paris pack the valley that the Spanish named "The Meadows." What those first Old World visitors saw has vanished under the concrete, wiring, and glitz that keep the crowds coming back for more.
Photo by John Gurzinski

How It Worked

The week of May 12-18, 2003, more than 25,000 professional and amateur photographers spread out across the nation to shoot over a million digital photographs with the goal of capturing the essence of daily life in America.

The professional photographers were equipped with Adobe Photoshop and Adobe Album software, Olympus C-5050 digital cameras, and Lexar Media's high-speed compact flash cards.

The 1,000 professional contract photographers plus another 5,000 stringers and students sent their images via FTP (file transfer protocol) directly to the *America 24/7* website. Meanwhile, thousands of amateur photographers uploaded their images to Snapfish's servers.

At *America 24/7*'s Mission Control headquarters, located at CNET in San Francisco, dozens of picture editors from the nation's most prestigious publications culled the images down to 25,000 of the very best, using Photo Mechanic by Camera Bits. These photos were transferred into Webware's ActiveMedia Digital Asset Management (DAM) system, which served as a central image library and enabled the designers to track, search, distribute, and reformat the images for the creation of the 51 books, foreign language editions, web and magazine syndication, posters, and exhibitions.

Once in the DAM, images were optimized (and in some cases resampled to increase image resolution) using Adobe Photoshop. Adobe InDesign and Adobe InCopy were used to design and produce the 51 books, which were edited and reviewed in multiple locations around the world in the form of Adobe Acrobat PDFs. Epson Stylus printers were used for photo proofing and to produce large-format images for exhibitions. The companies providing support for the *America 24/7* project offer many of the essential components for anyone building a digital darkroom. We encourage you to read more on the following pages about their respective roles in making *America 24/7* possible.

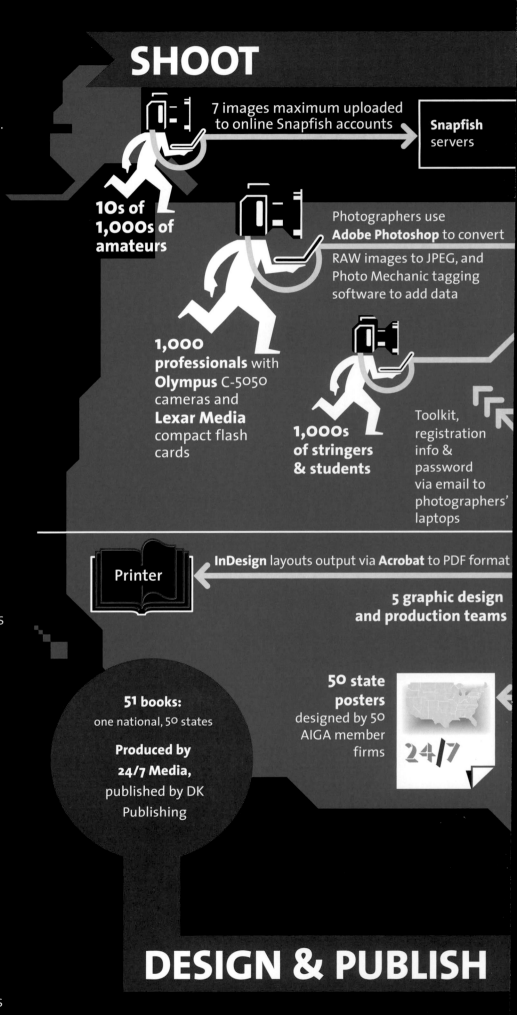

SHOOT

7 images maximum uploaded to online Snapfish accounts → **Snapfish** servers

10s of 1,000s of amateurs

Photographers use **Adobe Photoshop** to convert RAW images to JPEG, and Photo Mechanic tagging software to add data

1,000 professionals with **Olympus** C-5050 cameras and **Lexar Media** compact flash cards

1,000s of stringers & students

Toolkit, registration info & password via email to photographers' laptops

InDesign layouts output via **Acrobat** to PDF format

Printer

5 graphic design and production teams

51 books: one national, 50 states

Produced by 24/7 Media, published by DK Publishing

50 state posters designed by 50 AIGA member firms

24/7

DESIGN & PUBLISH

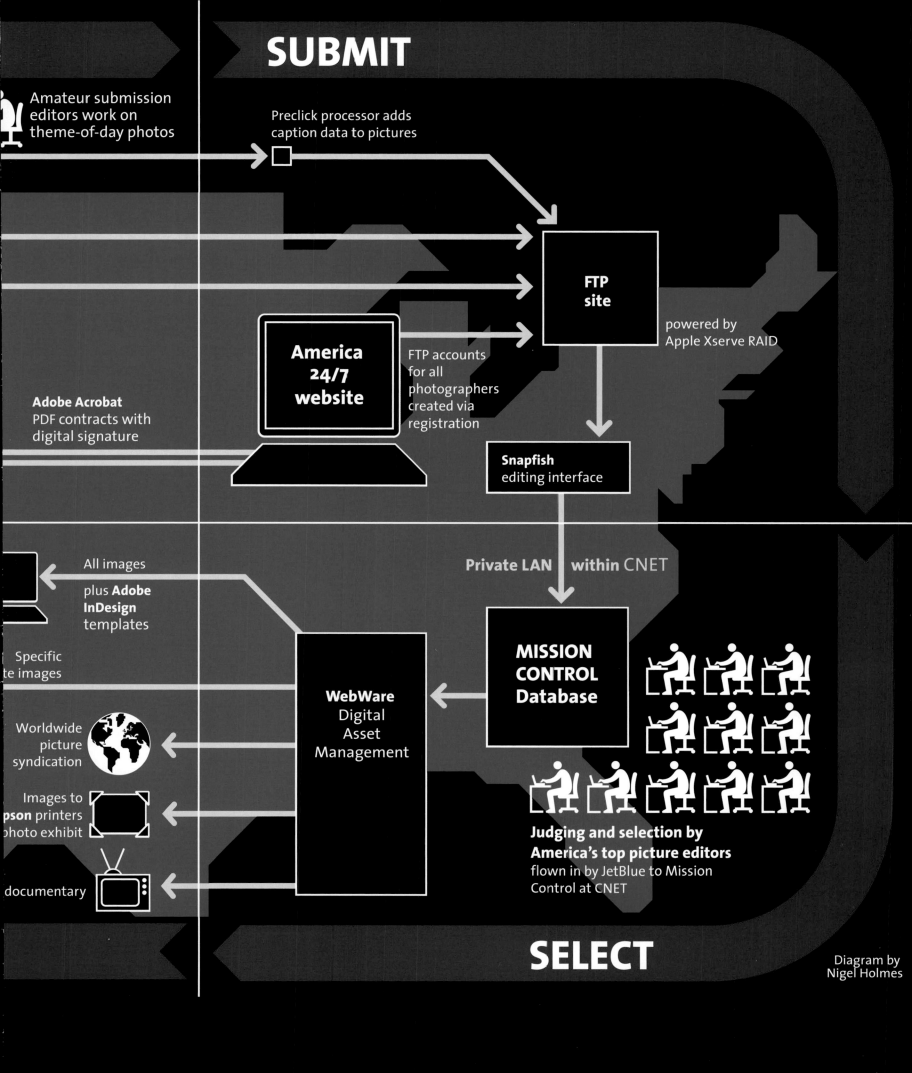

SUBMIT

Amateur submission editors work on theme-of-day photos

Preclick processor adds caption data to pictures

FTP site

powered by Apple Xserve RAID

America 24/7 website

FTP accounts for all photographers created via registration

Adobe Acrobat PDF contracts with digital signature

Snapfish editing interface

All images

plus **Adobe InDesign** templates

Private LAN within CNET

Specific te images

WebWare Digital Asset Management

MISSION CONTROL Database

Worldwide picture syndication

Images to pson printers photo exhibit

Judging and selection by America's top picture editors flown in by JetBlue to Mission Control at CNET

documentary

SELECT

Diagram by Nigel Holmes

Nevada 24/7

About Our Sponsors

America 24/7 gave digital photographers of all levels the opportunity to share their visions of what it means to live in the United States. This project was made possible by a digital photography revolution that is dramatically changing and improving picture-taking for professionals and amateurs alike. And an Adobe product, Photoshop®, has been at the center of this sea change.

Adobe's products reflect our customers' passion for the creative process, be it the photographer, graphic designer, layout artist, or printer. Adobe is the Publishing and Imaging Software Partner for *America 24/7* and products such as Adobe InDesign®, Photoshop, Acrobat®, and Illustrator® were used to produce this stunning book in a matter of weeks. We hope that our software has helped do justice to the mythic images, contributed by well-known photographers and the inspired hobbyist.

Adobe is proud to be a lead sponsor of *America 24/7*, a project that celebrates the vibrancy of the American spirit: the same spirit that helped found Adobe and inspires our employees and customers to deliver the very best.

Bruce Chizen
President and CEO
Adobe Systems Incorporated

Olympus, a global technology leader in designing precision healthcare solutions and innovative consumer electronics, is proud to be the official digital camera sponsor of *America 24/7*. The opportunity to introduce Americans from coast to coast to the thrill, excitement, and possibility of digital photography makes the vision behind this book a perfect fit for Olympus, a leader in digital cameras since 1996.

For most people, the essence of digital photography is best grasped through firsthand experience with the technology, which is precisely what *America 24/7* is about. We understand that direct experience is the pathway to inspiration, and welcome opportunities like this sponsorship to bring the power of the digital experience into the lives of people everywhere. To Olympus, *America 24/7* offers a platform to help realize a core mission: to deliver and make accessible the power of the digital experience to millions of American photographers, amateurs, and professionals alike.

The 1,000 professional photographers contracted to shoot on the America 24/7 project were all equipped with Olympus C-5050 digital cameras. Like all Olympus products, the C-5050 is offered by a company well known for designing, manufacturing, and servicing products used by professionals to perform their work, every day. Olympus is a customer-centric company committed to working one-to-one with a diverse group of professionals. From biomedical researchers who use our clinical microscopes, to doctors who perform life-saving procedures with our endoscopes, to professional photographers who use cameras in their daily work, Olympus is a trusted brand.

The digital imaging technology involved with *America 24/7* has enabled the soul of America to be visually conveyed, not just by professional observers, but by the American public who participated in this project—the very people who collectively breath life into this country's existence each day.

We are proud to be enabling so many photographers to capture the pictures on these pages that tell the story of who we are as a nation. From sea to shining sea, digital imagery allows us to connect to one another in ways we never dreamed possible.

At Olympus, our ideas have proliferated as rapidly as technology has evolved. We have channeled these visions into breakthrough products and solutions to meet the demands of our changing world-products like microscopes, endoscopes, and digital voice recorders, supported by the highly regarded training, educational, and consulting services we offer our customers.

Today, 83 years after we introduced our first microscope, we remain as young, as curious, and as committed as ever.

Lexar Media has grown from the digital photography revolution, which is why we are proud to have supplied the digital memory cards used in the America 24/7 project. Lexar Media's high-performance memory cards utilize our unique and patented controller coupled with high-speed flash memory from Samsung, the world's largest flash memory supplier. This powerful combination brings out the ultimate performance of any digital camera.

Photographers who demand the most from their equipment choose our products for their advanced features like write speeds up to 40X, Write Acceleration technology for enabled cameras, and Image Rescue, which recovers previously deleted or lost images. Leading camera manufacturers bundle Lexar Media digital memory cards with their cameras because they value its performance and reliability.

Lexar Media is at the forefront of digital photography as it transforms picture-taking worldwide, and we will continue to be a leader with new and innovative solutions for professionals and amateurs alike.

Snapfish, which developed the technology behind the *America 24/7* amateur photo event, is a leading online photo service, with more than 5 million members and 100 million photos posted online. Snapfish enables both film and digital camera owners to share, print, and store their most important photo memories, at prices that cannot be equaled. Digital camera users upload photos into a password-protected online album for free. Users can also order film-quality prints on professional photographic paper for as low as 25¢. Film camera users get a full set of prints, plus online sharing and storage, for just $2.99 per roll.

Founded in 1995, eBay created a powerful platform for the sale of goods and services by a passionate community of individuals and businesses. On any given day, there are millions of items across thousands of categories for sale on eBay. eBay enables trade on a local, national and international basis with customized sites in markets around the world.

Through an array of services, such as its payment solution provider PayPal, eBay is enabling global e-commerce for an ever-growing online community.

JetBlue Airways is proud to be *America 24/7's* preferred carrier, flying photographers, photo editors, and organizers across the United States.

Winner of Condé Nast Traveler's Readers' Choice Awards for Best Domestic Airline 2002, JetBlue provides friendly service and low fares for travelers in 22 cities in nine states across America.

On behalf of JetBlue's 5,000 crew members, we're excited to be involved in this remarkable project, and for the opportunity to serve American travelers each and every day, coast to coast, 24/7.

DIGITAL POND

Digital Pond has been a leading creator of large graphic displays for museums, corporations, trade shows, retail environments and fine art since 1992.

We were proud to bring together our creative, print and display capabilities to produce signage and displays for mission control, critical retouching for numerous key images for the book, and art galleries for the New York Public Library and Bryant Park.

The Pond's team and SplashPic® Online service enabled us to nimbly design, produce and install over 200 large graphic panels in two NYC locations within the truly "24/7" production schedule of less than ten days.

WebWare Corporation is pleased to be a major sponsor of the America 24/7 project. We take pride in being part of a groundbreaking adventure that is stretching the boundaries—and the imagination—in digital photography, digital asset management, publishing, news, and global events.

Our ActiveMedia Enterprise™ digital asset management software is the "nerve center" of *America 24/7*, the central repository for managing, sharing, and collaborating on the project's photographs. From photo editors and book publishers to 24/7's media relations and marketing personnel, ActiveMedia provides the application support that links all facets of the project team to the content worldwide.

WebWare helps Global 2000 firms securely manage, reuse, and distribute media assets locally or globally. Its suite of ActiveMedia software products provide powerful media services platforms for integrating rich media into content management systems marketing and communication portals; web publishing systems; and e-commerce portals.

Google's mission is to organize the world's information and make it universally accessible and useful.

With our focus on plucking just the right answer from an ocean of data, we were naturally drawn to the America 24/7 project. The book you hold is a compendium of images of American life distilled from thousands of photographs and infinite possibilities. Are you looking for emotion? Narrative? Shadows? Light? It's all here, thanks to a multitude of photographers and writers creating links between you, the reader, and a sea of wonderful stories. We celebrate the connections that constitute the human experience and are pleased to help engender them. And we're pleased to have been a small part of this project, which captures the results of that interaction so vividly, so dynamically, and so dramatically.

Special thanks to additional contributors: FileMaker, Apple, Camera Bits, LaCie, Now Software, Preclick, Outpost Digital, Xerox, Microsoft, WoodWing Software, net-linx Publishing Solutions, and Radical Media. The Savoy Hotel, San Francisco; The Pan Pacific, San Francisco; Four Seasons Hotel, San Francisco; and The Queen Anne Hotel. Photography editing facilities were generously hosted by CNET Networks, Inc.

Participating Photographers

Coordinator: Jim Laurie, Director of Photography, Stephens Press

Lin Alder, alderphoto.com
Larry Angier
Amy Beth Bennett
Randa Bishop
Diane Boisselle
Joy Bridgeman
Dan Burns, nofearfotos.com
Joe Cavaretta
Jim K. Decker, *Las Vegas Review-Journal*
Jean Dixon
Misha Erwitt
John Gurzinski
Naomi Harris
Lindsay Hebberd,
Cultural Portraits Productions, Inc.
Lynn Hrnciar

Adriene Hughes
Karen Jaggi, JaggiDesign.com
Eric Jarvis
William Kositzky
Jim Laurie, Stephens Press
Jessica Brandi Lifland
John Locher
Lynn Mahannah
Sam Morris
Marilyn Newton, *Reno Gazette-Journal*
Scott Sady, *Reno Gazette-Journal*
Brian D. Schultz
Scott T. Smith
Gregg Stokes
Ian Weiss
Day Williams

Thumbnail Picture Credits

Credits for thumbnail photographs are listed by the page number and are in order from left to right.

20 Karen Jaggi, JaggiDesign.com
Karen Jaggi, JaggiDesign.com
Karen Jaggi, JaggiDesign.com
Karen Jaggi, JaggiDesign.com
Day Williams
Karen Jaggi, JaggiDesign.com
Karen Jaggi, JaggiDesign.com

21 Scott Sady, *Reno Gazette-Journal*
Karen Jaggi, JaggiDesign.com
Larry Angier
Lindsay Hebberd,
Cultural Portraits Productions, Inc.
Karen Jaggi, JaggiDesign.com
Lindsay Hebberd,
Cultural Portraits Productions, Inc.
Karen Jaggi, JaggiDesign.com

24 Jessica Brandi Lifland
Jessica Brandi Lifland
Jessica Brandi Lifland
Jessica Brandi Lifland
Jessica Brandi Lifland
Jessica Brandi Lifland
Jessica Brandi Lifland

25 Jessica Brandi Lifland
Jessica Brandi Lifland
Jessica Brandi Lifland
Jessica Brandi Lifland
Karen Jaggi, JaggiDesign.com
Jessica Brandi Lifland
Jessica Brandi Lifland

26 Larry Angier
Larry Angier
Lin Alder, alderphoto.com
Larry Angier
Larry Angier
Lin Alder, alderphoto.com
Larry Angier

27 Larry Angier
Larry Angier
Larry Angier
Shannon Litz, *The Record-Courier*
Lin Alder, alderphoto.com
Scott T. Smith
Larry Angier

28 Jessica Brandi Lifland
Jessica Brandi Lifland
Jessica Brandi Lifland

Jessica Brandi Lifland
Jessica Brandi Lifland
Jessica Brandi Lifland
Jessica Brandi Lifland

29 Jim K. Decker, *Las Vegas Review-Journal*
Jim K. Decker, *Las Vegas Review-Journal*
Scott T. Smith
Jessica Brandi Lifland
Jessica Brandi Lifland
Jessica Brandi Lifland
Jessica Brandi Lifland

30 Eric Jarvis
Naomi Harris
Jessica Brandi Lifland
Jessica Brandi Lifland
John Gurzinski
Marilyn Newton, *Reno Gazette-Journal*
John Gurzinski

31 Shannon Litz, *The Record-Courier*
Lindsay Hebberd,
Cultural Portraits Productions, Inc.
Eric Jarvis
Shelly Castellano, SCPIX.com
Jessica Brandi Lifland
Lindsay Hebberd,
Cultural Portraits Productions, Inc.
Shannon Litz, *The Record-Courier*

40 Shannon Litz, *The Record-Courier*
Jean Dixon
Lin Alder, alderphoto.com
Shannon Litz, *The Record-Courier*
Jean Dixon
Shannon Litz, *The Record-Courier*
Scott T. Smith

41 Shannon Litz, *The Record-Courier*
Scott T. Smith
Lin Alder, alderphoto.com
Scott T. Smith
Scott T. Smith
Scott T. Smith
Scott T. Smith

42 Amy Beth Bennett
Amy Beth Bennett
Amy Beth Bennett
Amy Beth Bennett

Amy Beth Bennett
Scott T. Smith
Amy Beth Bennett

43 Amy Beth Bennett
Amy Beth Bennett
Amy Beth Bennett
Amy Beth Bennett
Amy Beth Bennett
Scott T. Smith
Amy Beth Bennett

46 Kim Komenich
Darius Kuzmickas
Day Williams
Day Williams
Larry Angier
Marilyn Newton, *Reno Gazette-Journal*
Scott T. Smith

47 Lindsay Hebberd,
Cultural Portraits Productions, Inc.
Larry Angier
Marilyn Newton, *Reno Gazette-Journal*
Larry Angier
Marilyn Newton, *Reno Gazette-Journal*
Scott T. Smith
Lindsay Hebberd,
Cultural Portraits Productions, Inc.

50 John Locher
John Locher
Misha Erwitt
John Locher
John Locher
John Locher
John Locher

52 John Gurzinski
Naomi Harris
Larry Angier
Larry Angier
Scott T. Smith
Scott Sady, *Reno Gazette-Journal*
Naomi Harris

53 Scott T. Smith
Larry Angier
Scott Sady, *Reno Gazette-Journal*
Larry Angier
Naomi Harris
Scott Sady, *Reno Gazette-Journal*
Lindsay Hebberd,
Cultural Portraits Productions, Inc.

56 Larry Angier
Jessica Brandi Lifland
Jessica Brandi Lifland
Jessica Brandi Lifland
Jessica Brandi Lifland
Jim K. Decker, *Las Vegas Review-Journal*
Joe Cavaretta

57 Larry Angier
Jean Dixon
Joe Cavaretta
Joe Cavaretta
Jean Dixon
Jessica Brandi Lifland
Jessica Brandi Lifland

62 Jim Laurie, Stephens Press
Jim Laurie, Stephens Press
Jim Laurie, Stephens Press
Jim Laurie, Stephens Press
Jim Laurie, Stephens Press
Jim Laurie, Stephens Press
Jim Laurie, Stephens Press

63 Jim Laurie, Stephens Press
Jim Laurie, Stephens Press
Jim Laurie, Stephens Press
Jim Laurie, Stephens Press
Jim Laurie, Stephens Press
Jim Laurie, Stephens Press
Jim Laurie, Stephens Press

66 Dan Burns, nofearfotos.com
Dan Burns, nofearfotos.com
John Locher
Dan Burns, nofearfotos.com
Scott Sady, *Reno Gazette-Journal*
Scott Sady, *Reno Gazette-Journal*
John Locher

68 Katherine Ruddy
Naomi Harris
Katherine Ruddy
Naomi Harris
Katherine Ruddy
Naomi Harris
Scott T. Smith

69 Scott T. Smith
Naomi Harris
Katherine Ruddy
Naomi Harris
Naomi Harris
Naomi Harris
Lindsay Hebberd, Cultural Portraits
Productions, Inc.

72 Day Williams
Day Williams
Day Williams
Day Williams
Scott T. Smith
Day Williams
Larry Angier

73 Larry Angier
Scott T. Smith
Day Williams
Shannon Litz, *The Record-Courier*
Scott T. Smith
Scott T. Smith
Scott T. Smith

74 Eric Jarvis
Jessica Brandi Lifland
Eric Jarvis
Jessica Brandi Lifland
Jessica Brandi Lifland
Eric Jarvis
Jessica Brandi Lifland

75 Lindsay Hebberd,
Cultural Portraits Productions, Inc.
Jessica Brandi Lifland
Jessica Brandi Lifland
Jessica Brandi Lifland
Lindsay Hebberd,
Cultural Portraits Productions, Inc.
Jessica Brandi Lifland

76 Brian D. Schultz
Amy Beth Bennett
Randa Bishop
Randa Bishop
Randa Bishop
Dan Burns, nofearfotos.com
Dan Burns, nofearfotos.com

77 Jim K. Decker, *Las Vegas Review-Journal*
Larry Angier
Dan Burns, nofearfotos.com
Scott T. Smith
Lindsay Hebberd,
Cultural Portraits Productions, Inc.
Sam Morris
Larry Angier

78 Scott T. Smith
Jim K. Decker, *Las Vegas Review-Journal*
Day Williams
Dan Burns, nofearfotos.com
Dan Burns, nofearfotos.com
Dan Burns, nofearfotos.com
Scott T. Smith

79 Scott T. Smith
Scott T. Smith
Scott T. Smith

Scott T. Smith
Scott T. Smith
Scott T. Smith
Scott T. Smith

80 Larry Angier
Dan Burns, nofearfotos.com
Larry Angier
Larry Angier
Larry Angier
Marilyn Newton, *Reno Gazette-Journal*
Larry Angier

81 Scott T. Smith
Larry Angier
Larry Angier
Larry Angier
Larry Angier
Larry Angier
Marilyn Newton, *Reno Gazette-Journal*

86 Amy Beth Bennett
Amy Beth Bennett
Scott T. Smith
Lindsay Hebberd,
Cultural Portraits Productions, Inc.
Warren Mell
Amy Beth Bennett
John Gurzinski

87 Amy Beth Bennett
Amy Beth Bennett
Randa Bishop
Amy Beth Bennett
Randa Bishop
Amy Beth Bennett
John Gurzinski

89 Jim K. Decker, *Las Vegas Review-Journal*
Lynn Hrnciar
Shannon Litz, *The Record-Courier*
Shannon Litz, *The Record-Courier*
Lin Alder, alderphoto.com
Lin Alder, alderphoto.com
Scott T. Smith

90 Scott T. Smith
Jim K. Decker, *Las Vegas Review-Journal*
Jim K. Decker, *Las Vegas Review-Journal*
Joe Cavaretta
Jim K. Decker, *Las Vegas Review-Journal*
Jim K. Decker, *Las Vegas Review-Journal*
Day Williams

91 Scott Sady, *Reno Gazette-Journal*
Jean Dixon
Day Williams
Jean Dixon
Lin Alder, alderphoto.com
Jean Dixon
Lin Alder, alderphoto.com

99 Katherine Ruddy
Brian D. Schultz
Misha Erwitt
Jim Laurie, Stephens Press
Jim Laurie, Stephens Press
Scott T. Smith
Kim Komenich

100 Lindsay Hebberd,
Cultural Portraits Productions, Inc.
Misha Erwitt
Jim K. Decker, *Las Vegas Review-Journal*
Jim K. Decker, *Las Vegas Review-Journal*
Misha Erwitt
Lindsay Hebberd,
Cultural Portraits Productions, Inc.
Katherine Ruddy

101 Lindsay Hebberd,
Cultural Portraits Productions, Inc.
Misha Erwitt
Misha Erwitt
Lindsay Hebberd,
Cultural Portraits Productions, Inc.
Jim K. Decker, *Las Vegas Review-Journal*

Naomi Harris
Lindsay Hebberd,
Cultural Portraits Productions, Inc.

104 Marilyn Newton, *Reno Gazette-Journal*
Lin Alder, alderphoto.com
Marilyn Newton, *Reno Gazette-Journal*
Marilyn Newton, *Reno Gazette-Journal*
Marilyn Newton, *Reno Gazette-Journal*
Marilyn Newton, *Reno Gazette-Journal*
Marilyn Newton, *Reno Gazette-Journal*

105 Lindsay Hebberd,
Cultural Portraits Productions, Inc.
Scott T. Smith
Marilyn Newton, *Reno Gazette-Journal*
Scott T. Smith
Lindsay Hebberd,
Cultural Portraits Productions, Inc.
Scott T. Smith
Marilyn Newton, *Reno Gazette-Journal*

106 Day Williams
Randa Bishop
Lindsay Hebberd,
Cultural Portraits Productions, Inc.
Lindsay Hebberd,
Cultural Portraits Productions, Inc.
Lindsay Hebberd,
Cultural Portraits Productions, Inc.
Jim K. Decker, *Las Vegas Review-Journal*
Lindsay Hebberd,
Cultural Portraits Productions, Inc.

107 Larry Angier
Naomi Harris
Misha Erwitt
Naomi Harris
Lindsay Hebberd,
Cultural Portraits Productions, Inc.
Lindsay Hebberd,
Cultural Portraits Productions, Inc.
Katherine Ruddy

109 Sam Morris
Sam Morris
Sam Morris
Amy Beth Bennett
Sam Morris
Sam Morris
Sam Morris

110 Joe Cavaretta
Scott T. Smith
Joe Cavaretta
Joe Cavaretta
Joe Cavaretta
Joe Cavaretta
Joe Cavaretta

111 Joe Cavaretta
Joe Cavaretta
Joe Cavaretta
Joe Cavaretta
Joe Cavaretta
Joe Cavaretta
Joe Cavaretta

112 Scott T. Smith
Jessica Brandi Lifland
Jim K. Decker, *Las Vegas Review-Journal*
Larry Angier
Jim K. Decker, *Las Vegas Review-Journal*
Jim K. Decker, *Las Vegas Review-Journal*
Jim K. Decker, *Las Vegas Review-Journal*

113 Jim K. Decker, *Las Vegas Review-Journal*
Larry Angier
Scott T. Smith
Jim Laurie, Stephens Press
Scott T. Smith
Jim K. Decker, *Las Vegas Review-Journal*
Jim Laurie, Stephens Press

114 Jessica Brandi Lifland
Jessica Brandi Lifland
Jessica Brandi Lifland
Steve Cerocke, www.photoquests.com

Jessica Brandi Lifland
Jessica Brandi Lifland
Jessica Brandi Lifland

115 Jessica Brandi Lifland
Steve Cerocke, www.photoquests.com
Jessica Brandi Lifland
Steve Cerocke, www.photoquests.com
Jessica Brandi Lifland
Jessica Brandi Lifland
Jessica Brandi Lifland

116 Jim K. Decker, *Las Vegas Review-Journal*
Jim K. Decker, *Las Vegas Review-Journal*
Jim K. Decker, *Las Vegas Review-Journal*
Scott T. Smith
Jim K. Decker, *Las Vegas Review-Journal*
Jim K. Decker, *Las Vegas Review-Journal*
Jim K. Decker, *Las Vegas Review-Journal*

117 Scott T. Smith
Scott T. Smith
Jim Laurie, Stephens Press
Jim Laurie, Stephens Press
Scott T. Smith
Scott T. Smith
Scott T. Smith

118 Brian D. Schultz
Brian D. Schultz
Lindsay Hebberd,
Cultural Portraits Productions, Inc.
Brian D. Schultz
Lindsay Hebberd,
Cultural Portraits Productions, Inc.
Brian D. Schultz
Brian D. Schultz

119 Larry Angier
Jim Laurie, Stephens Press
Larry Angier
Brian D. Schultz
Larry Angier
Scott T. Smith
Jim Laurie, Stephens Press

121 Jim K. Decker, *Las Vegas Review-Journal*
Jim Laurie, Stephens Press
Dan Burns, nofearfotos.com
Jim Laurie, Stephens Press
Jim K. Decker, *Las Vegas Review-Journal*
Jessica Brandi Lifland
Jim K. Decker, *Las Vegas Review-Journal*

122 Jessica Brandi Lifland
Eric Jarvis
Jessica Brandi Lifland
Eric Jarvis
Eric Jarvis
Eric Jarvis
Jessica Brandi Lifland

123 Jessica Brandi Lifland
John Gurzinski
Jessica Brandi Lifland
John Gurzinski
John Gurzinski
Jessica Brandi Lifland
John Gurzinski

124 Lin Alder, alderphoto.com
Jessica Brandi Lifland
Larry Angier
Larry Angier
Jim Laurie, Stephens Press
Larry Angier
Jessica Brandi Lifland

125 Larry Angier
Jim Laurie, Stephens Press
Larry Angier
Jessica Brandi Lifland
Larry Angier
Larry Angier
Jim Laurie, Stephens Press

128 Jean Dixon
Amy Beth Bennett
Amy Beth Bennett

Amy Beth Bennett
Darius Kuzmickas
Amy Beth Bennett
Jim K. Decker, *Las Vegas Review-Journal*

129 Sam Morris
Sam Morris
Sam Morris
Scott T. Smith
Jessica Brandi Lifland
Jim K. Decker, *Las Vegas Review-Journal*
Amy Beth Bennett

133 John Gurzinski
John Gurzinski
John Gurzinski
John Gurzinski
John Gurzinski
John Gurzinski

134 John Gurzinski
John Gurzinski
John Gurzinski
John Gurzinski
John Gurzinski
John Gurzinski
Randa Bishop

135 Randa Bishop
John Gurzinski
John Gurzinski
John Gurzinski
Randa Bishop
John Gurzinski
John Gurzinski

Staff

The *America 24/7* series was imagined years ago by our friend Oscar Dystel, a publishing legend whose vision and enthusiasm have been a source of great inspiration.

We also wish to express our gratitude to our truly visionary publisher, DK.

Rick Smolan, Project Director
David Elliot Cohen, Project Director

Administrative
Katya Able, Operations Director
Gina Privitere, Communications Director
Chuck Gathard, Technology Director
Kim Shannon, Photographer Relations Director
Erin O'Connor, Photographer Relations Intern
Leslie Hunter, Partnership Director
Annie Polk, Publicity Manager
John McAlester, Website Manager
Alex Notides, Office Manager
C. Thomas Hardin, State Photography Coordinator

Design
Brad Zucroff, Creative Director
Karen Mullarkey, Photography Director
Judy Zimola, Production Manager
David Simoni, Production Designer
Mary Dias, Production Designer
Heidi Madison, Associate Picture Editor
Don McCartney, Production Designer
Diane Dempsey Murray, Production Designer
Jan Rogers, Associate Picture Editor
Bill Shore, Production Designer and Image Artist
Larry Nighswander, Senior Picture Editor
Bill Marr, Sarah Leen, Senior Picture Editors
Peter Truskier, Workflow Consultant
Jim Birkenseer, Workflow Consultant

Editorial
Maggie Canon, Managing Editor
Curt Sanburn, Senior Editor
Teresa L. Trego, Production Editor
Lea Aschkenas, Writer
Olivia Boler, Writer
Korey Capozza, Writer
Beverly Hanly, Writer
Bridgett Novak, Writer
Alison Owings, Writer
Fred Raker, Writer
Joe Wolff, Writer
Elise O'Keefe, Copy Chief
Will Hector, Copy Editor
Daisy Hernández, Copy Editor
Jennifer Wolfe, Copy Editor

Infographic Design
Nigel Holmes

Literary Agent
Carol Mann, The Carol Mann Agency

Legal Counsel
Barry Reder, Coblentz, Patch, Duffy & Bass, LLP
Phil Feldman, Coblentz, Patch, Duffy & Bass, LLP
Gabe Perle, Ohlandt, Greeley, Ruggiero & Perle, LLP
Jon Hart, Dow, Lohnes & Albertson, PLLC
Mike Hays, Dow, Lohnes & Albertson, PLLC
Stephen Pollen, Warshaw Burstein, Cohen, Schlesinger & Kuh, LLP
Rick Pappas

Accounting and Finance
Rita Dulebohn, Accountant
Robert Powers, Calegari, Morris & Co. Accountants
Eugene Blumberg, Blumberg & Associates
Arthur Langhaus, KLS Professional Advisors Group, Inc.

Picture Editors
J. David Ake, Associated Press
Caren Alpert, formerly *Health* magazine
Simon Barnett, *Newsweek*
Caroline Couig, *San Jose Mercury News*
Mike Davis, formerly *National Geographic*
Michel duCille, *Washington Post*
Deborah Dragon, *Rolling Stone*
Victor Fisher, formerly Associated Press
Frank Folwell, *USA Today*
MaryAnne Golon, *Time*
Liz Grady, formerly *National Geographic*
Randall Greenwell, *San Francisco Chronicle*
C. Thomas Hardin, formerly *Louisville Courier-Journal*
Kathleen Hennessy, *San Francisco Chronicle*
Scot Jahn, *U.S. News & World Report*
Steve Jessmore, *Flint Journal*
John Kaplan, University of Florida
Kim Komenich, *San Francisco Chronicle*
Eliane Laffont, *Hachette Filipacchi Media*
Jean-Pierre Laffont, *Hachette Filipacchi Media*
Andrew Locke, MSNBC
Jose Lopez, *The New York Times*
Maria Mann, formerly AFP
Bill Marr, formerly *National Geographic*
Michele McNally, *Fortune*
James Merithew, *San Francisco Chronicle*
Eric Meskauskas, *New York Daily News*
Maddy Miller, *People* magazine
Michelle Molloy, *Newsweek*
Dolores Morrison, *New York Daily News*
Karen Mullarkey, formerly *Newsweek, Rolling Stone, Sports Illustrated*
Larry Nighswander, Ohio University School of Visual Communication
Jim Preston, *Baltimore Sun*
Sarah Rozen, formerly *Entertainment Weekly*
Mike Smith, *The New York Times*
Neal Ulevich, formerly Associated Press

Website and Digital Systems
Jeff Burchell, Applications Engineer

Television Documentary
Sandy Smolan, Producer/Director
Rick King, Producer/Director
Bill Medsker, Producer

Video News Release
Mike Cerre, Producer/Director

Digital Pond
Peter Hogg
Kris Knight
Roger Graham
Philip Bond
Frank De Pace
Lisa Li

Senior Advisors
Jennifer Erwitt, Strategic Advisor
Tom Walker, Creative Advisor
Megan Smith, Technology Advisor
Jon Kamen, Media and Partnership Advisor
Mark Greenberg, Partnership Advisor
Patti Richards, Publicity Advisor
Cotton Coulson, Mission Control Advisor

Executive Advisors
Sonia Land
George Craig
Carole Bidnick

Advisors
Chris Anderson
Samir Arora
Russell Brown
Craig Cline
Gayle Cline
Harlan Felt
George Fisher
Phillip Moffitt
Clement Mok
Laureen Seeger
Richard Saul Wurman

DK Publishing
Bill Barry
Joanna Bull
Therese Burke
Sarah Coltman
Christopher Davis
Todd Fries
Dick Heffernan
Jay Henry
Stuart Jackman
Stephanie Jackson
Chuck Lang
Sharon Lucas
Cathy Melnicki
Nicola Munro
Eunice Paterson
Andrew Welham

Colourscan
Jimmy Tsao
Eddie Chia
Richard Law
Josephine Yam
Paul Koh
Chee Cheng Yeong
Dan Kang

Chief Morale Officer
Goose, the dog

24/7 books available for every state. Collect the entire series of 50 books. Go to www.america24-7.com/store